DESDE AZTLAN
A Sacred Geometry Chicano Codex

By
Israel F. Haros Lopez

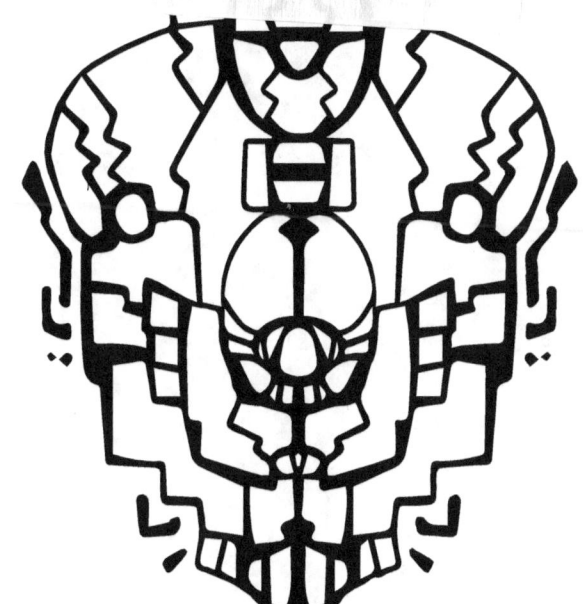

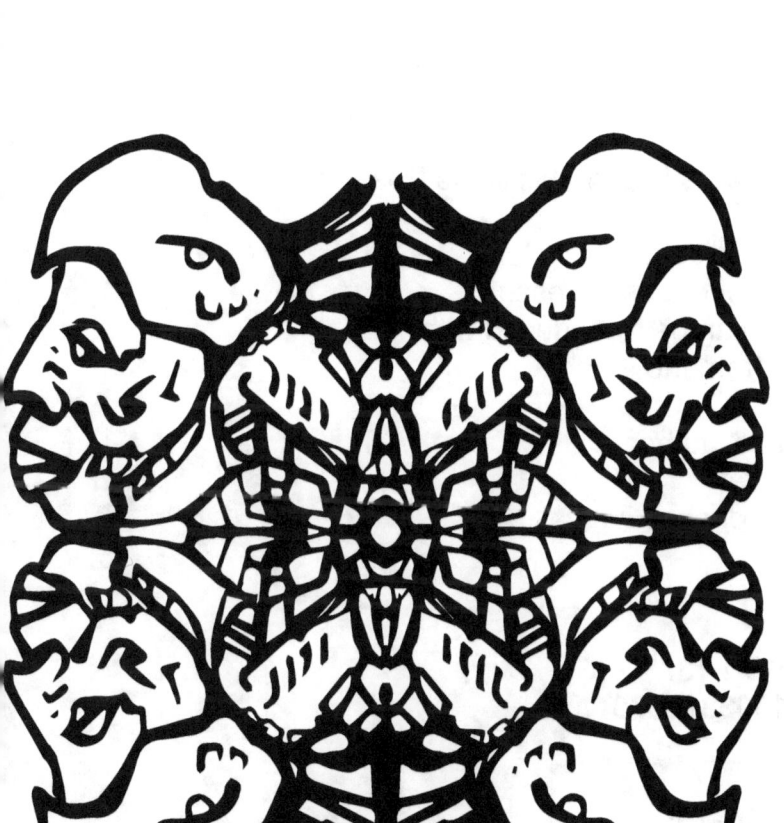

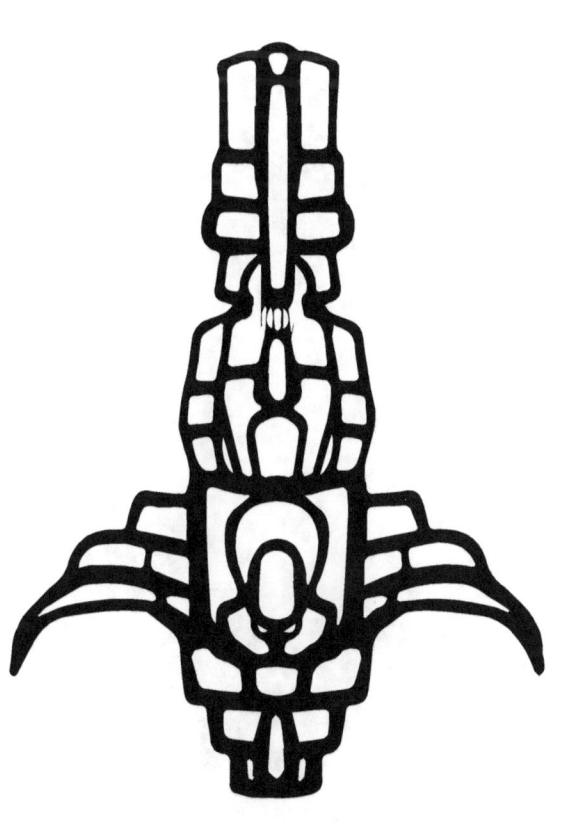

Desde Aztlan
A Sacred Geometry Chicano Codex

Drawn by Israel F. Haros Lopez

Cover Design by
Israel F. Haros Lopez

Desde Aztlan: A Sacred Geometry Chicano Codex

Copyright © 2014 by Israel F. Haros Lopez. All Rights Reserved.

First Edition.
Waterhummingbirdhouse Press.
Portions of this book can be reproduced with
permission from the author.

Contact author
at
waterhummingbirdhouse@gmail.com

ISBN-13:
978-1503313378

ISBN-10:
1503313379

Para
Geovanny Vásconez, Aurelio Diaz,
Don Tulio, Alberto Martinez,
R. Rodriguez,
y todos los que viven
dentro de la geometria sagrada

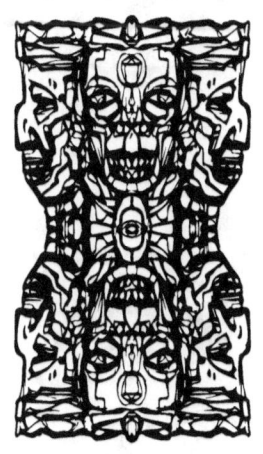

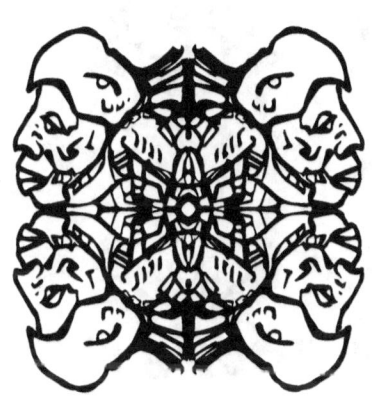

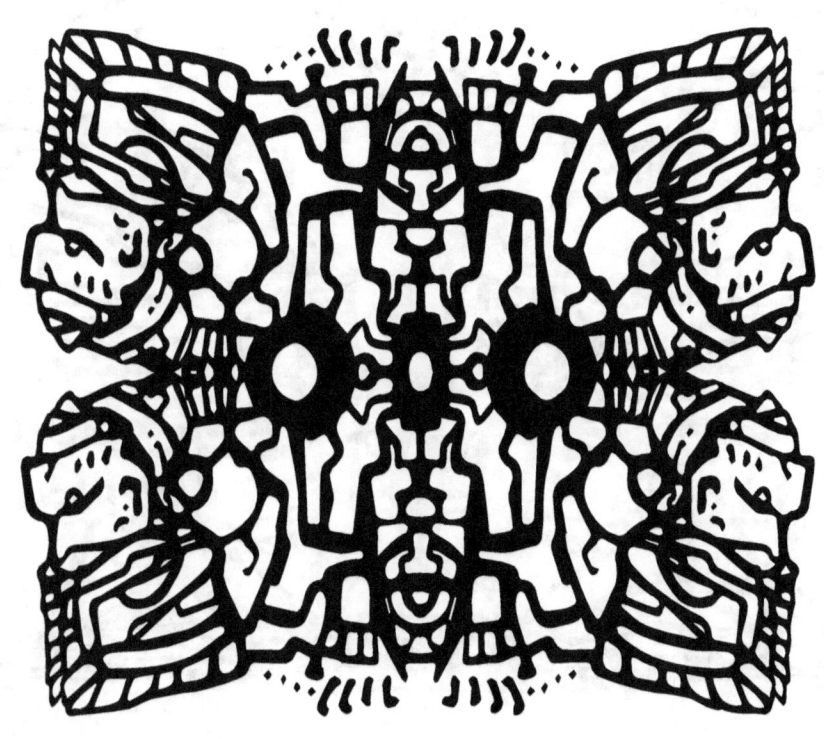

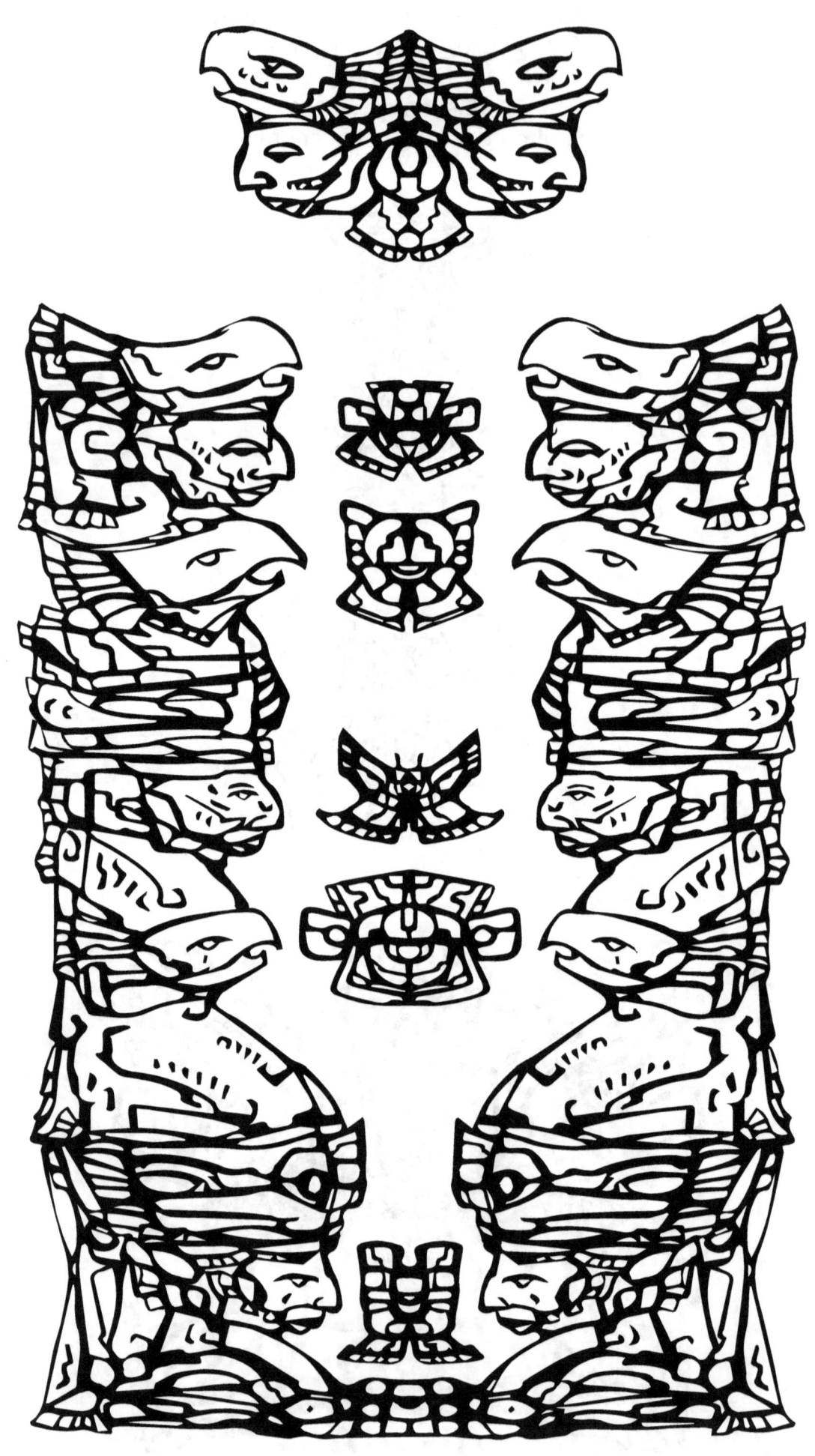

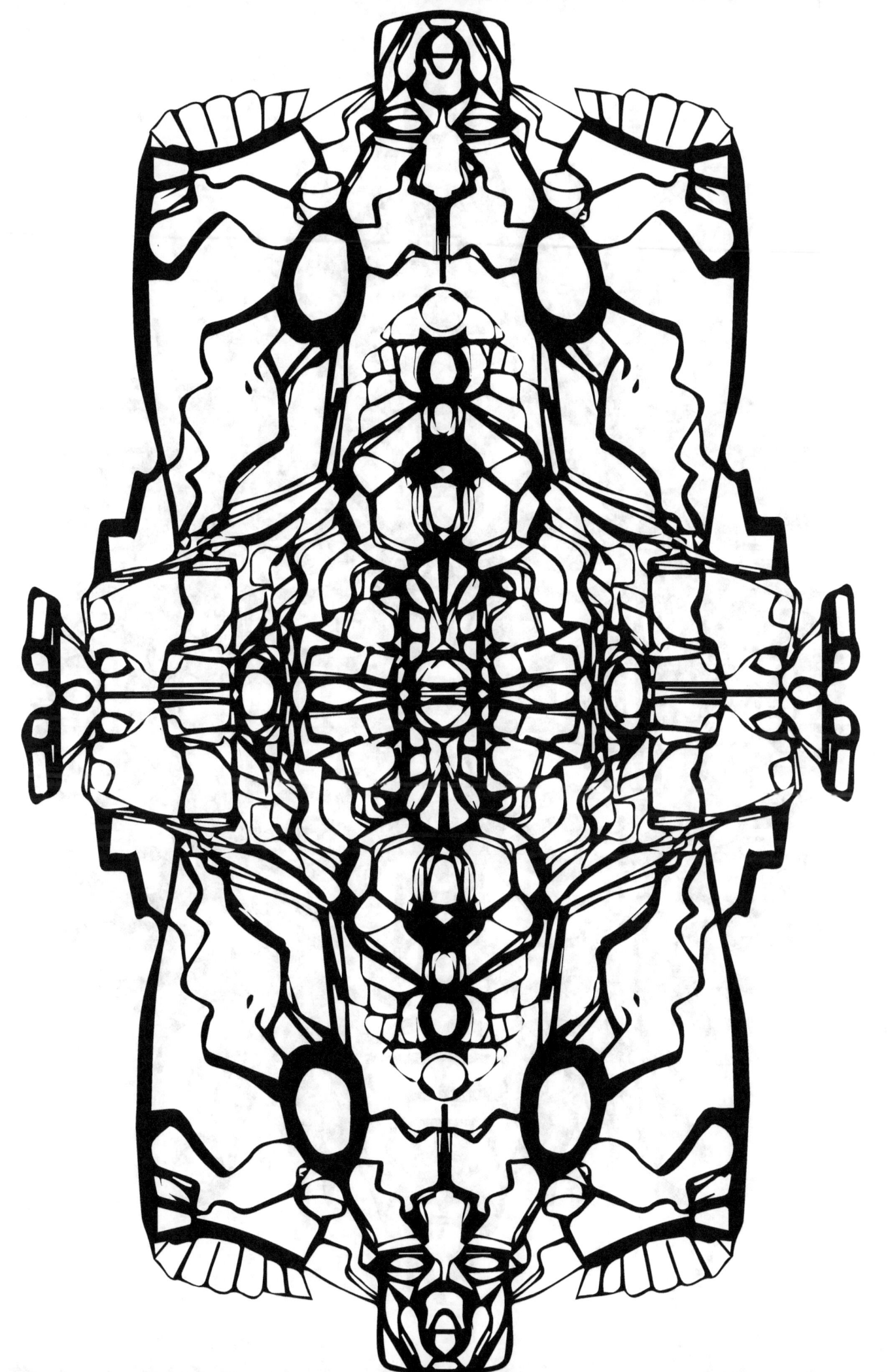

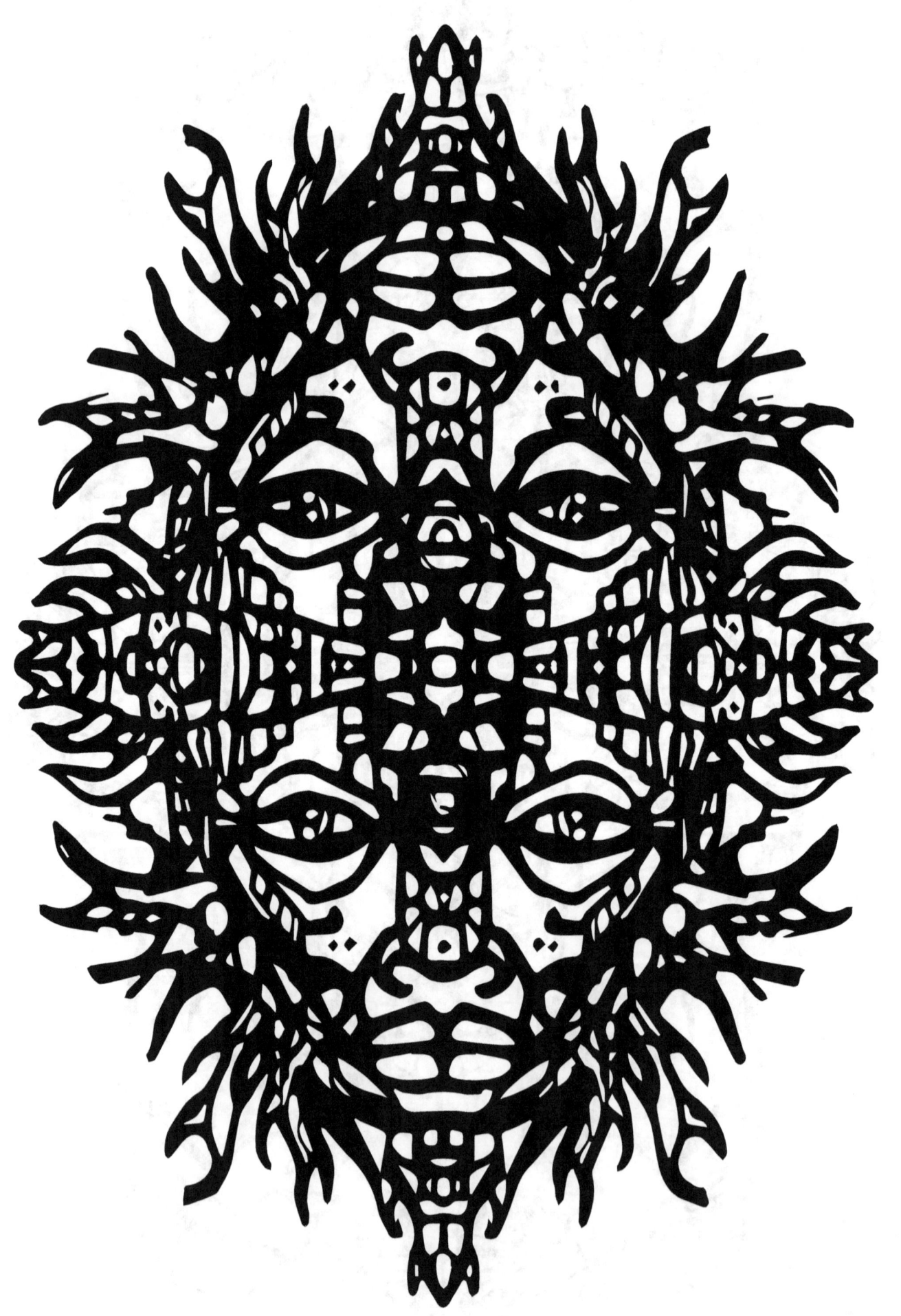

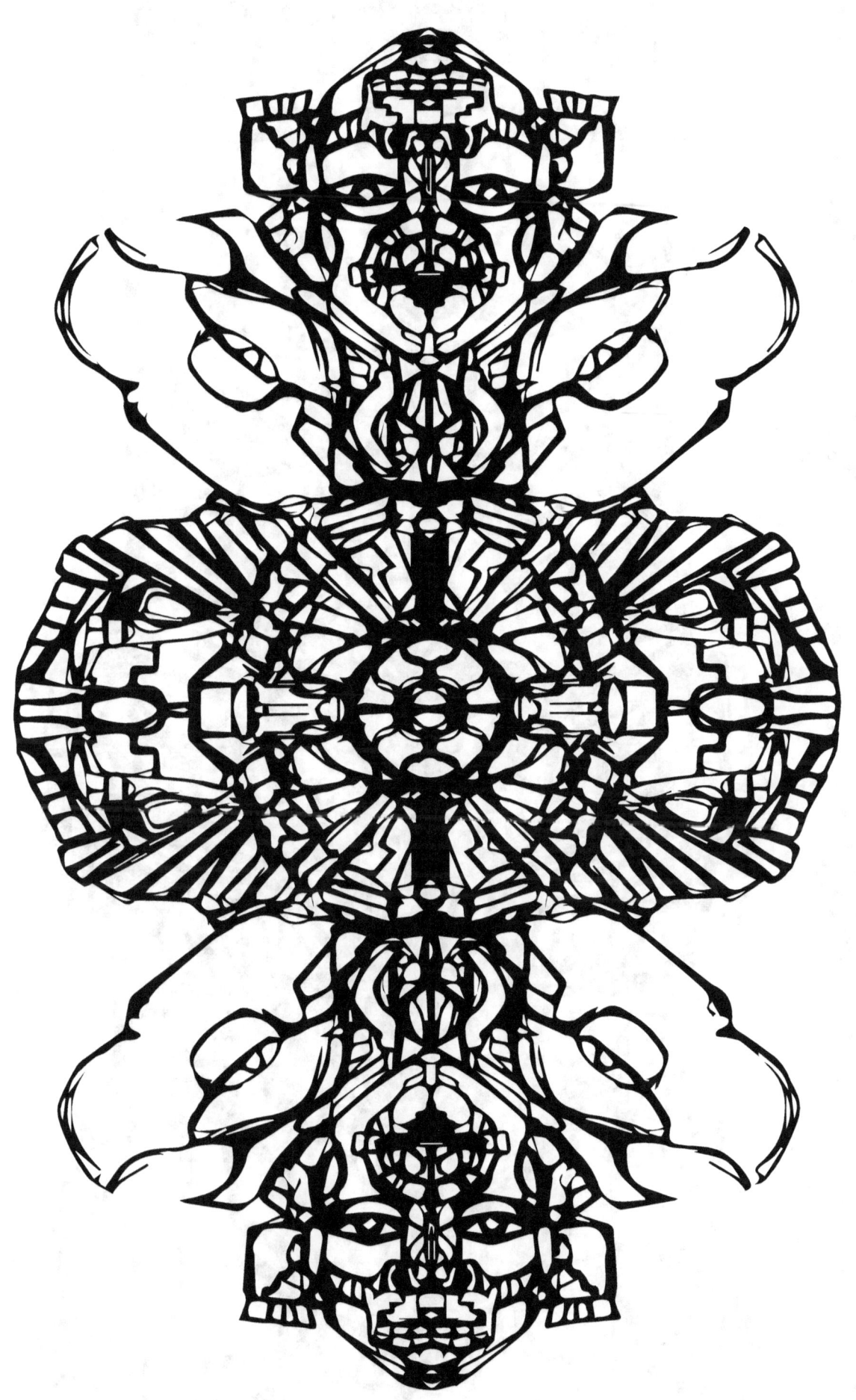

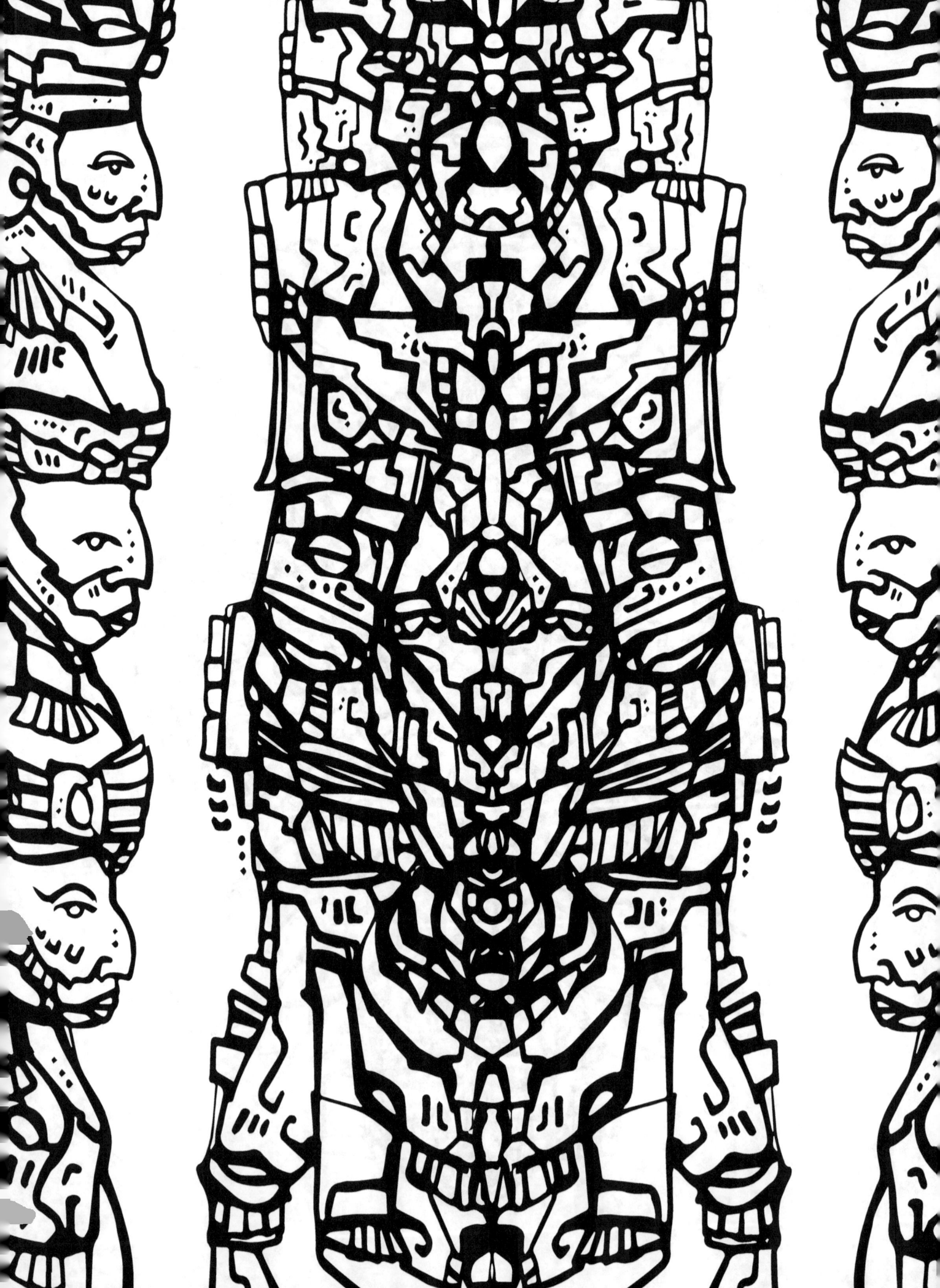

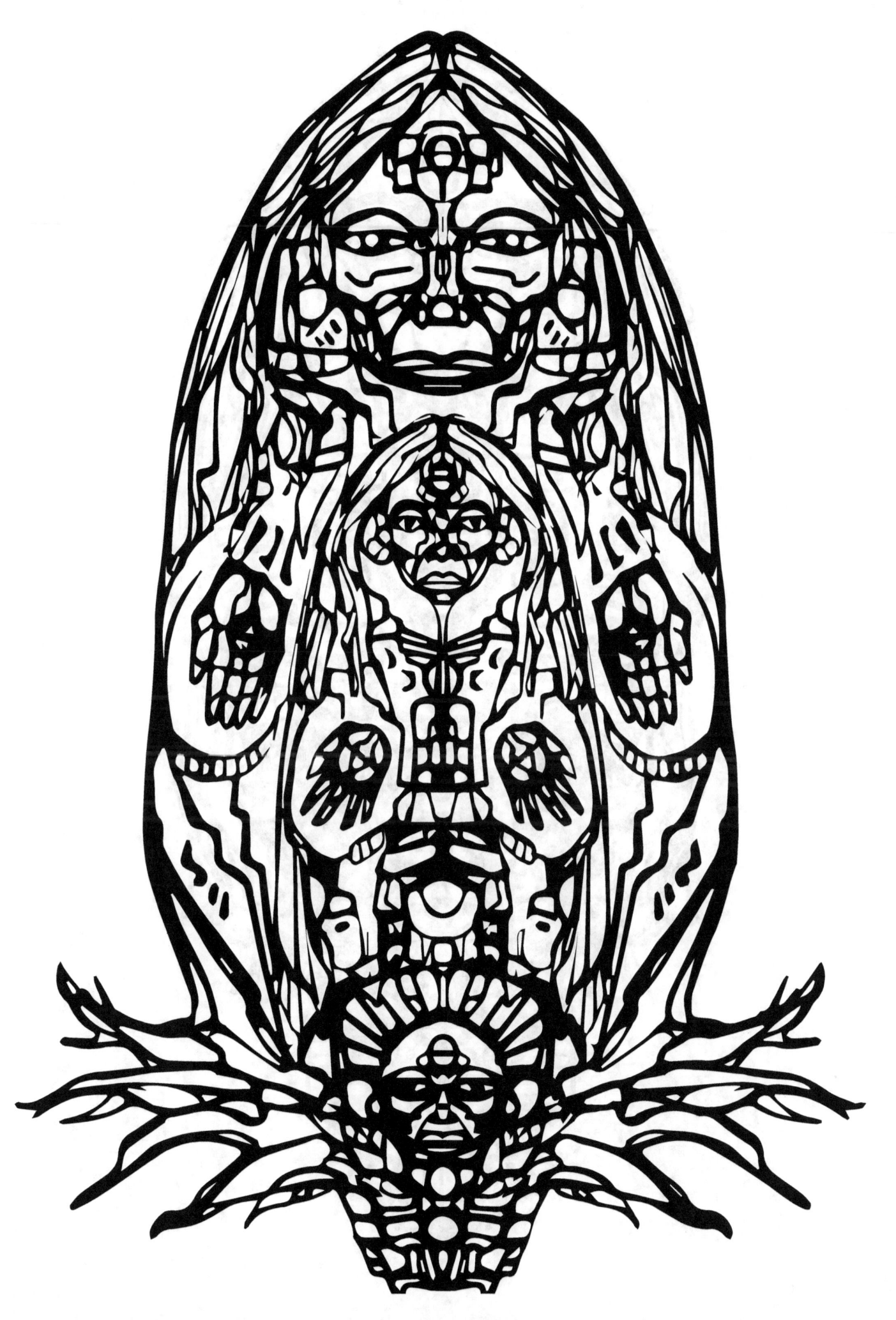

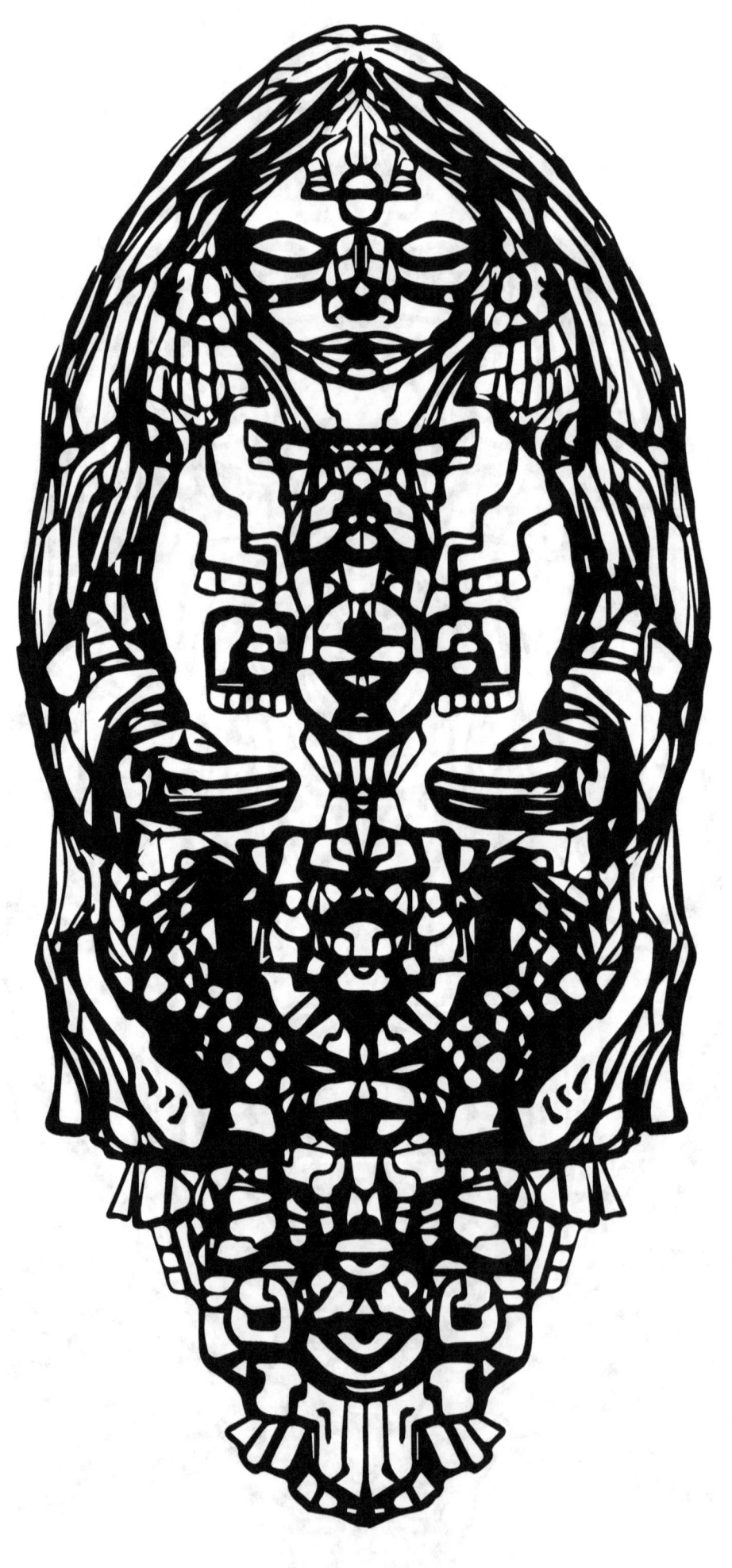

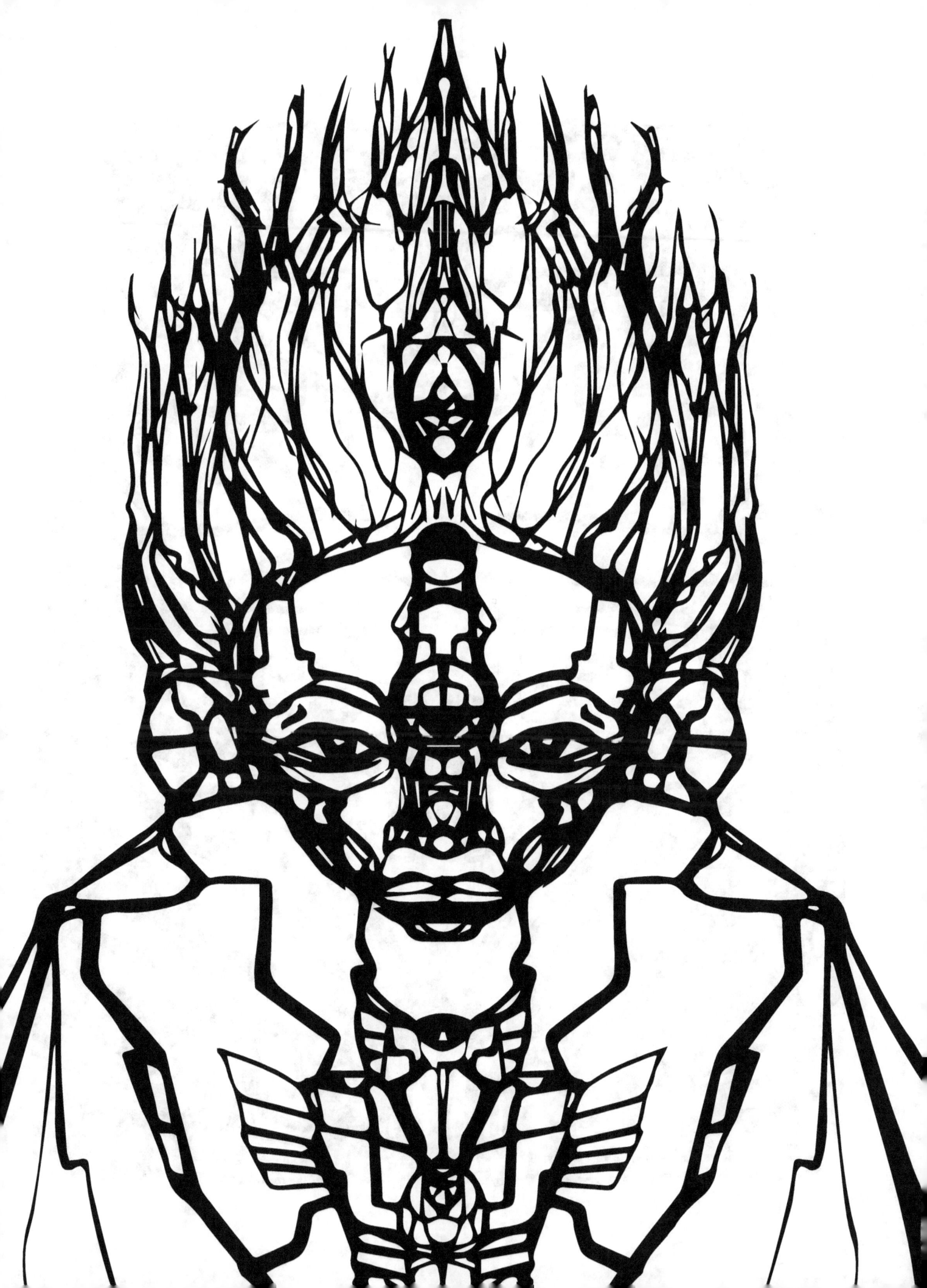

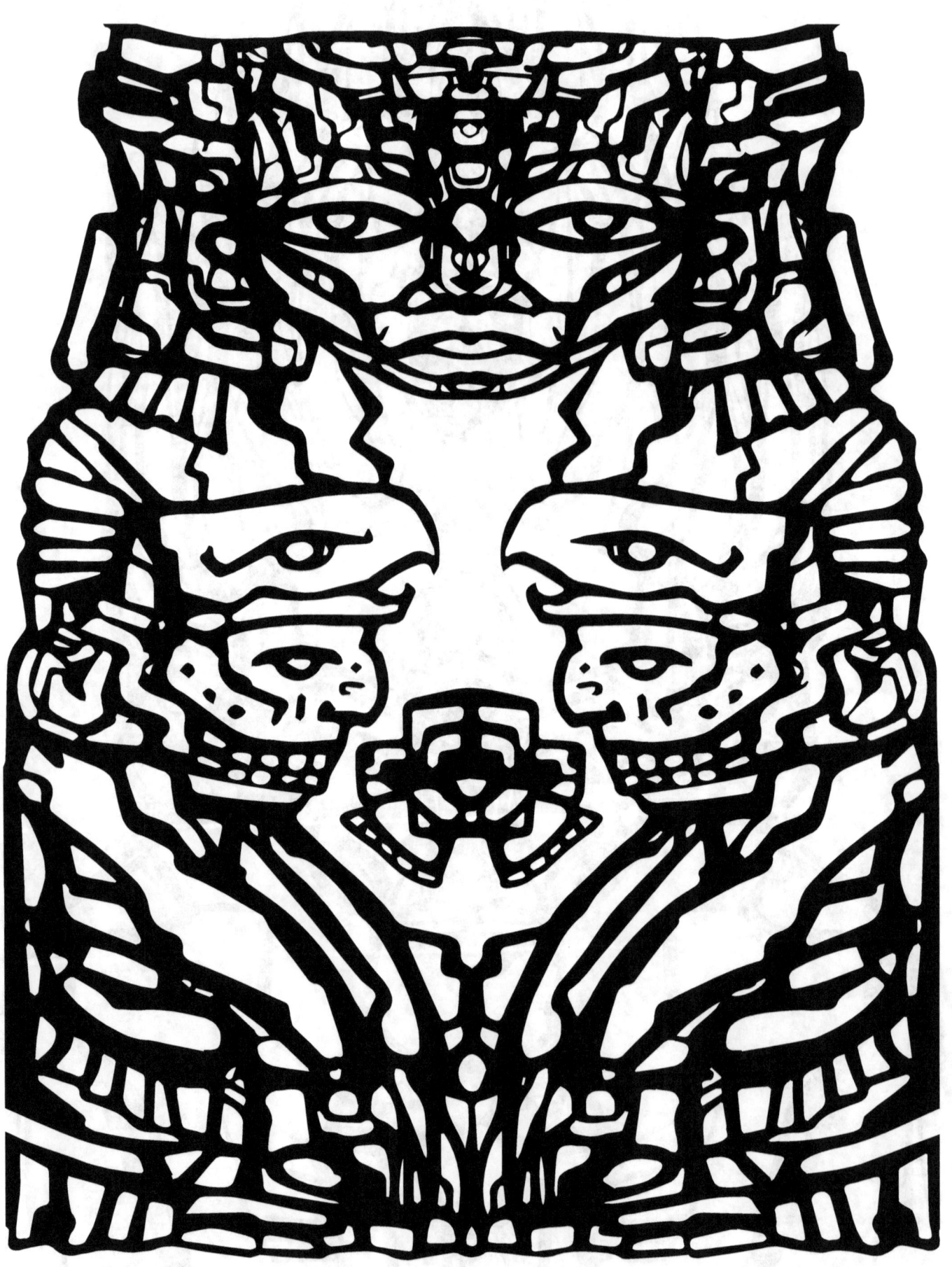

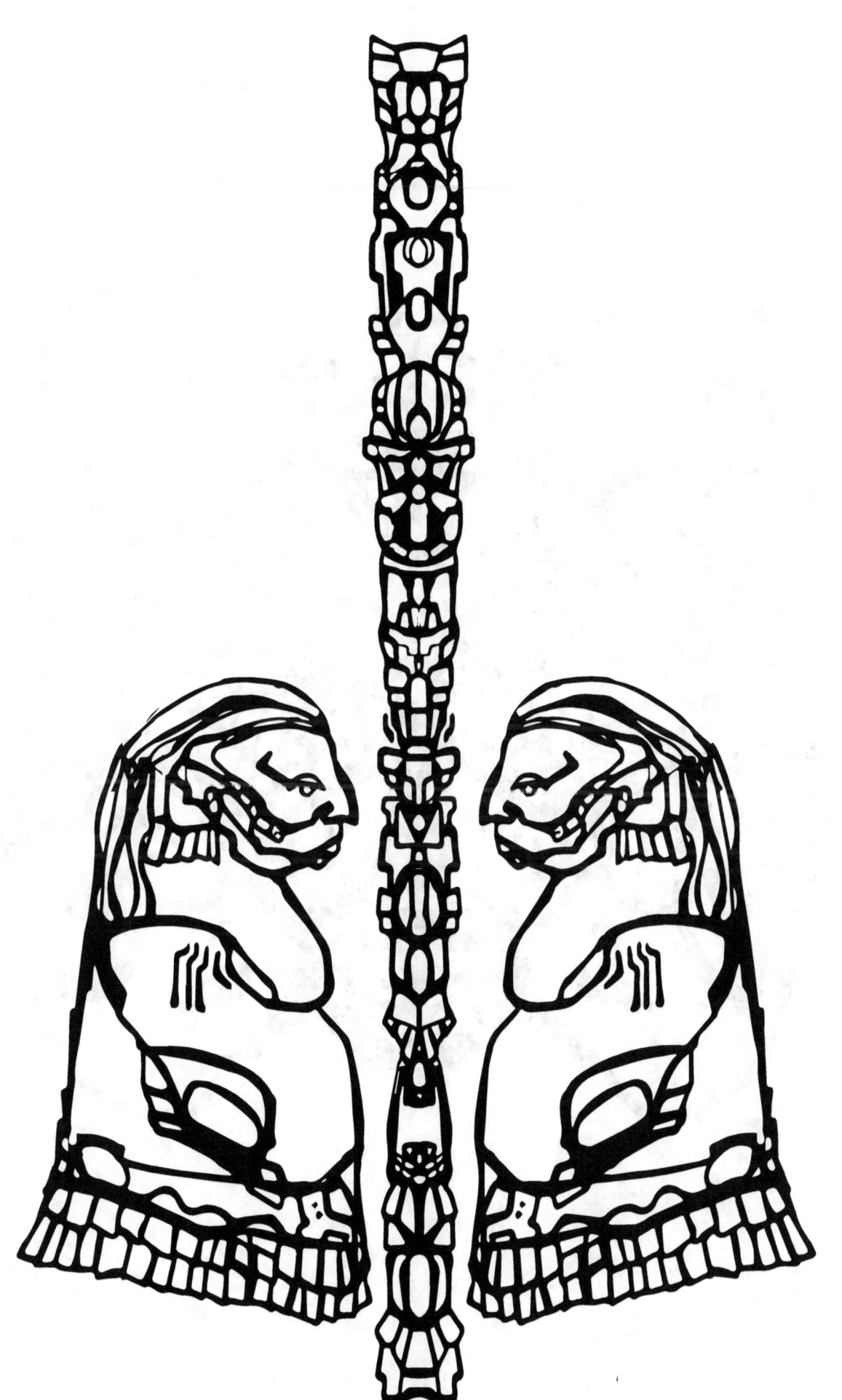

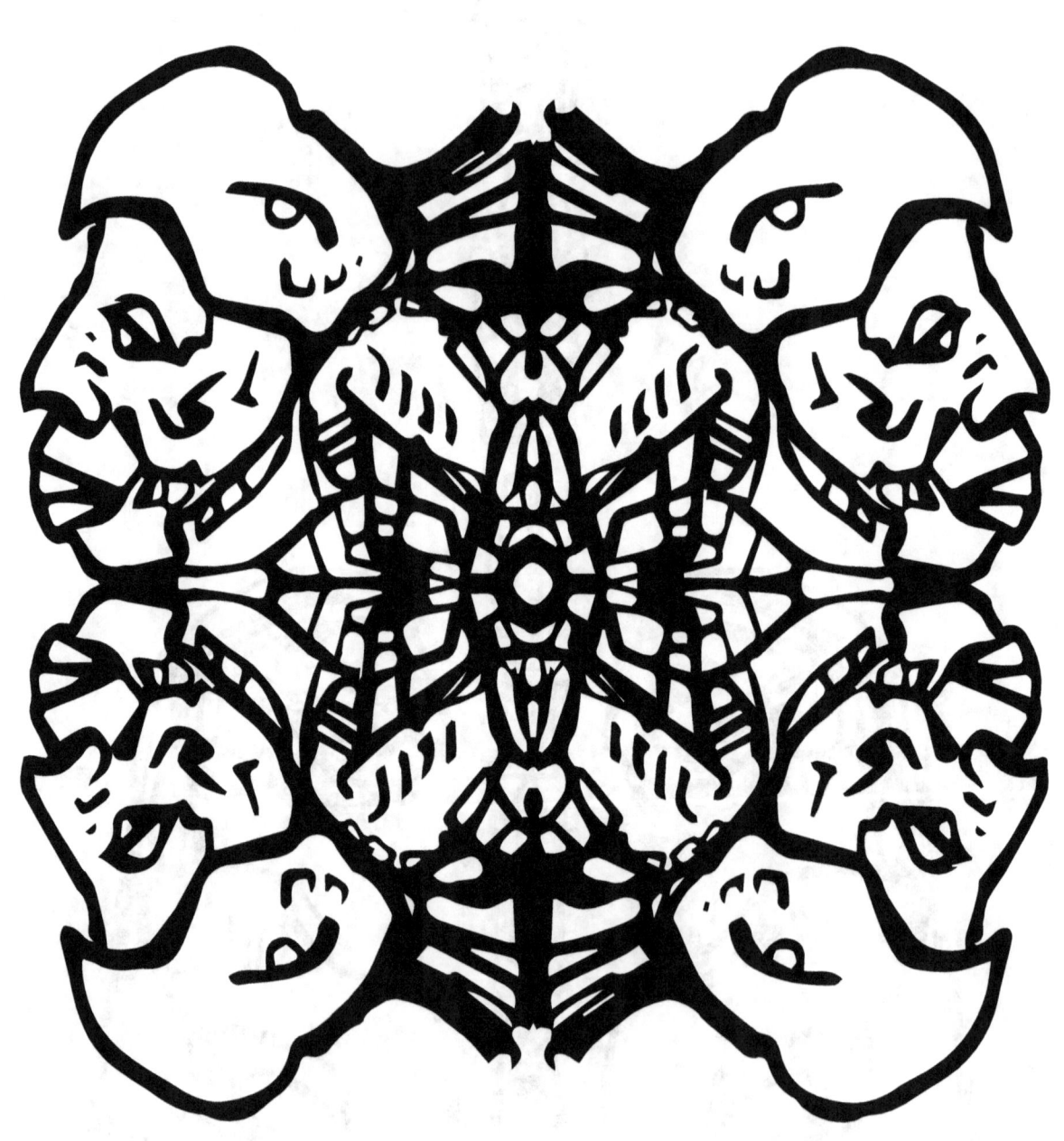

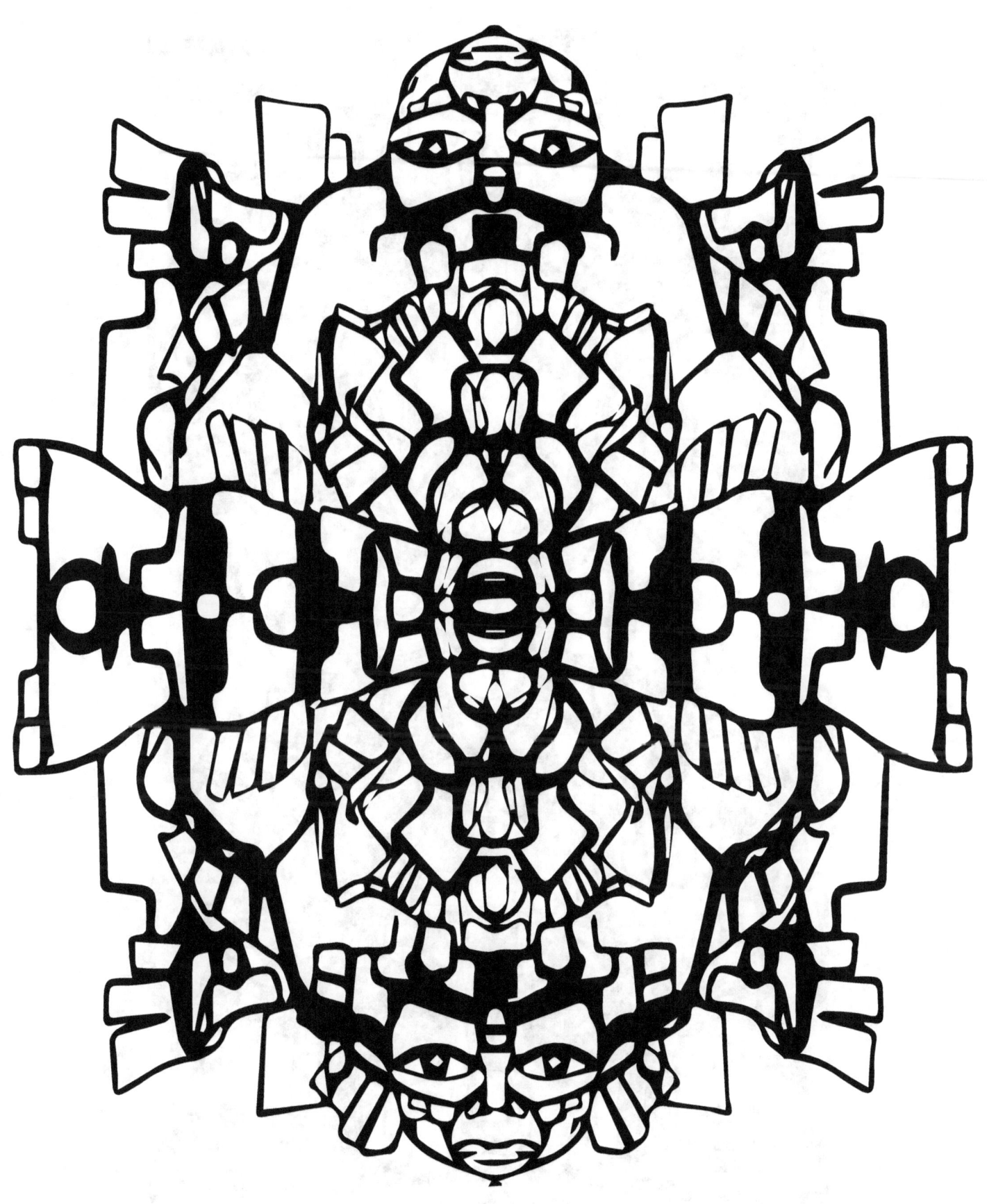

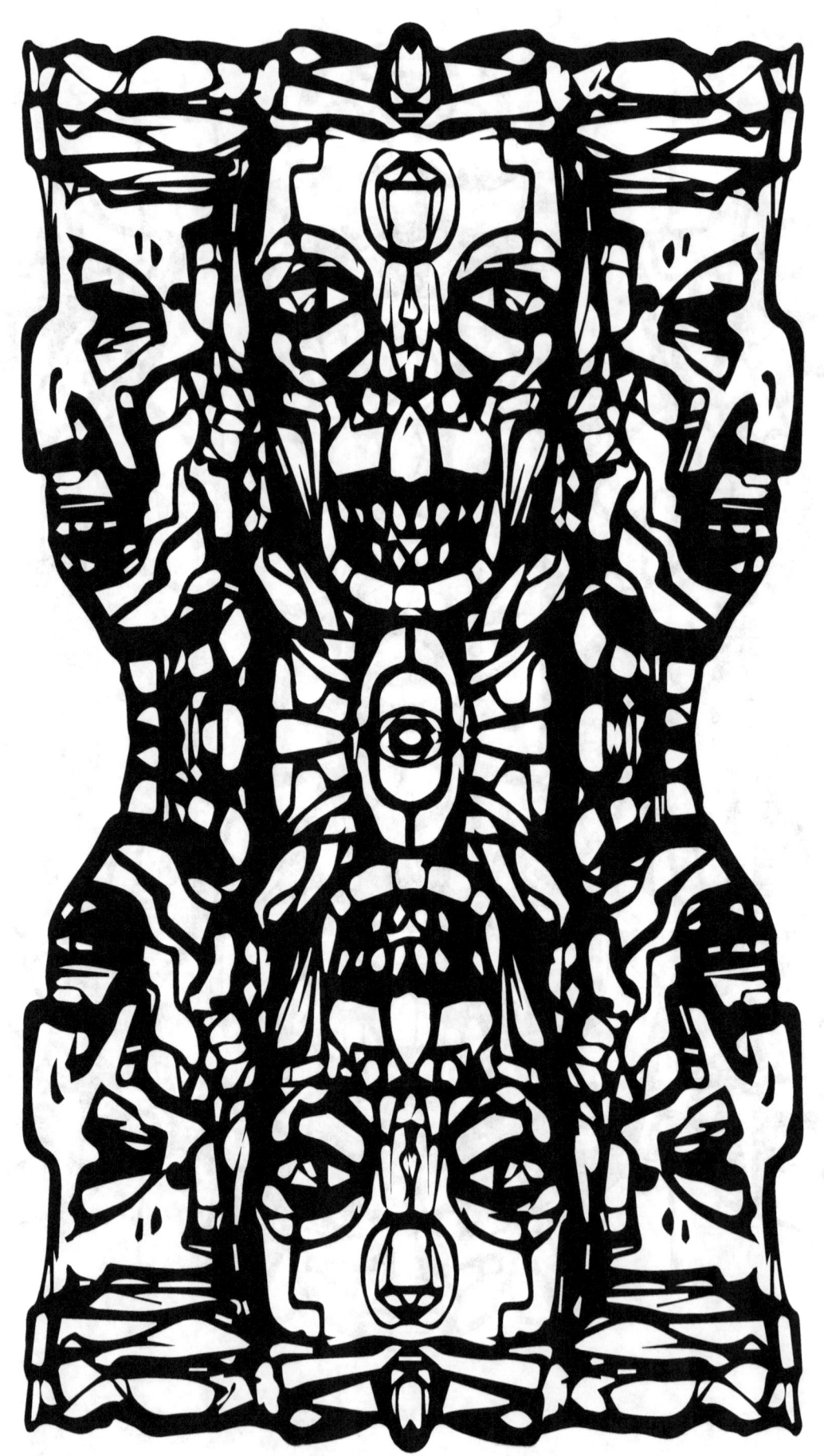

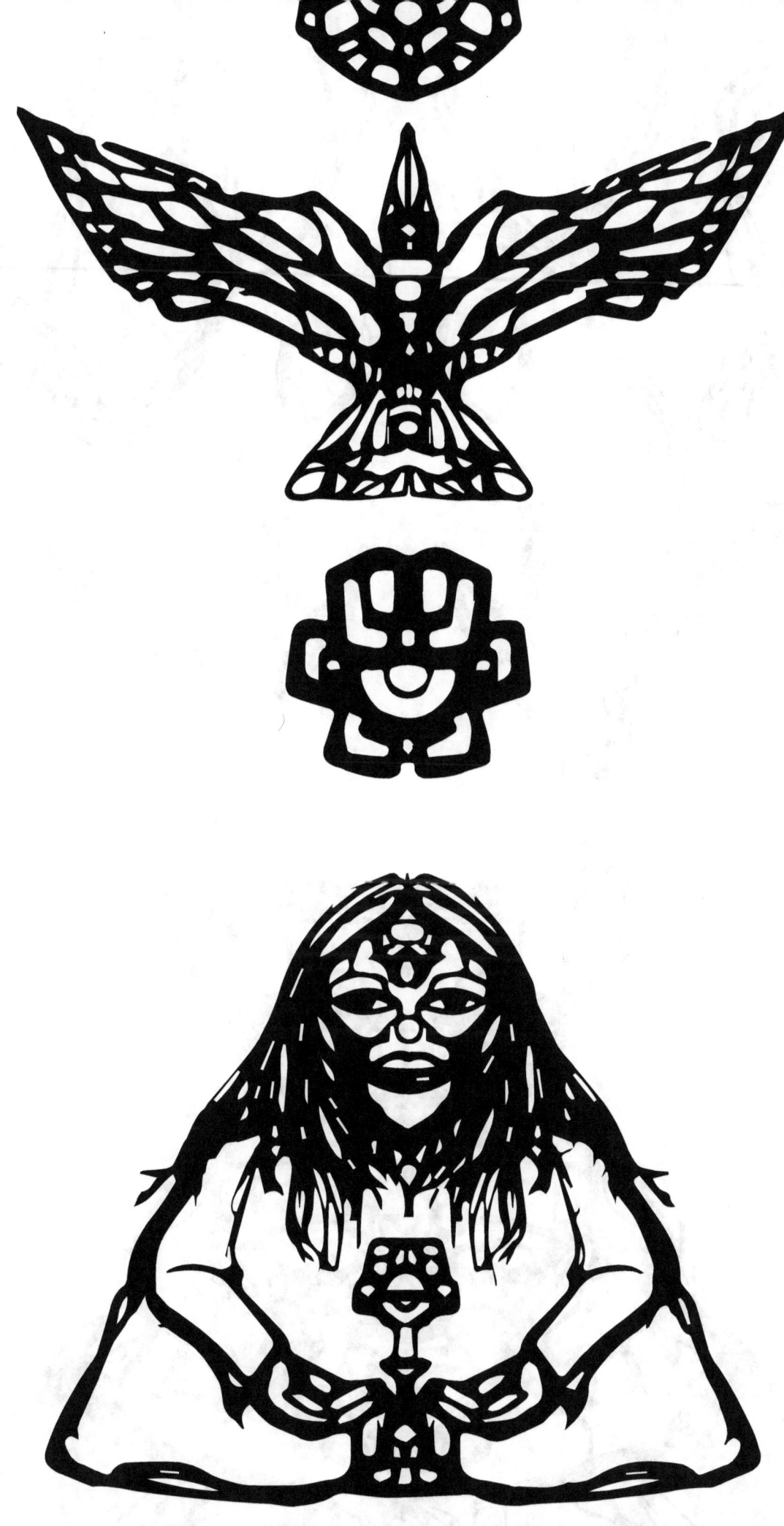

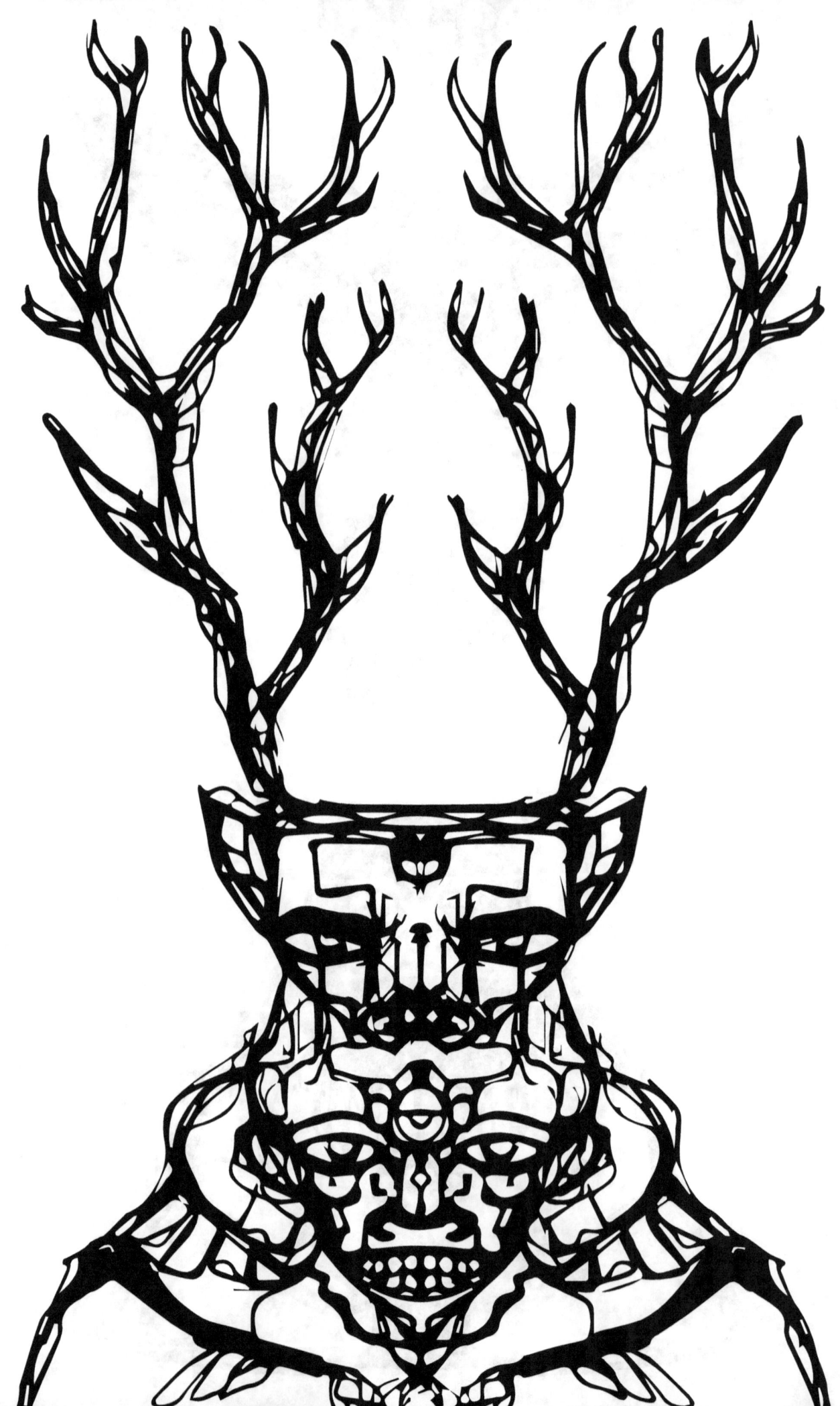

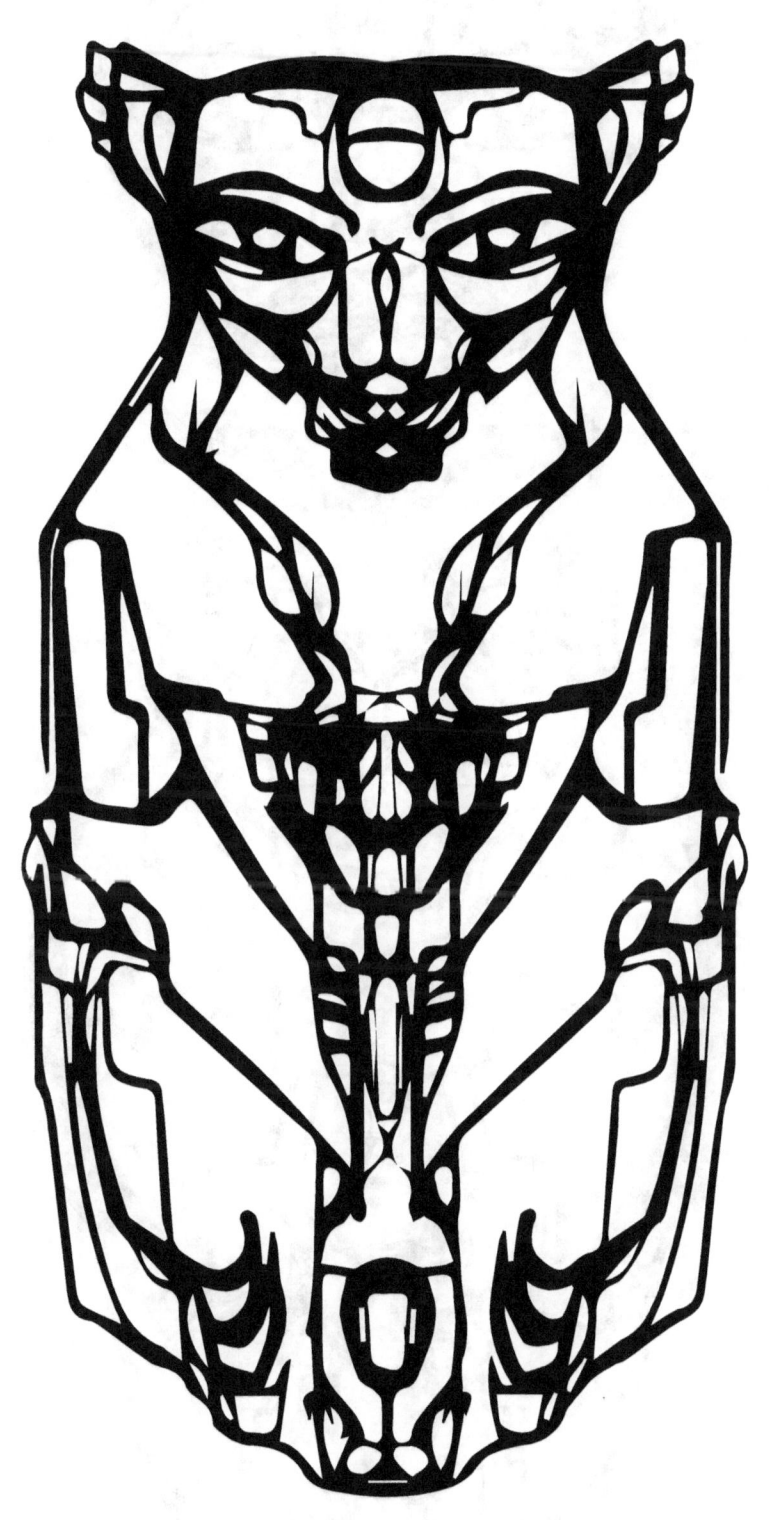

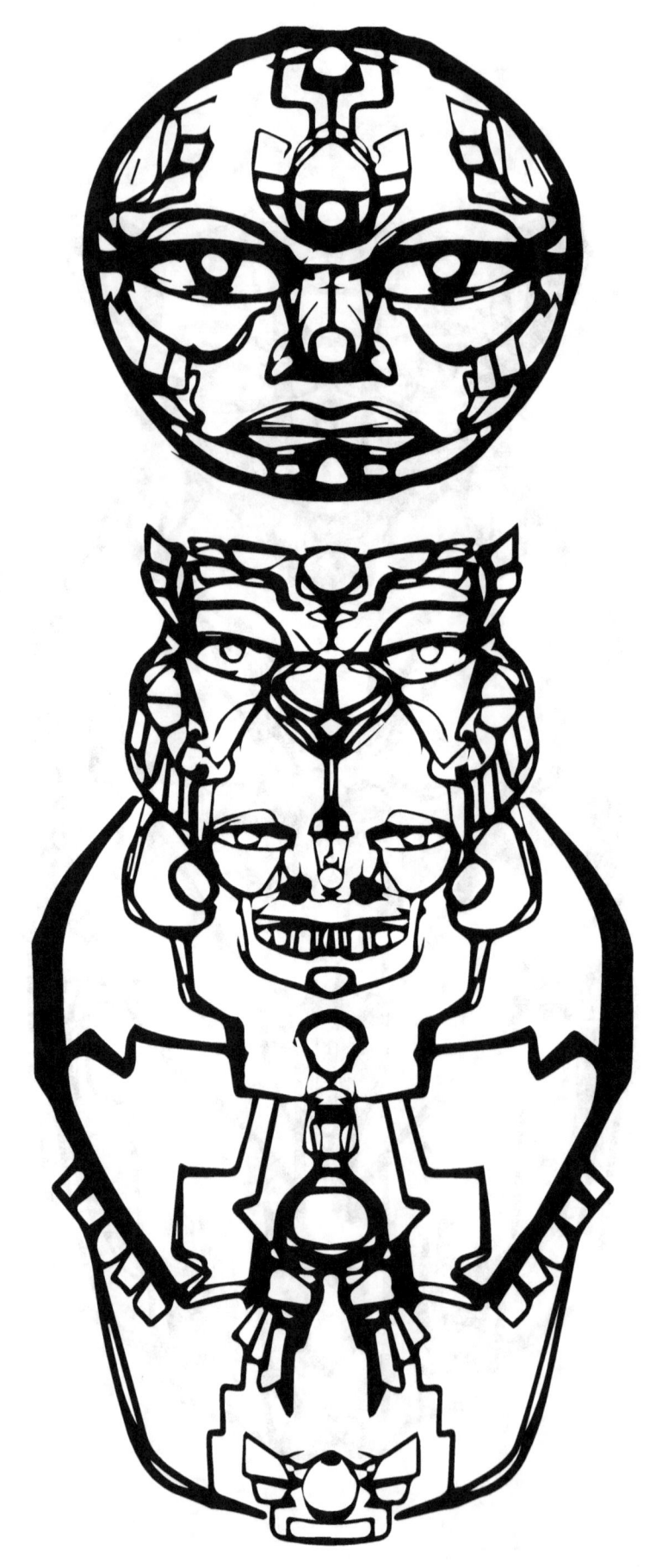

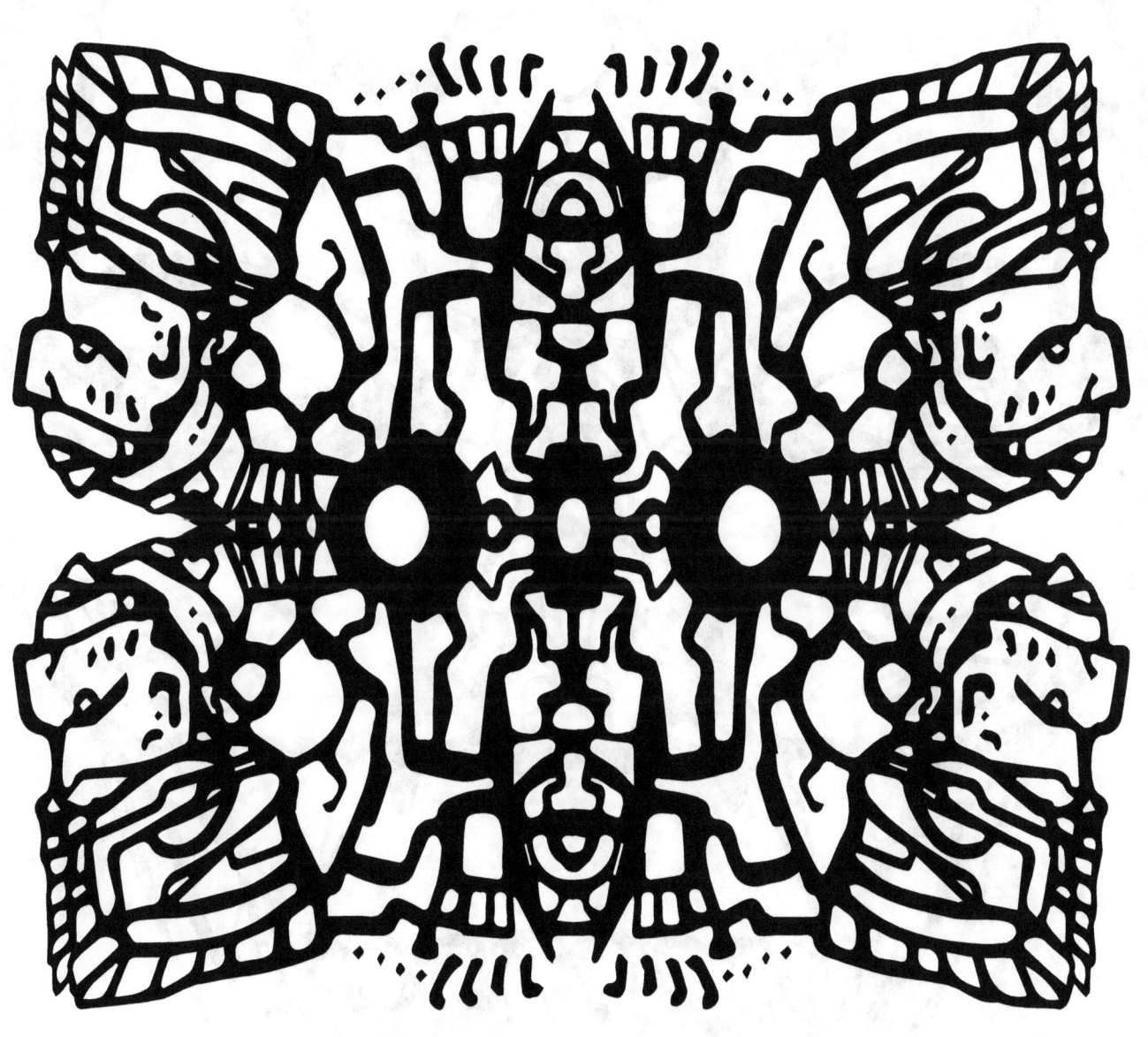

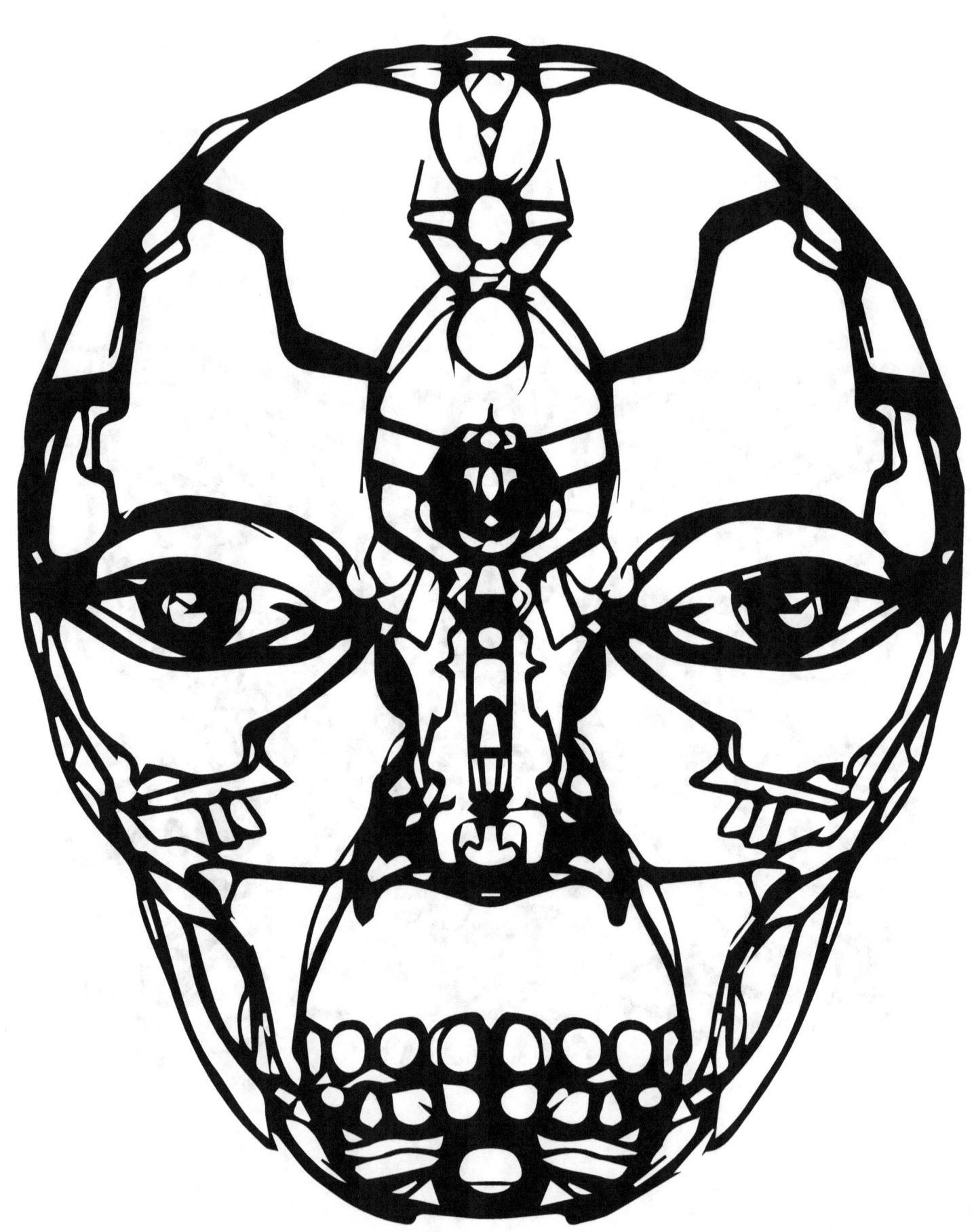

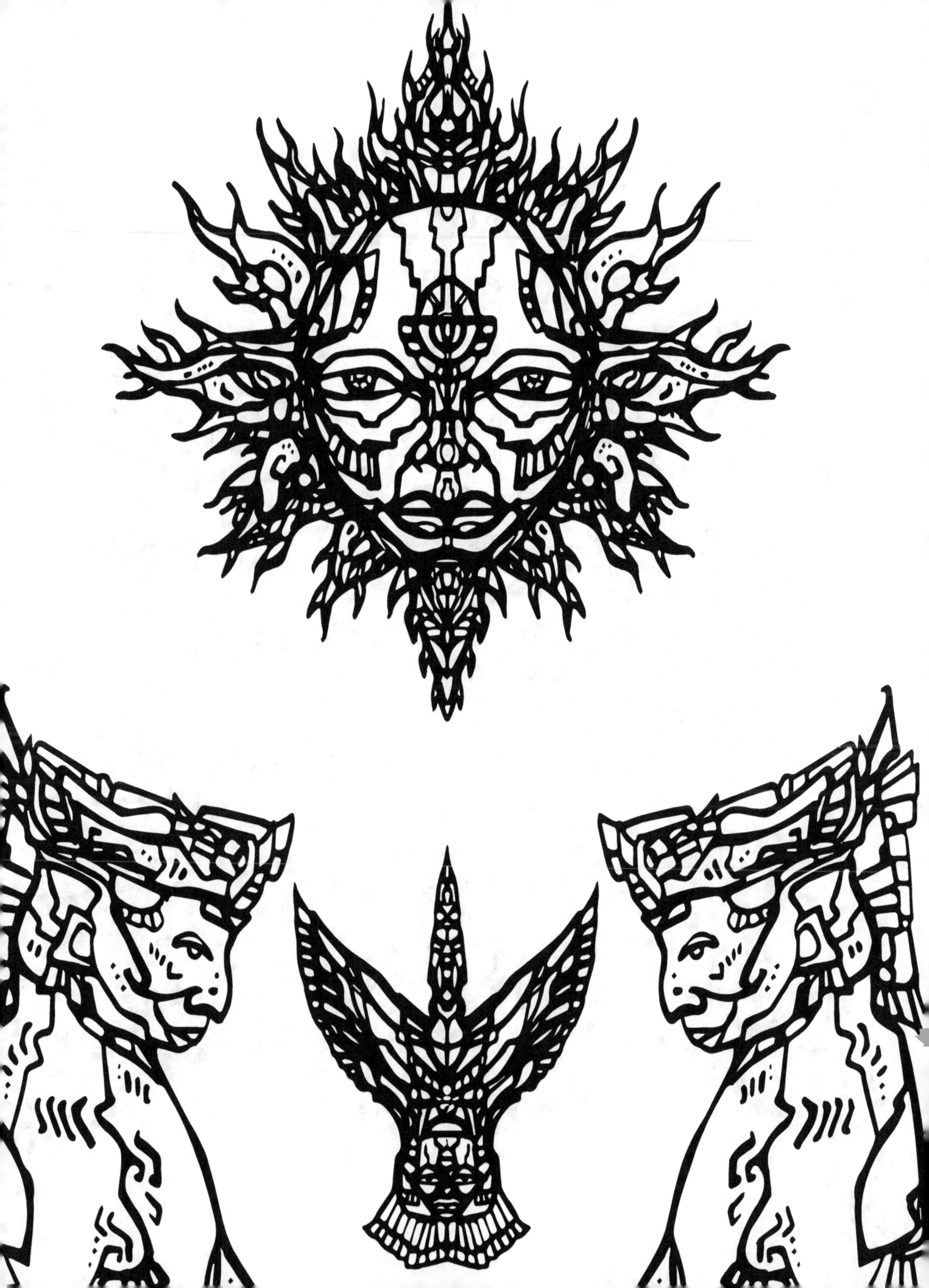

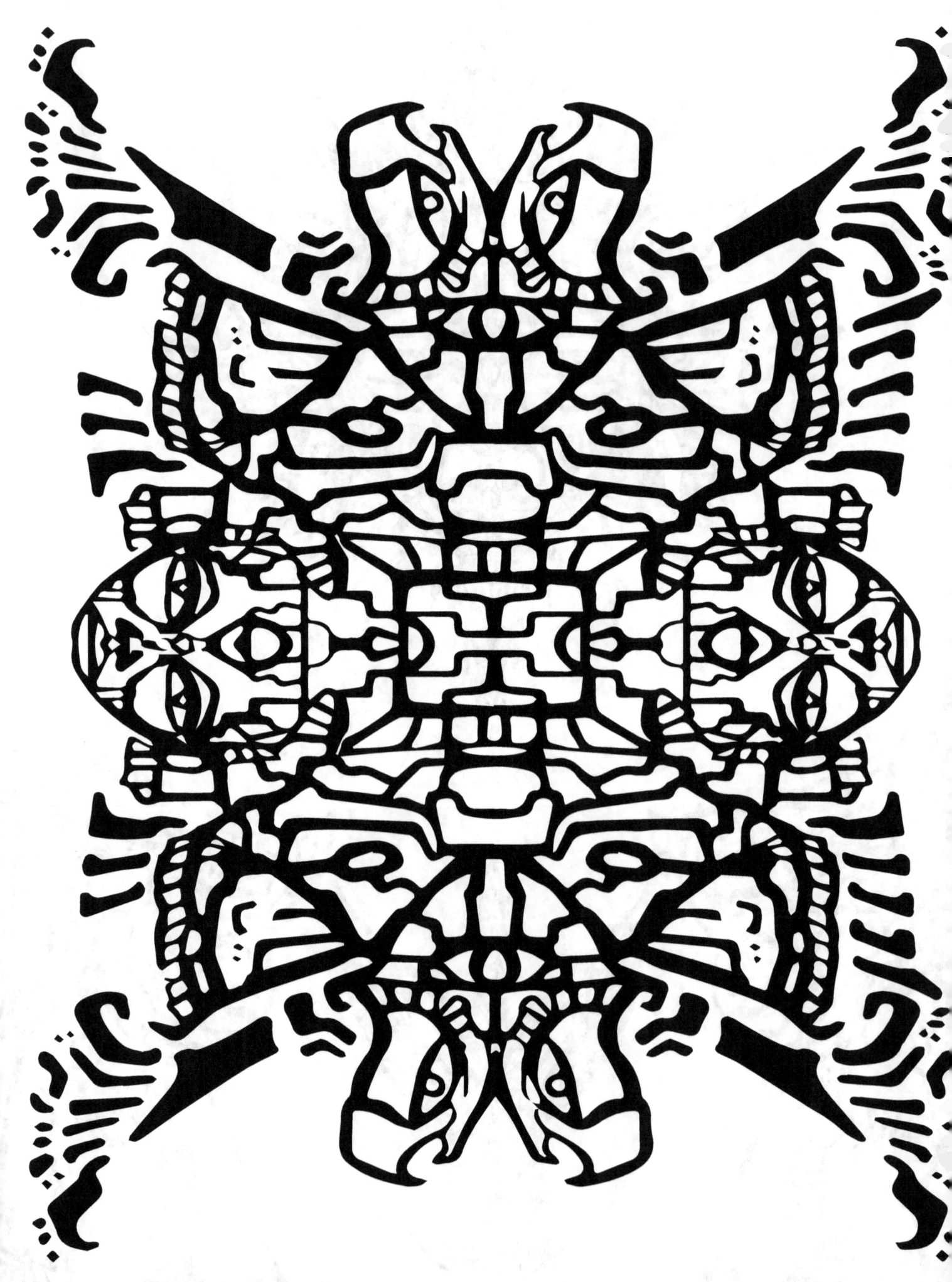

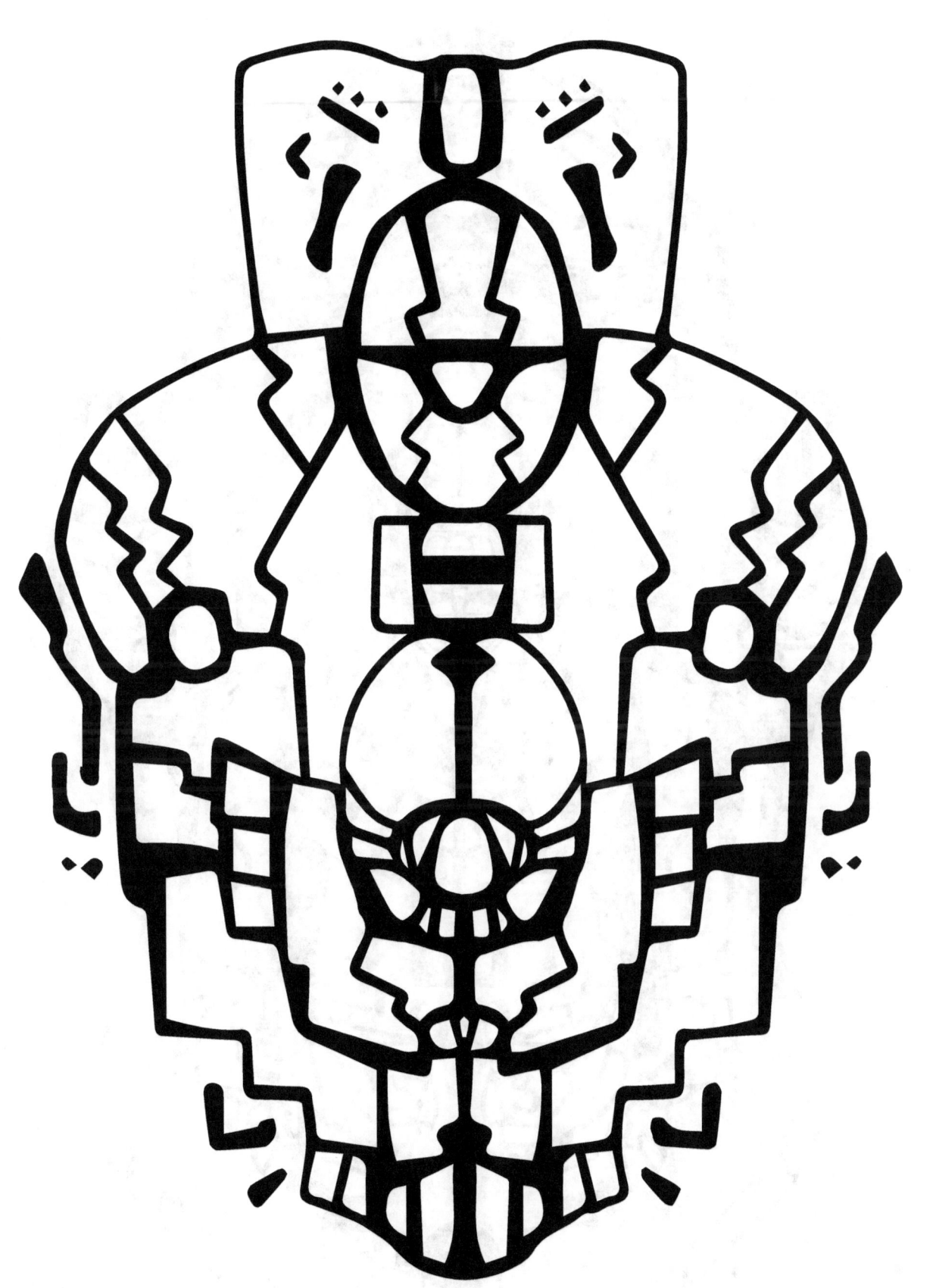

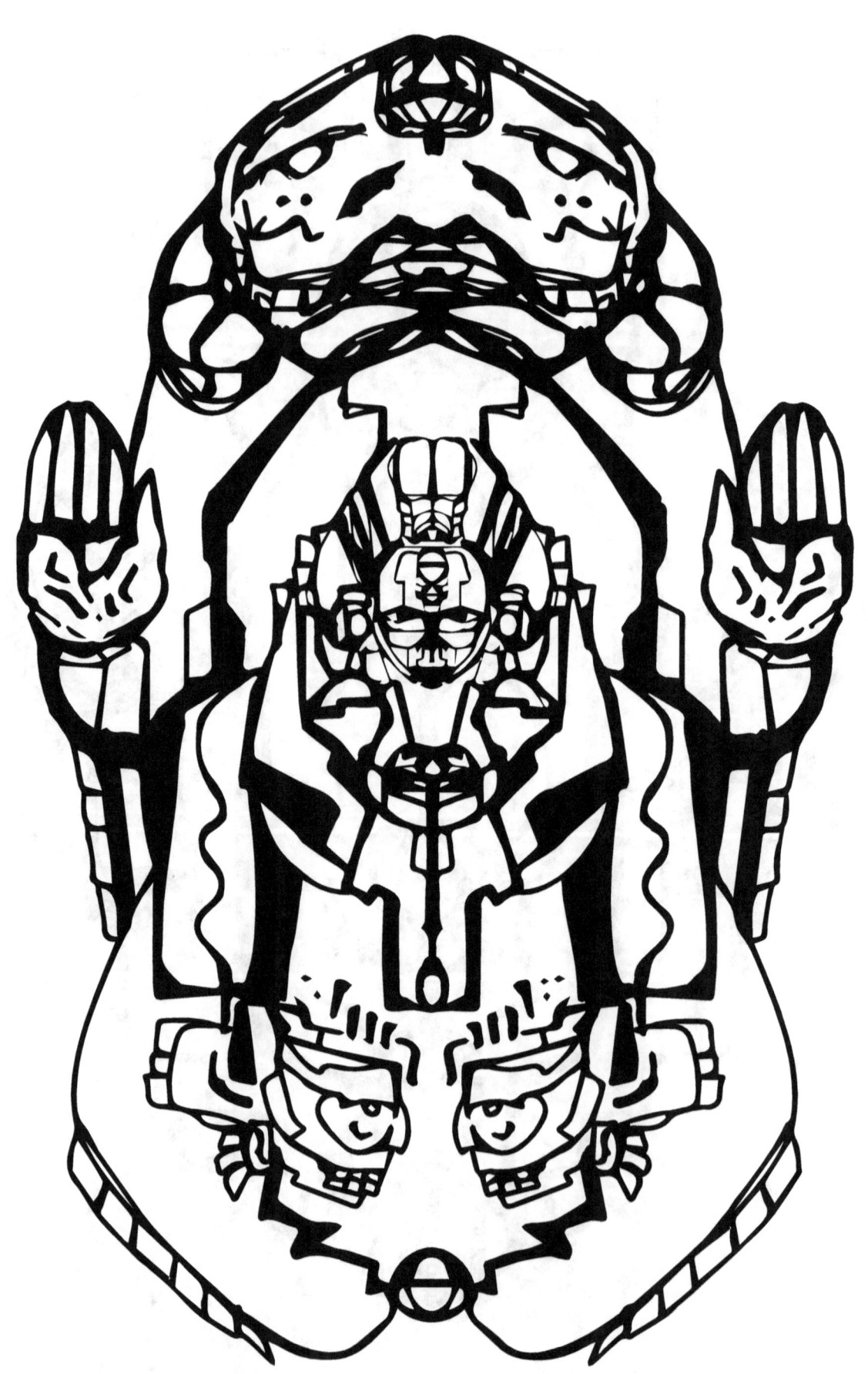

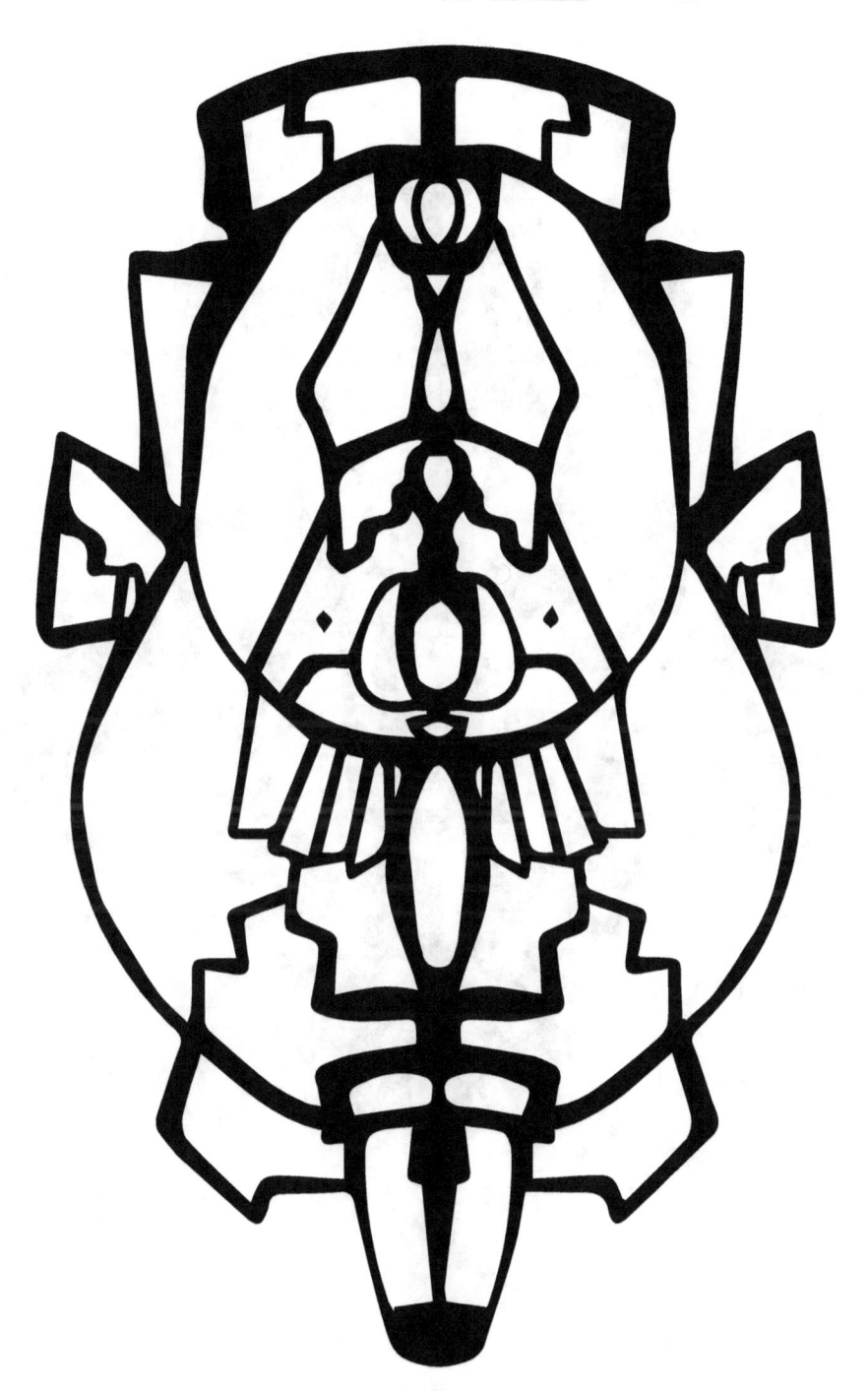

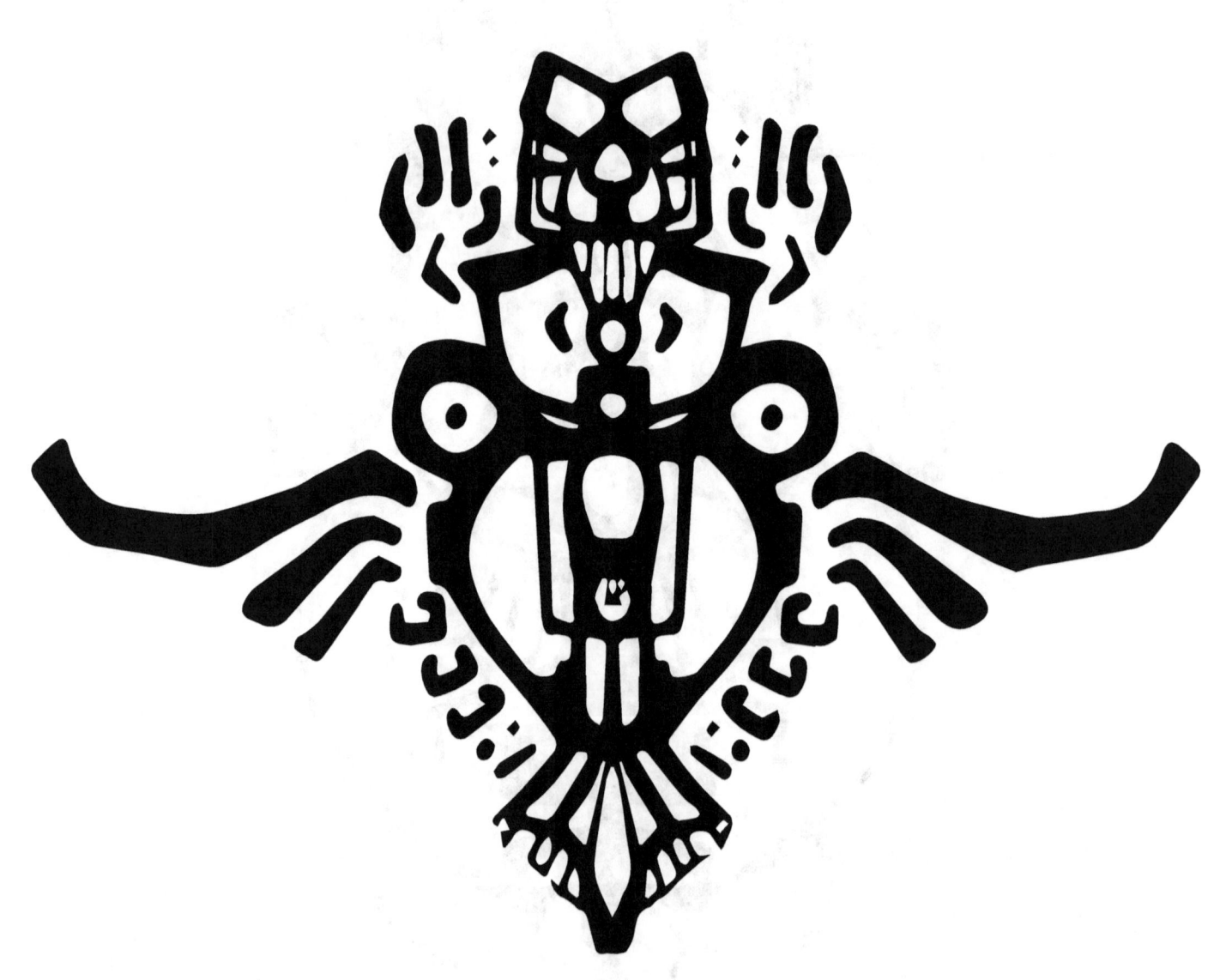

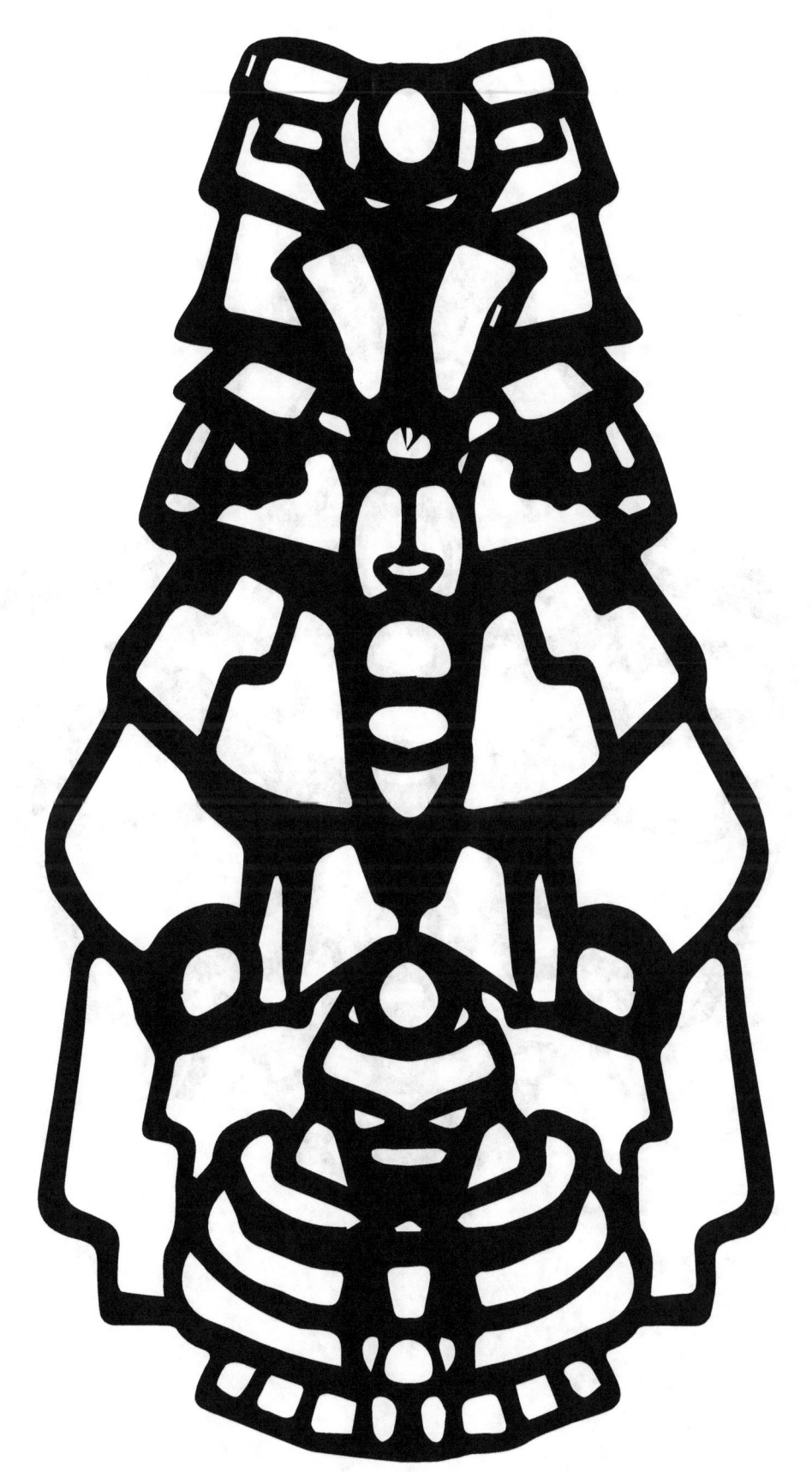

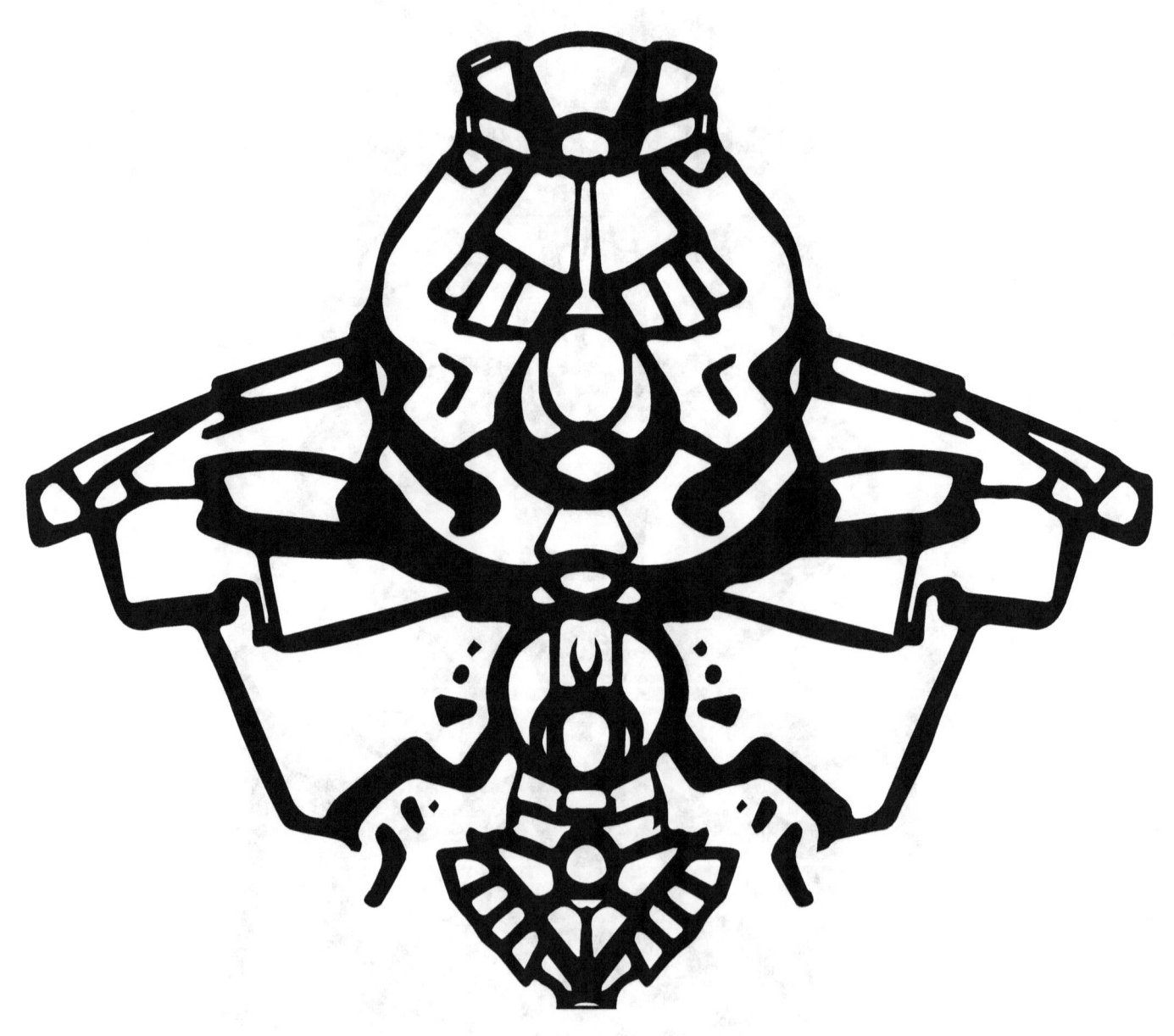

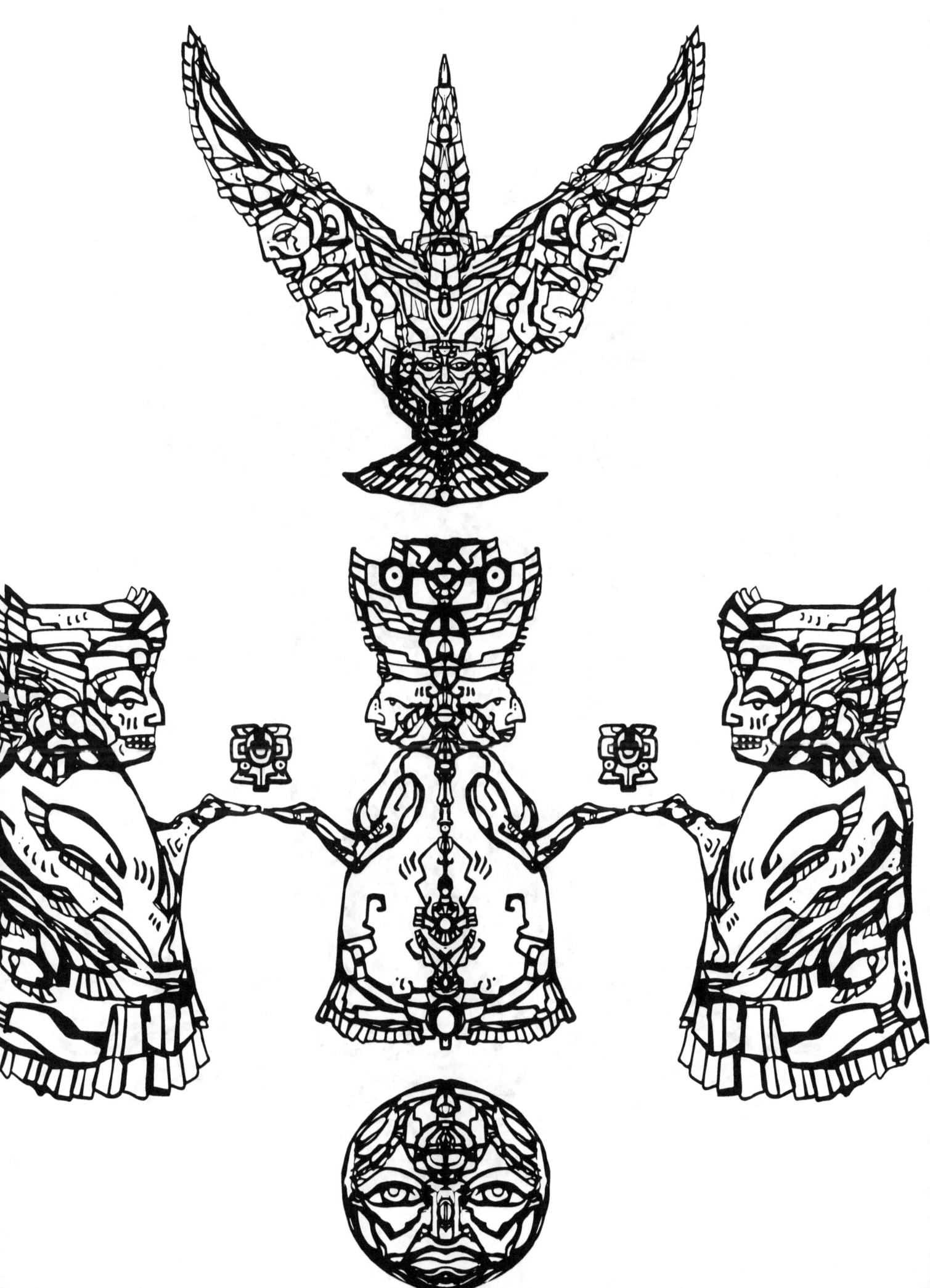

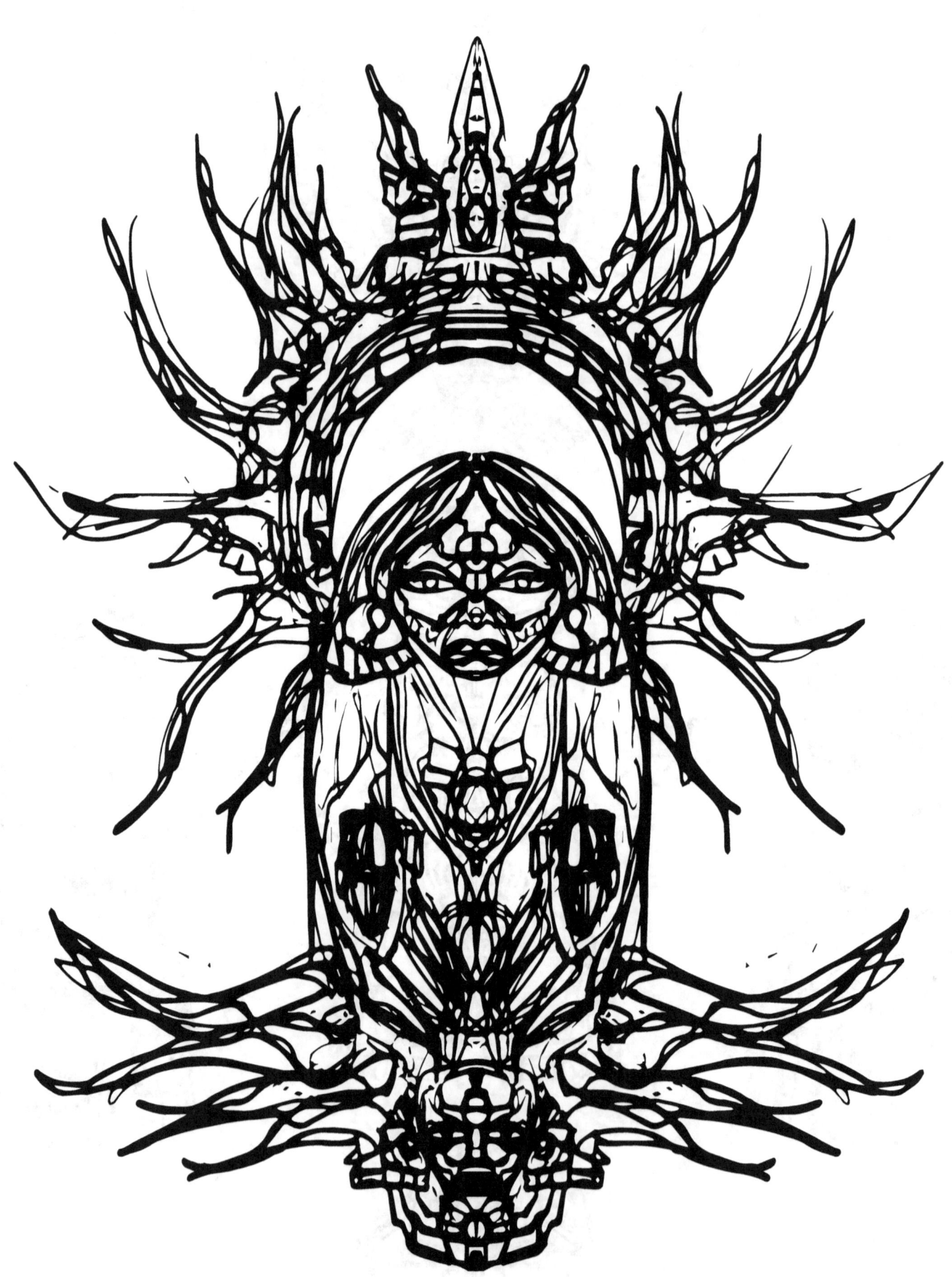

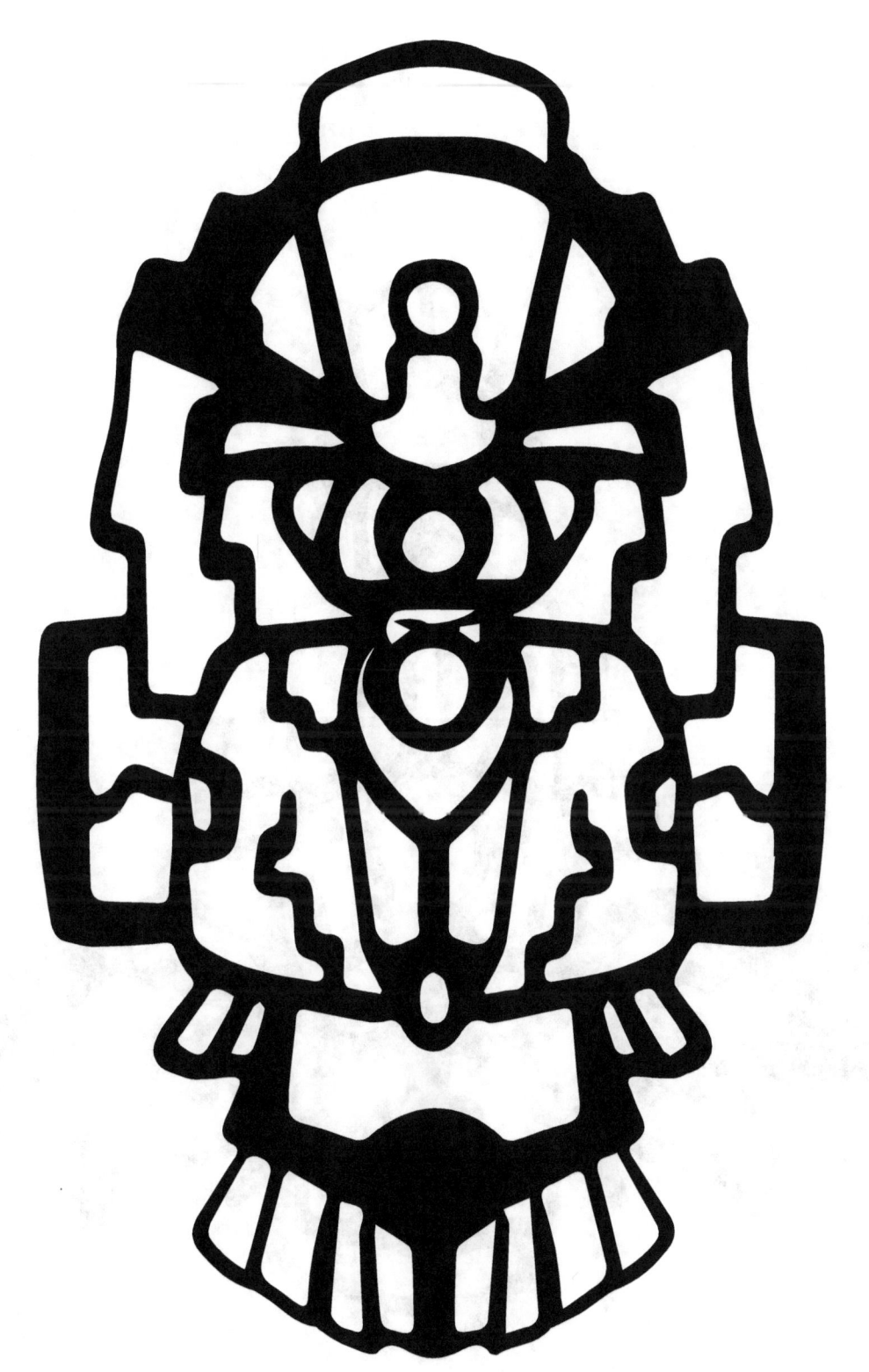

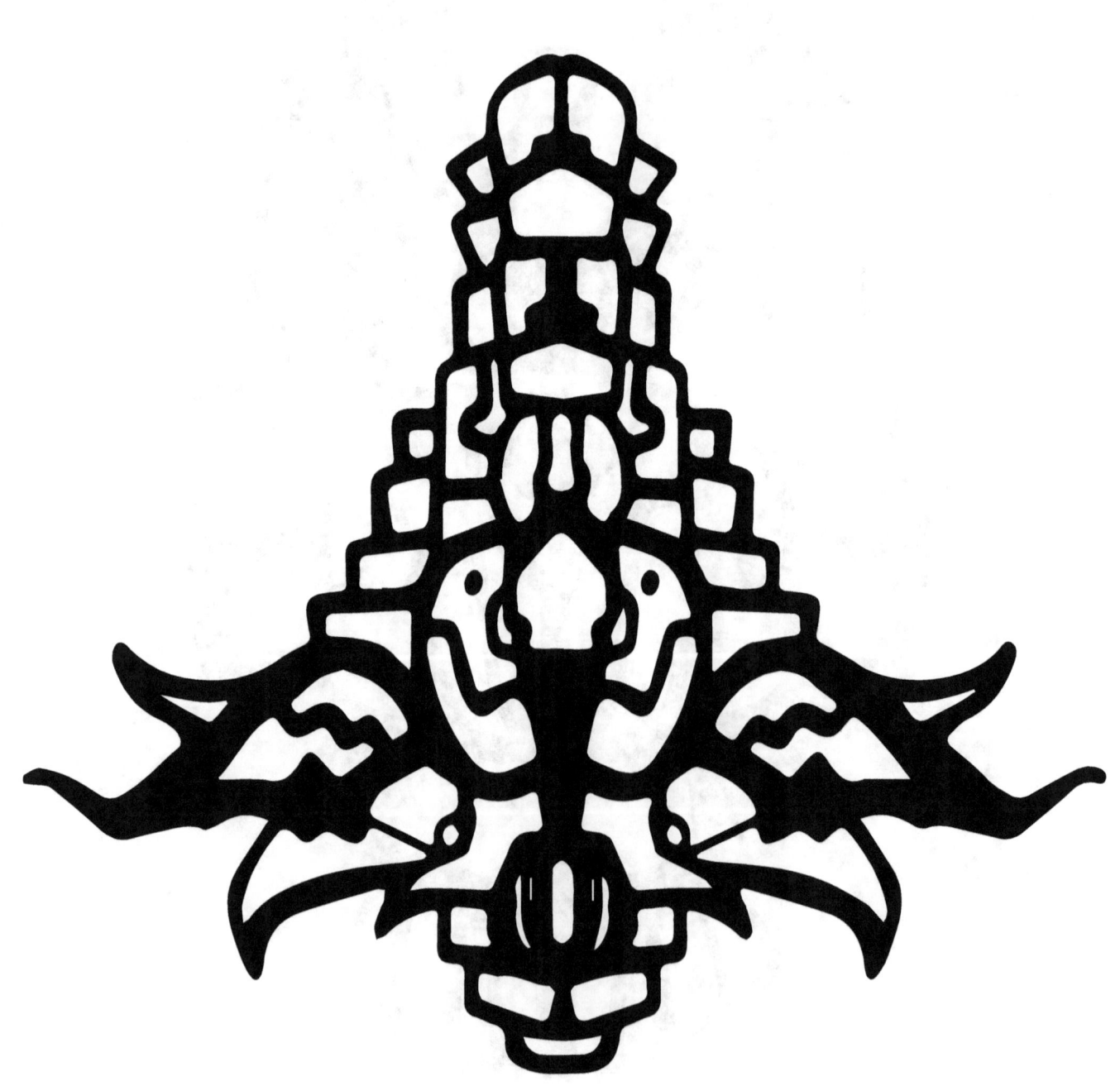

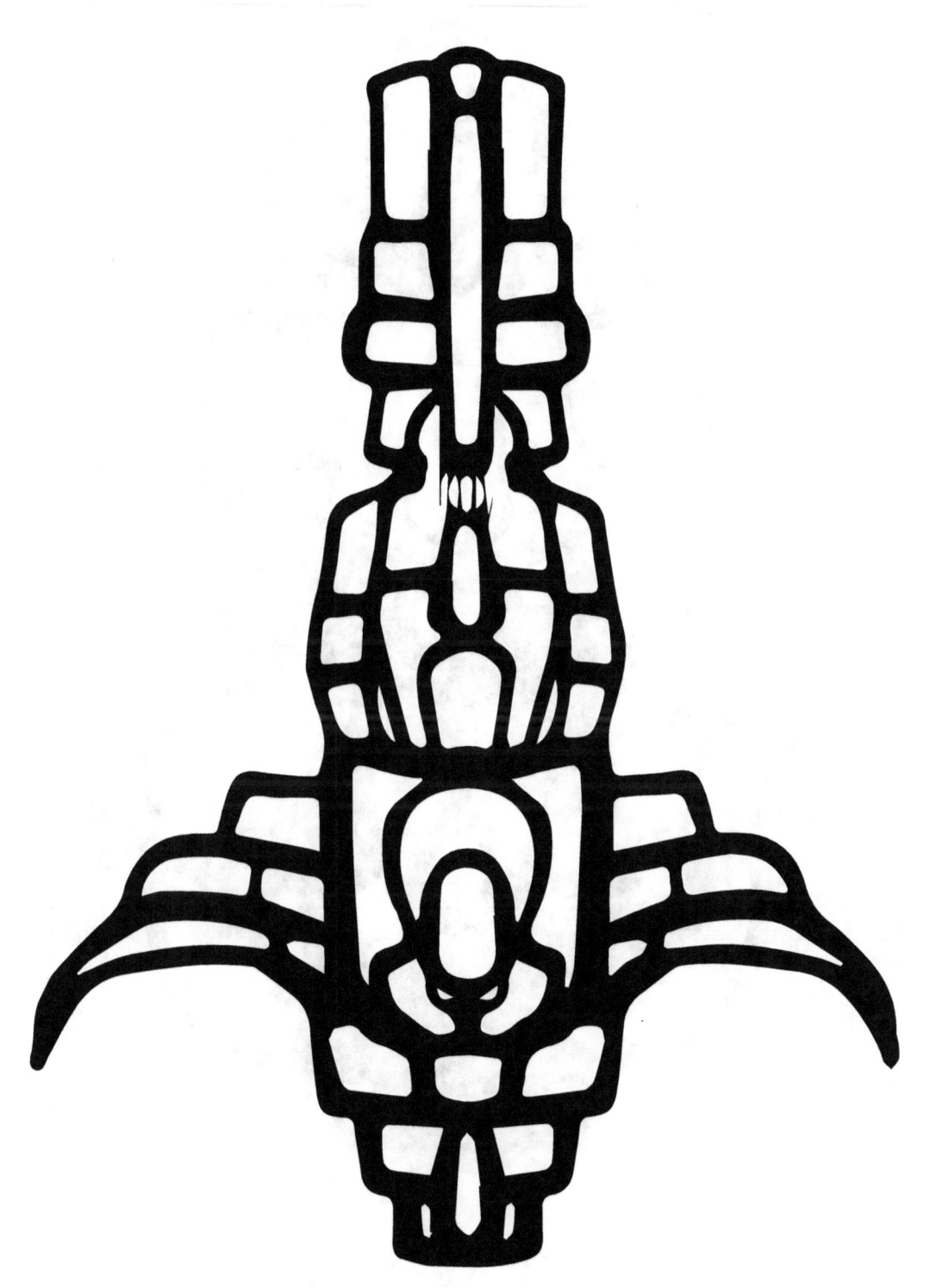

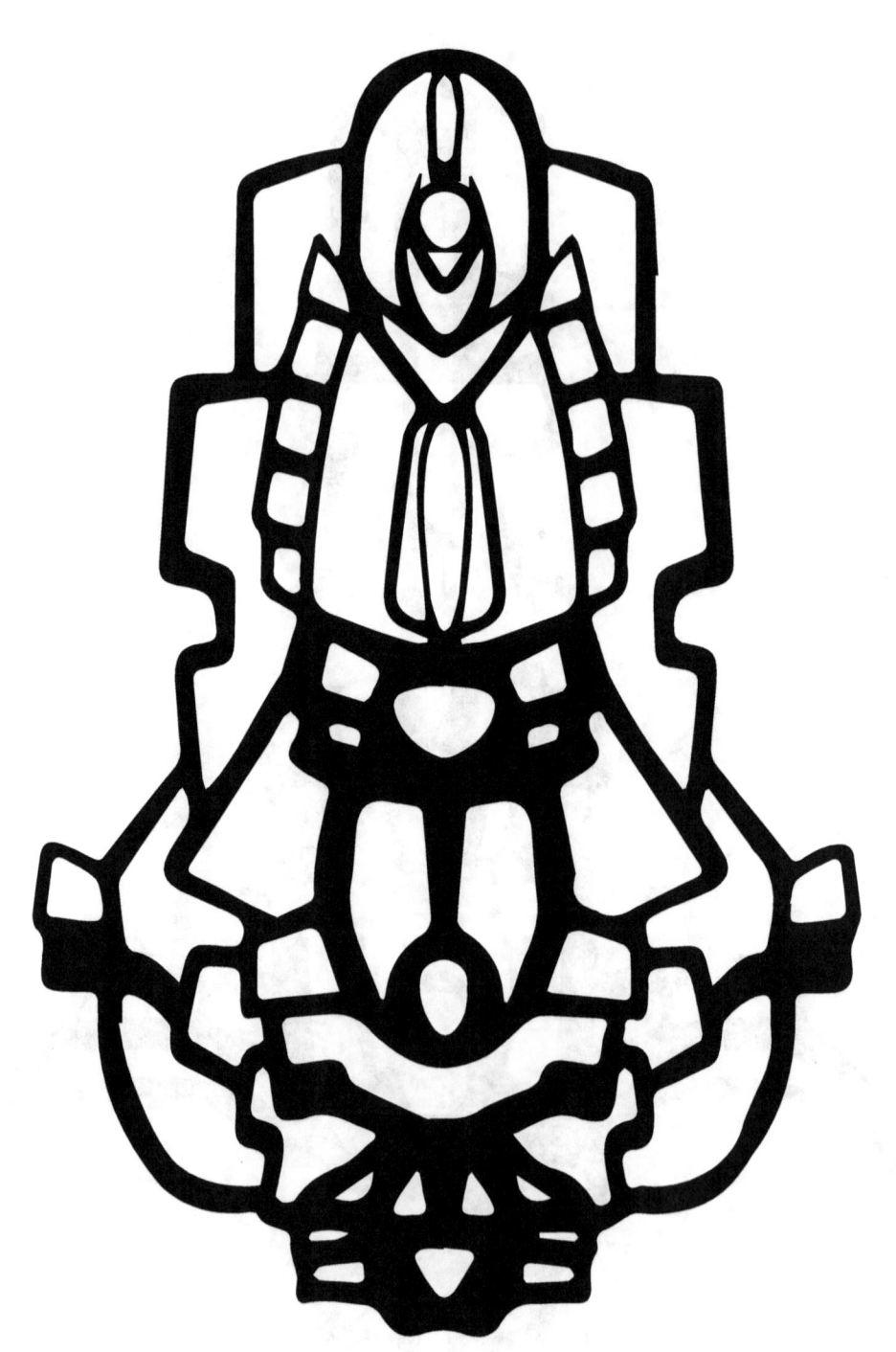

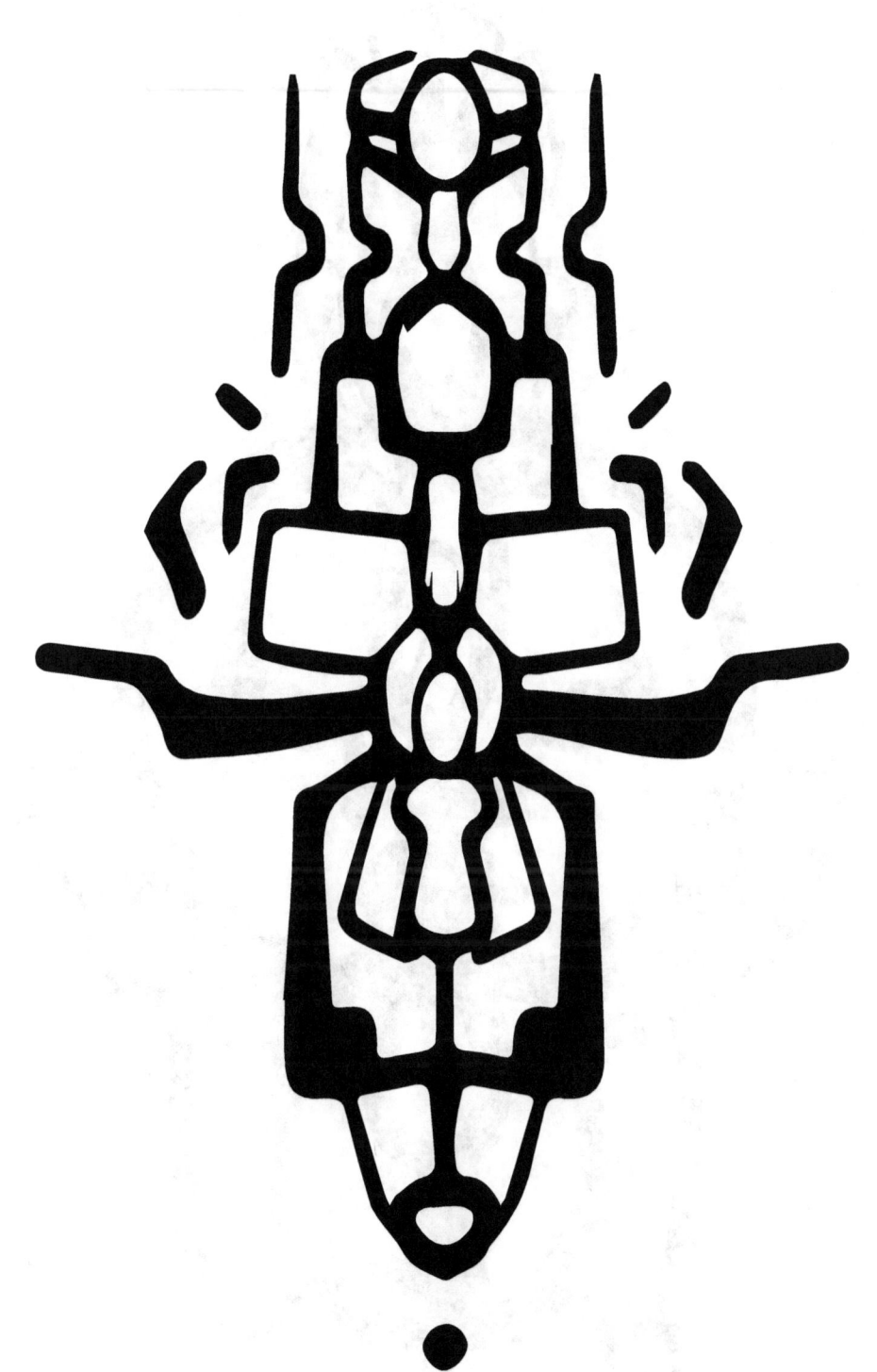

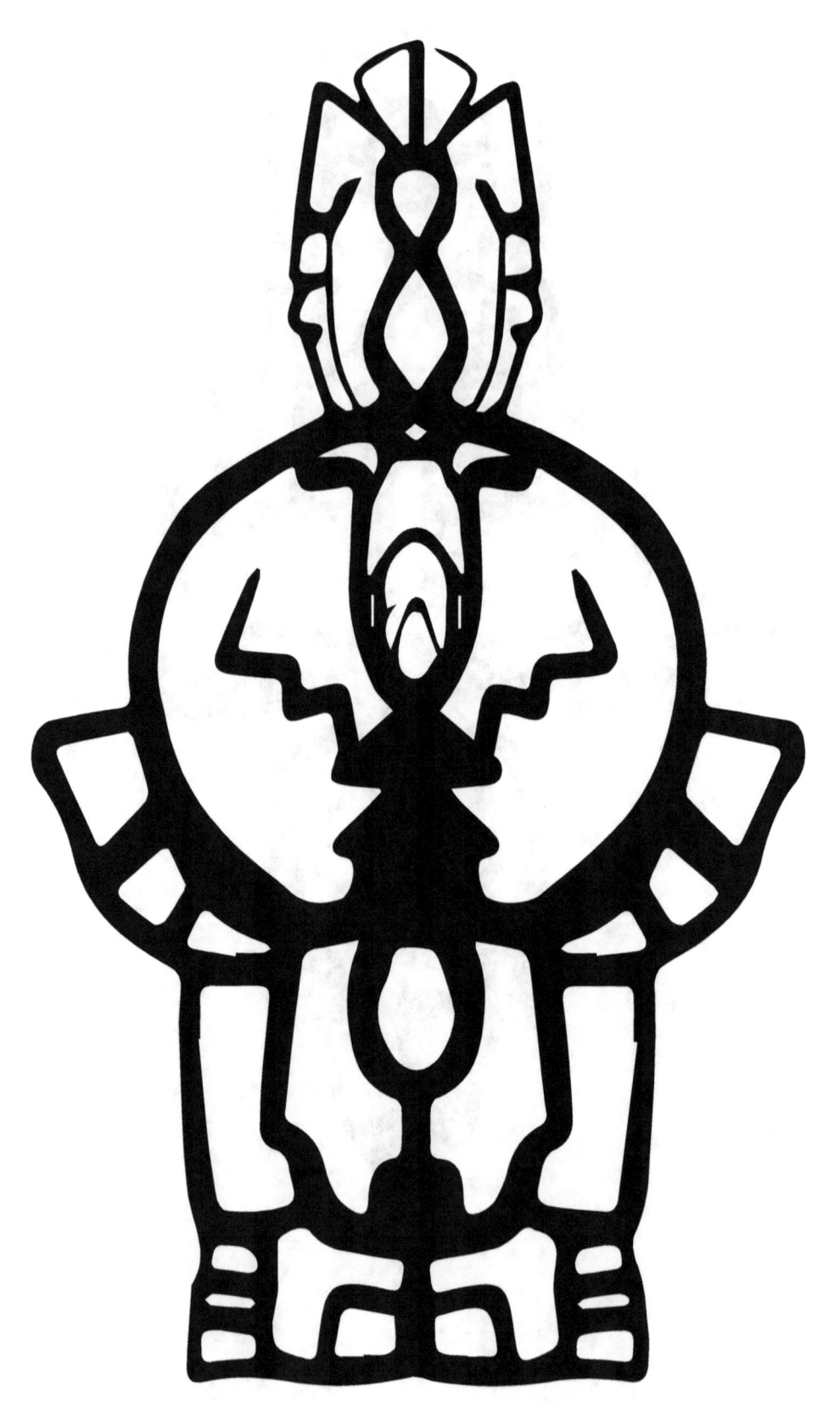

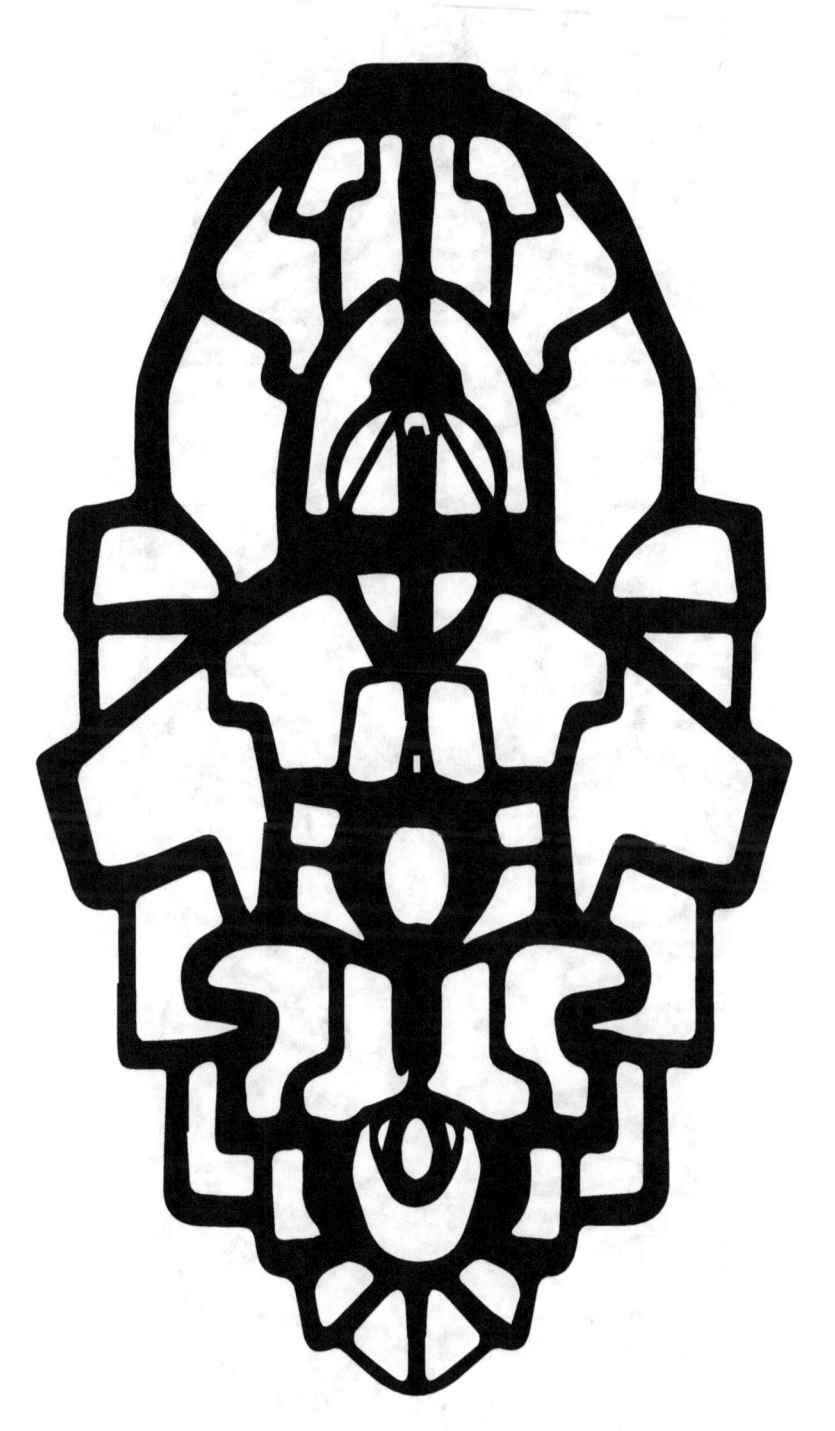

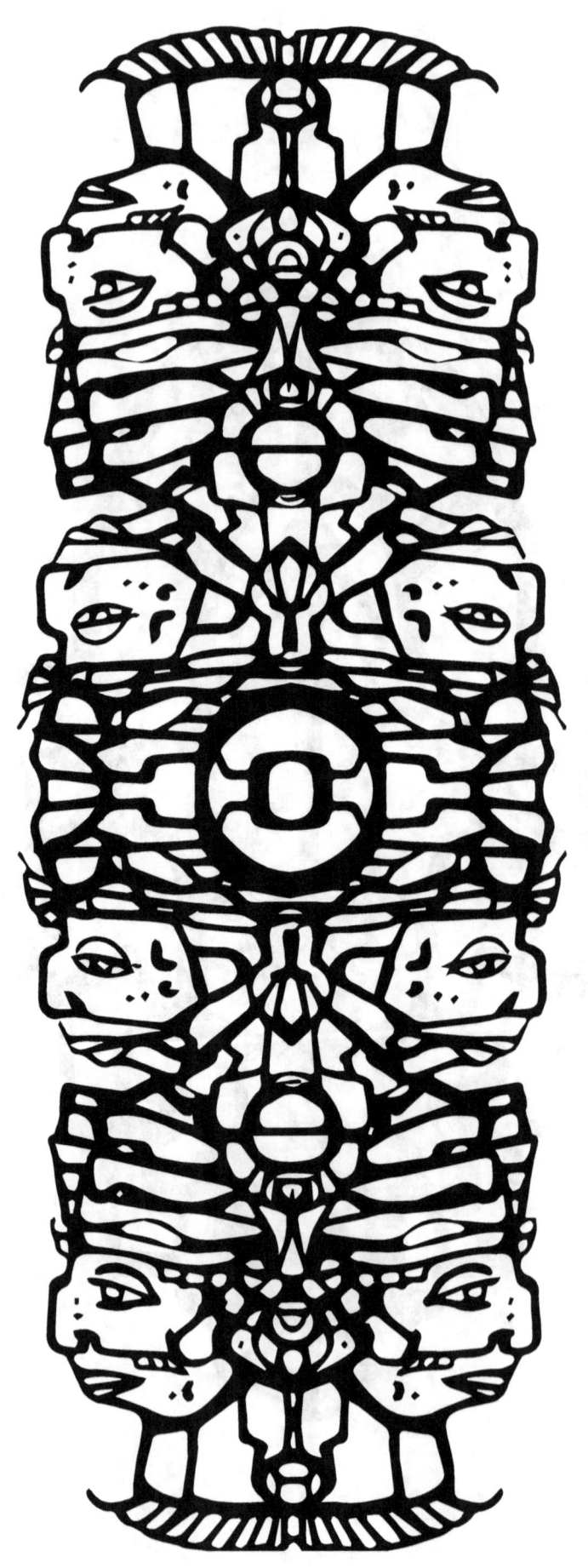

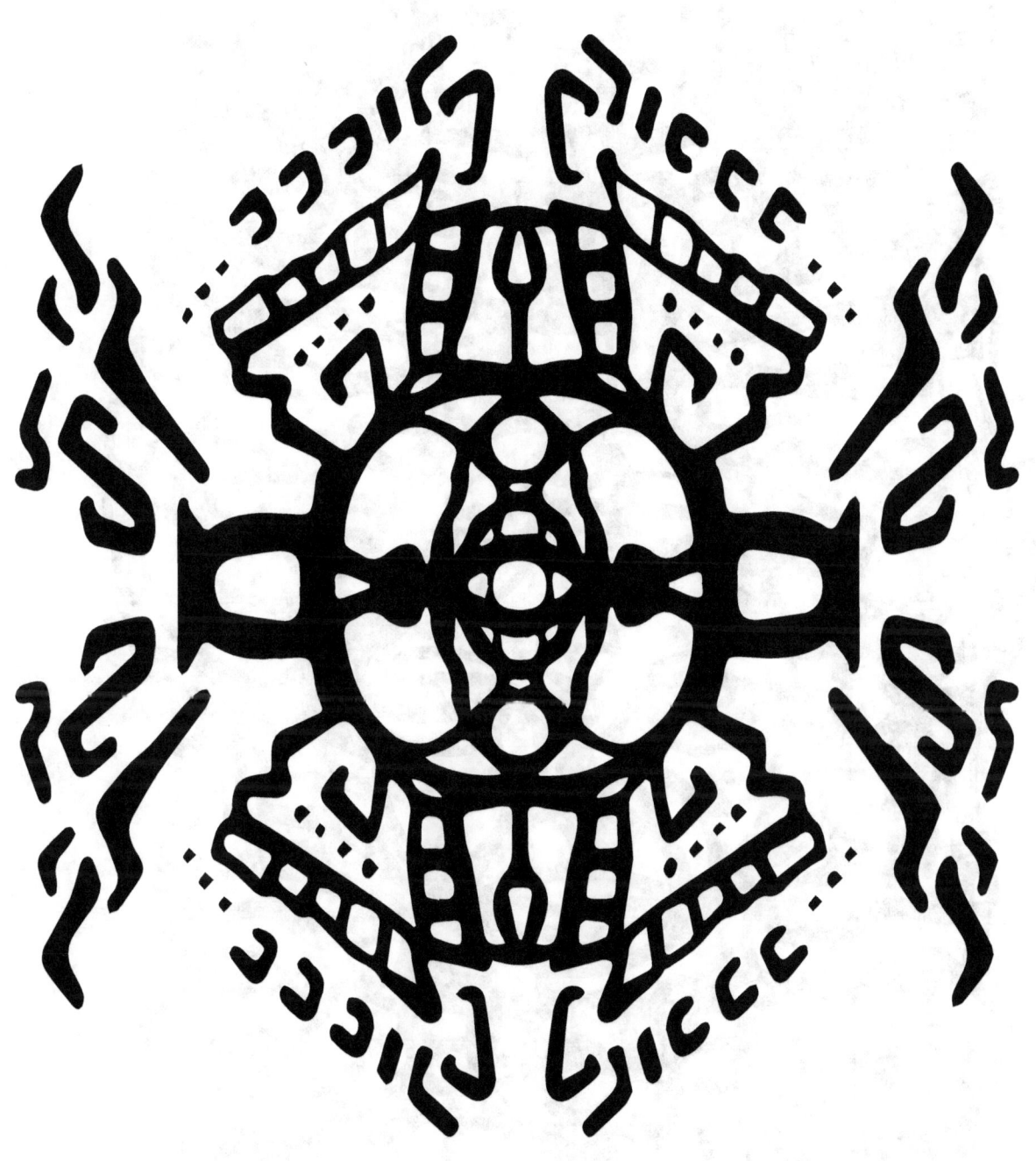

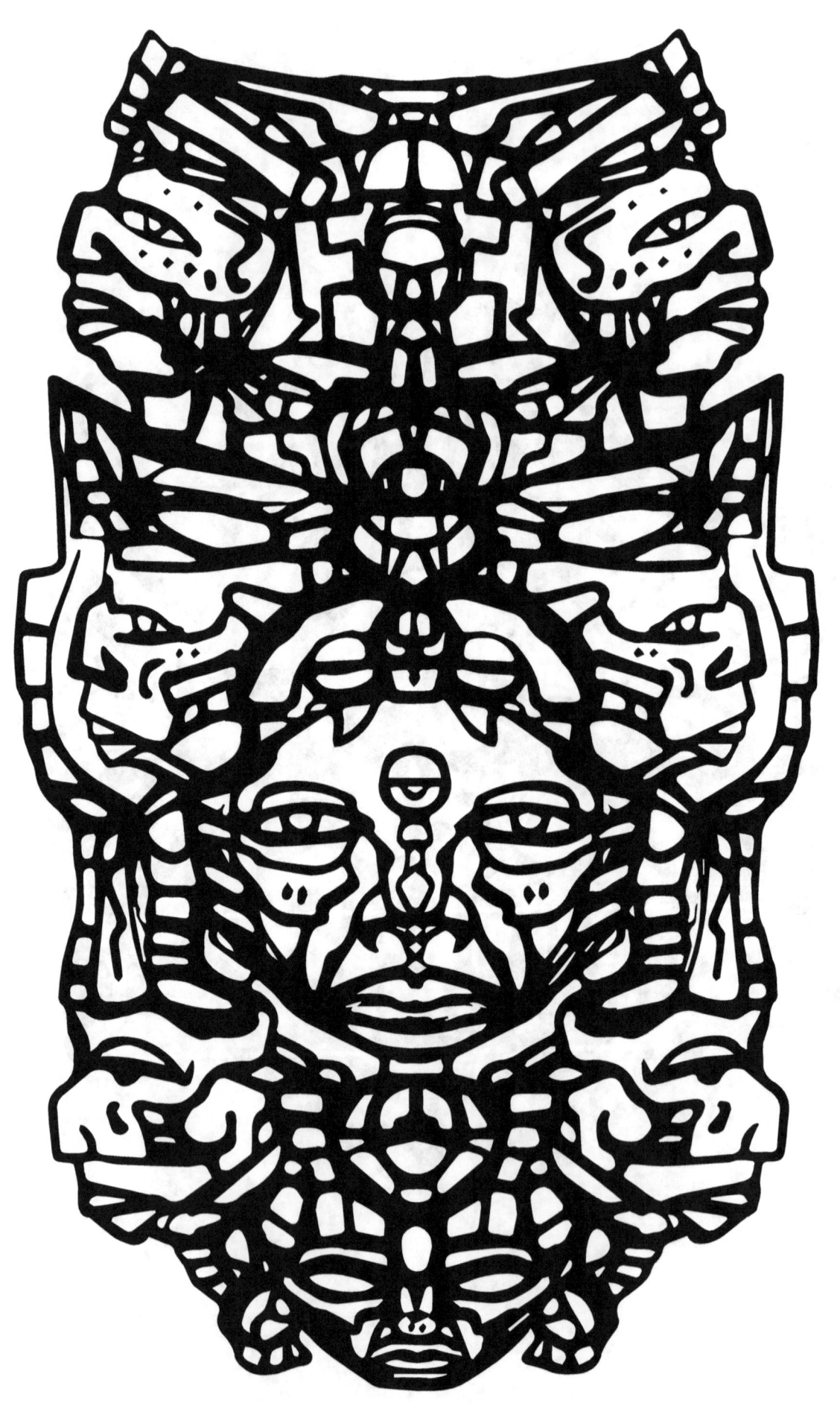

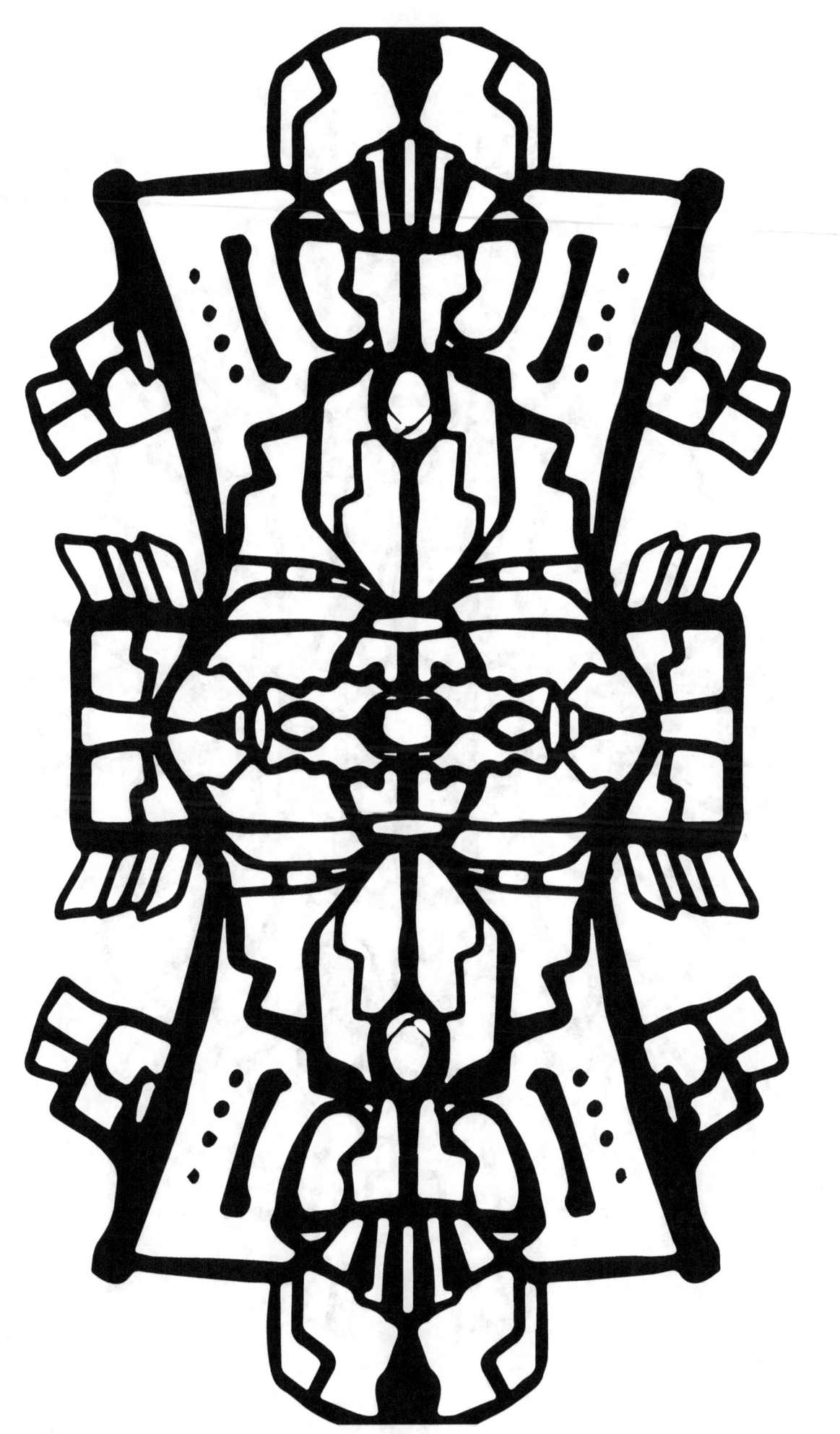

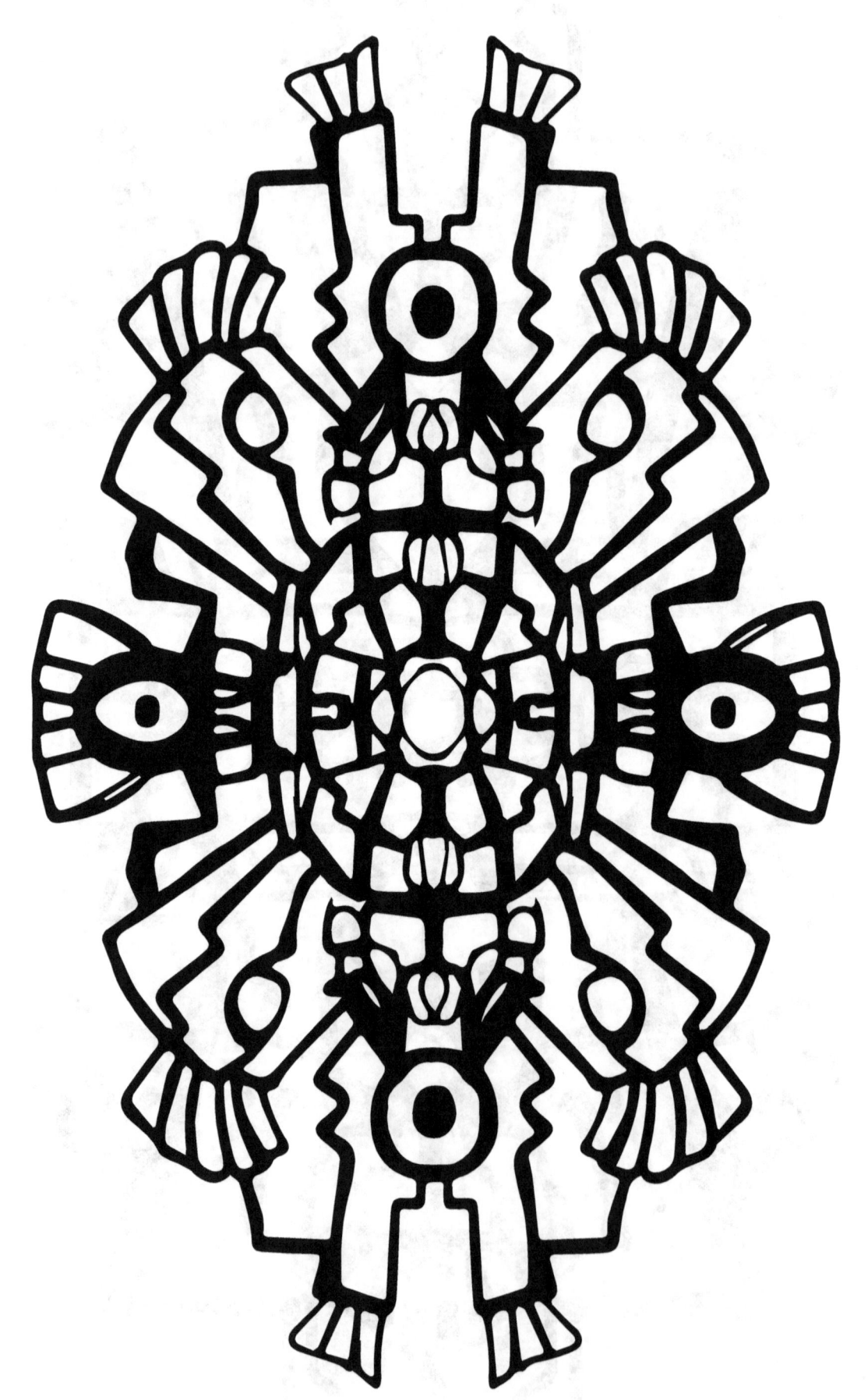

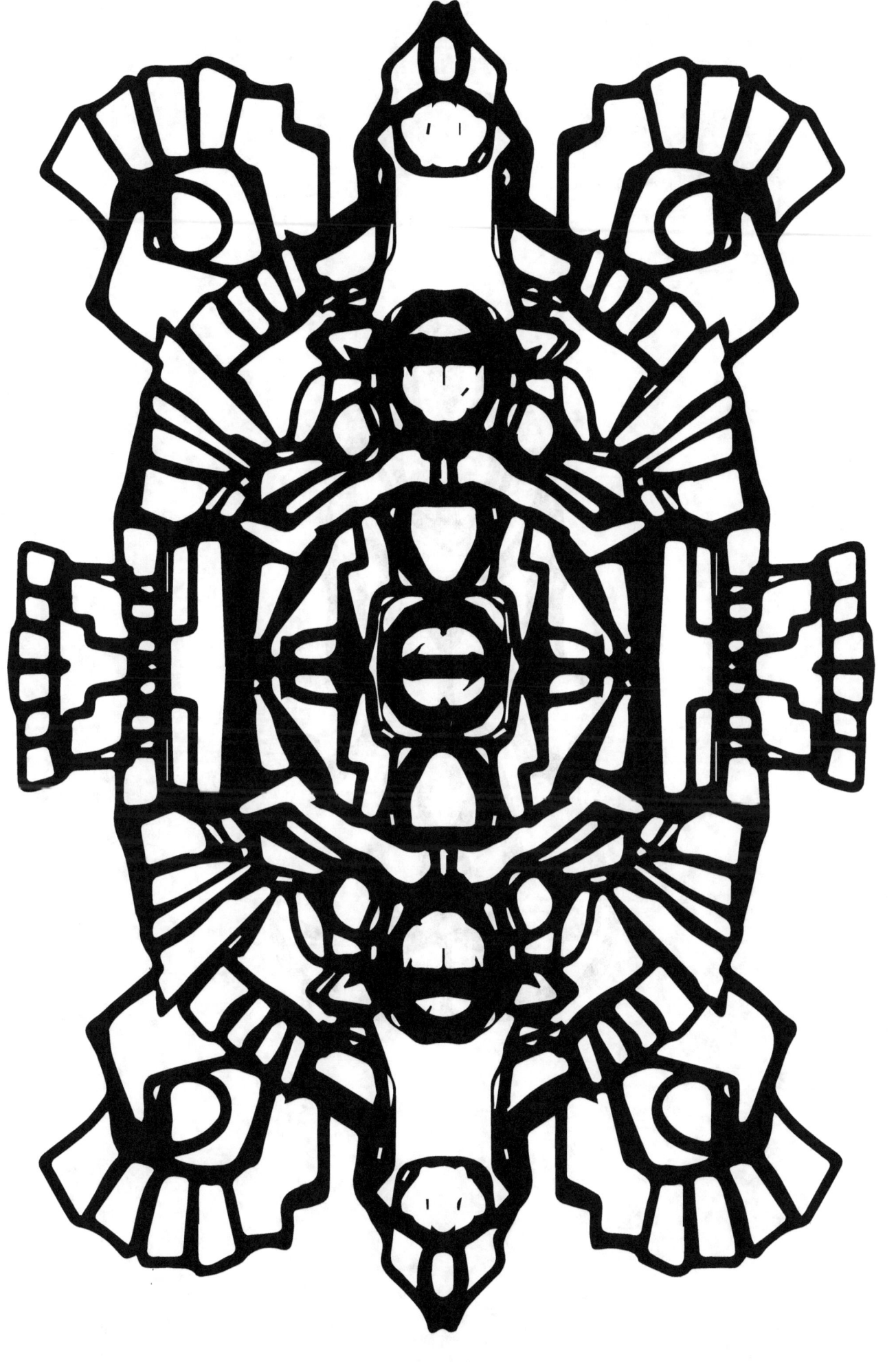

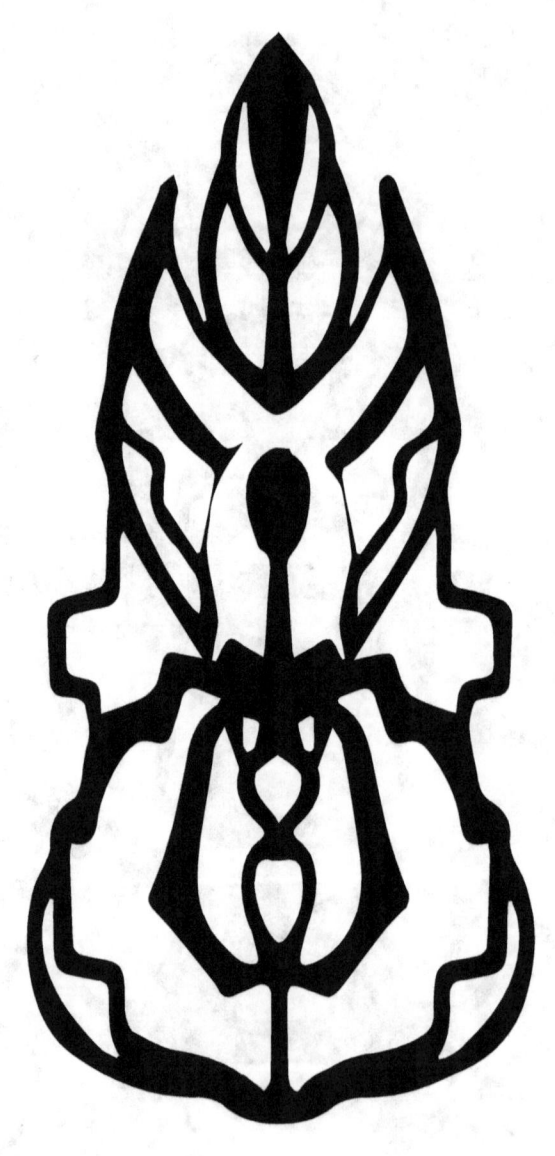

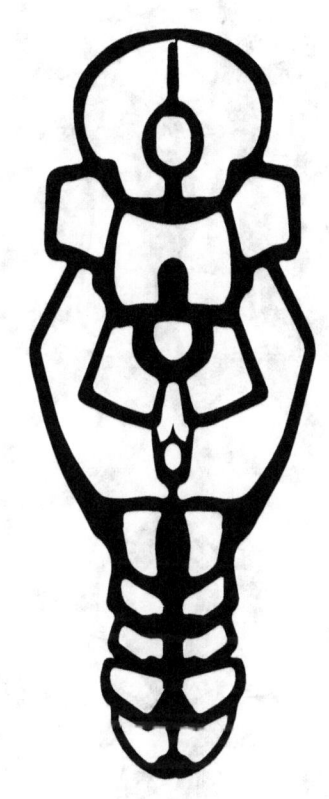

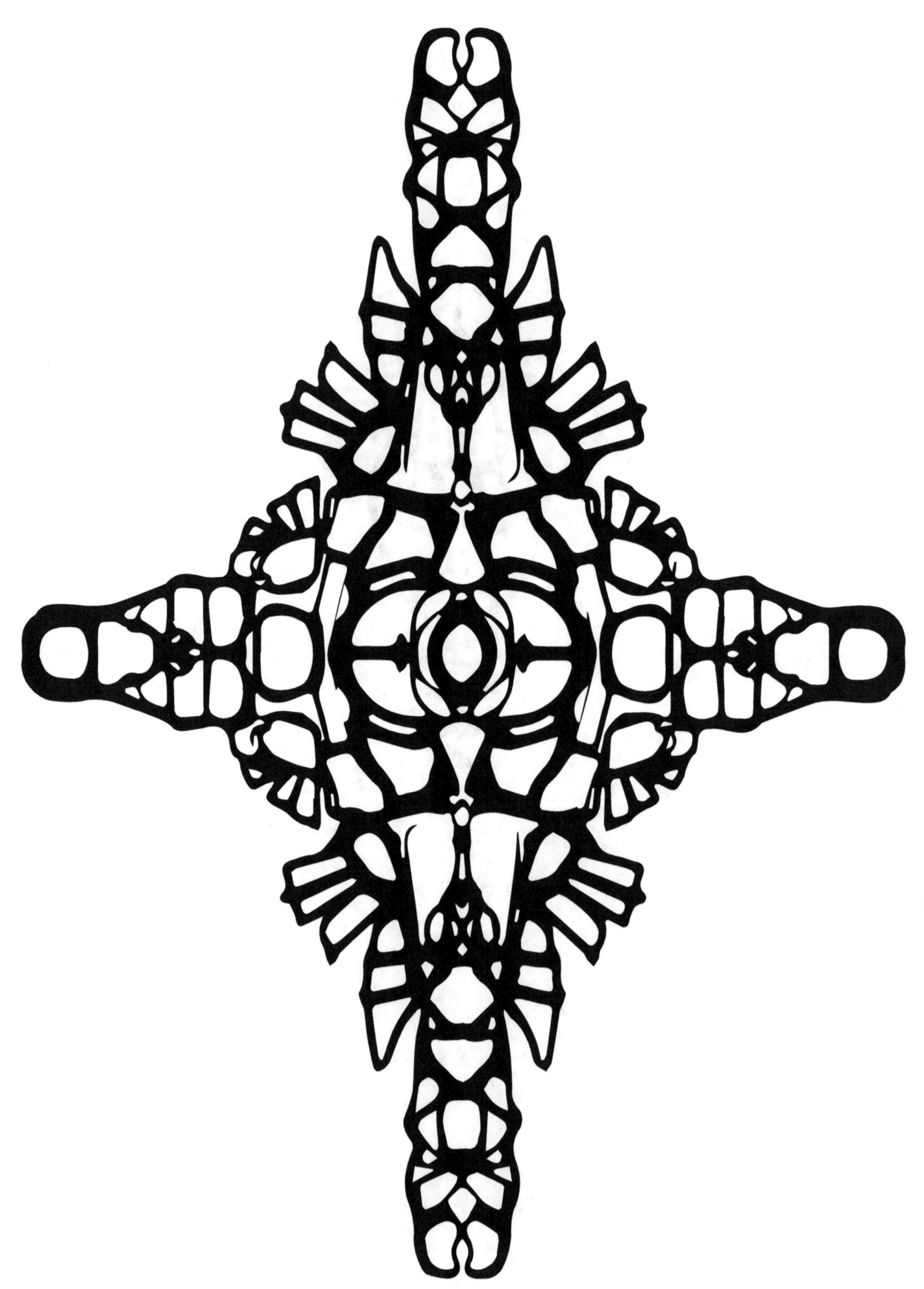

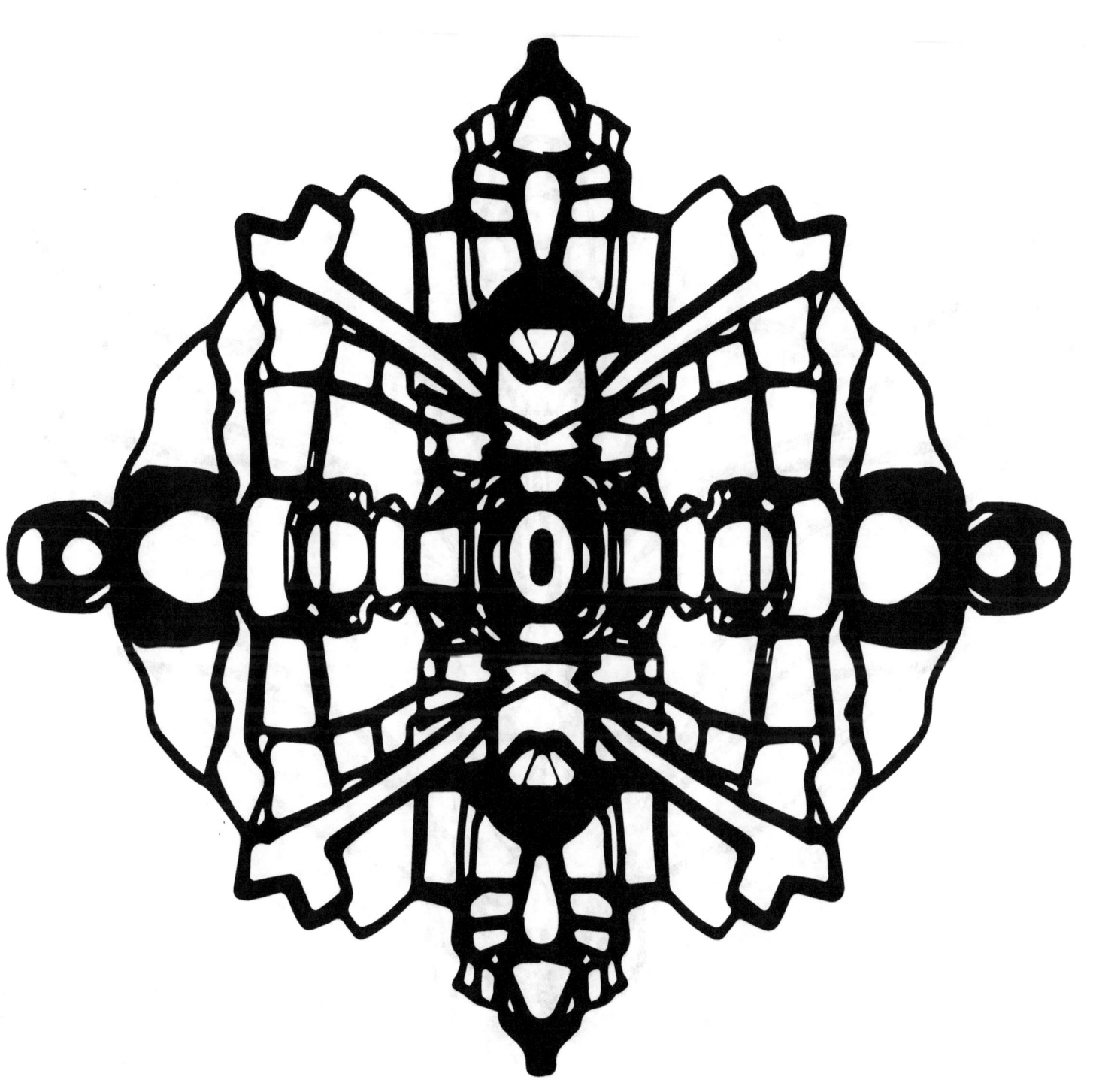

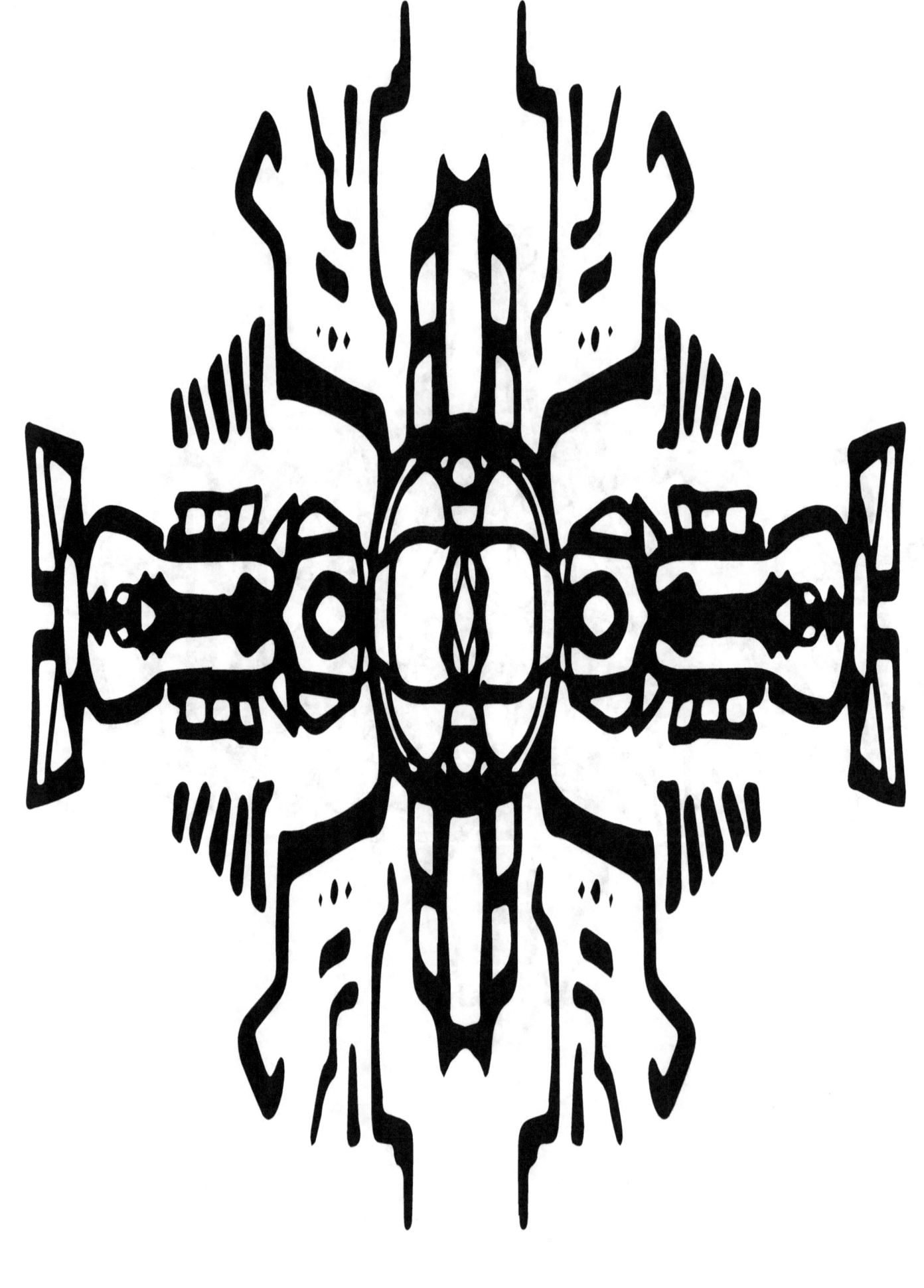

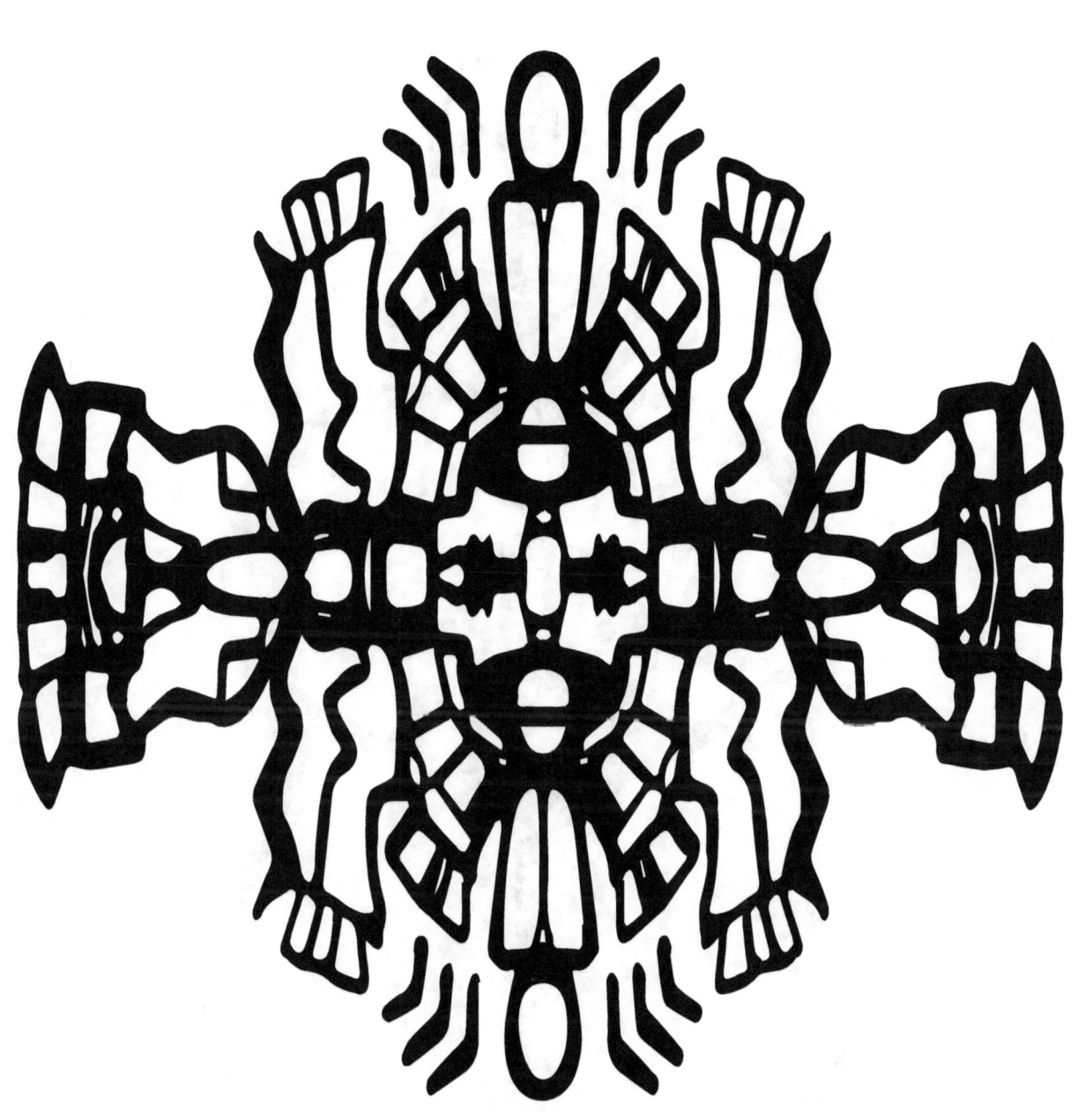

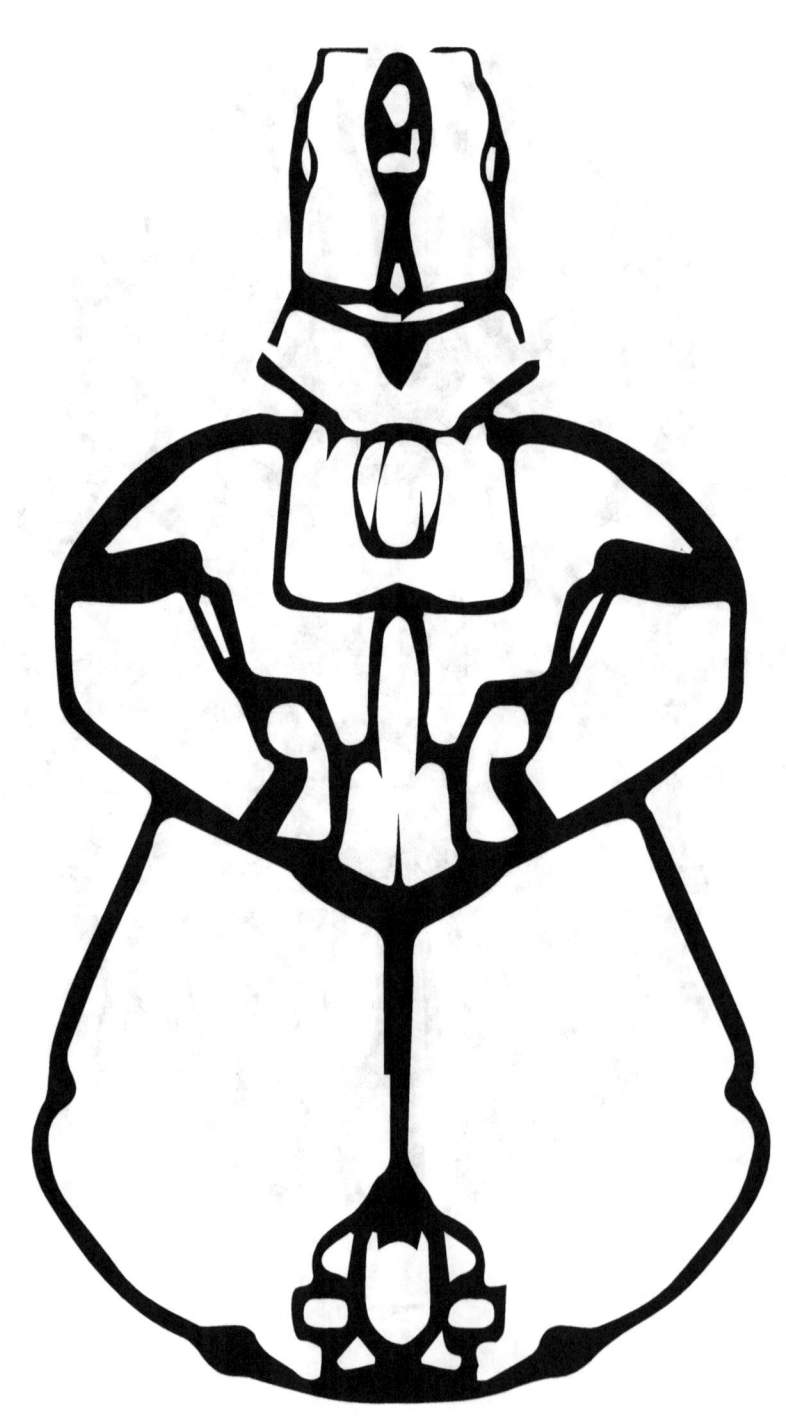

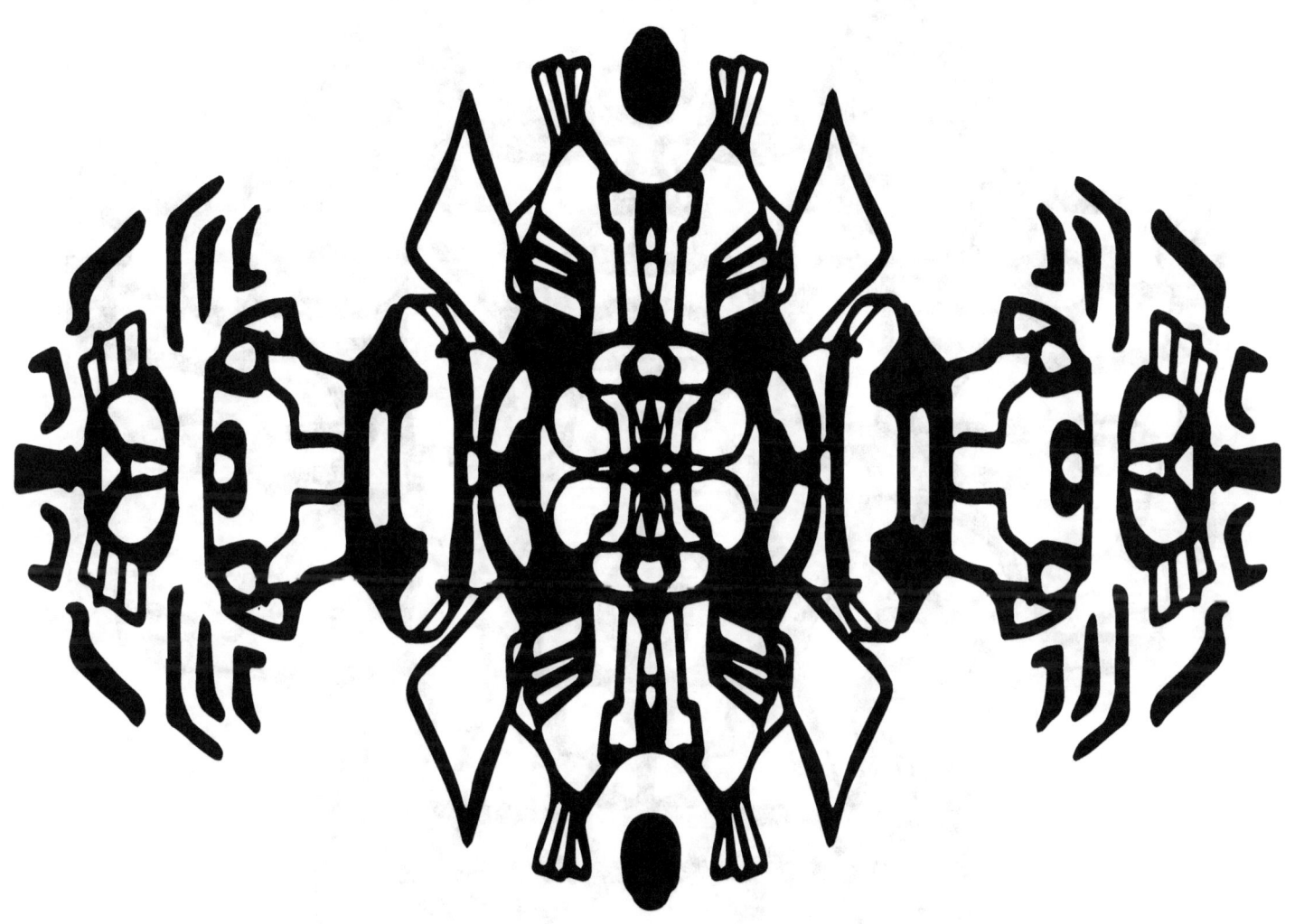

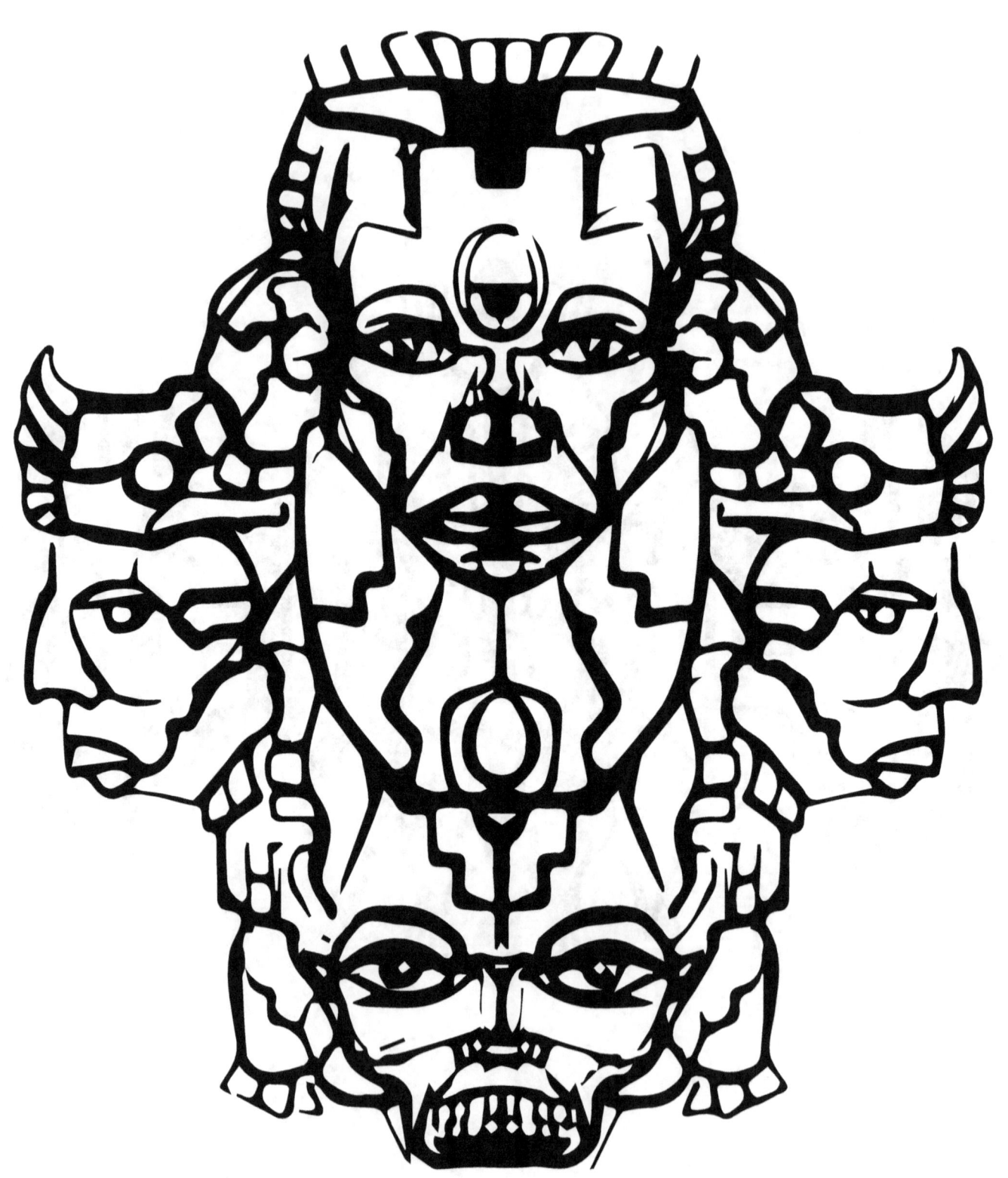

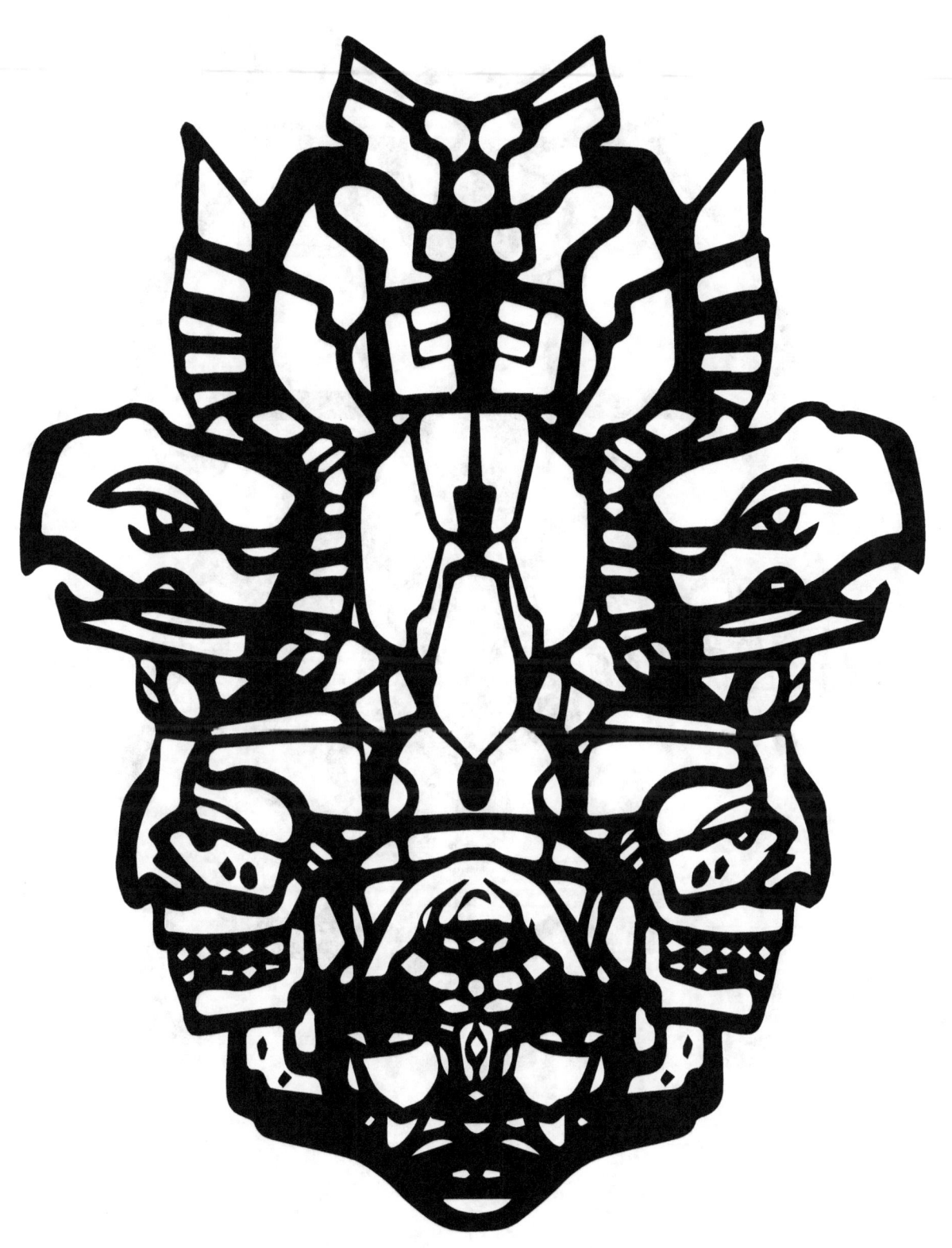

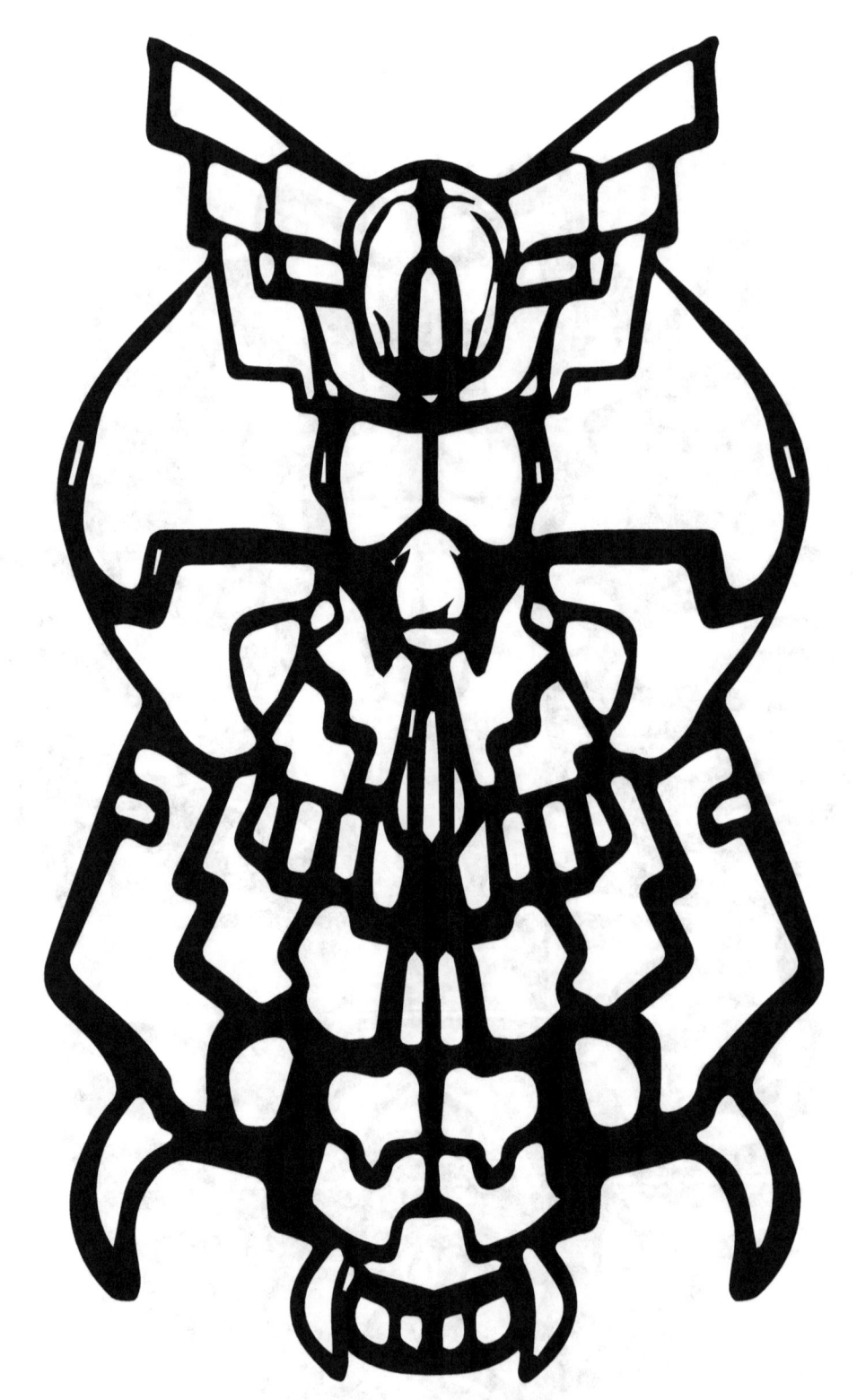

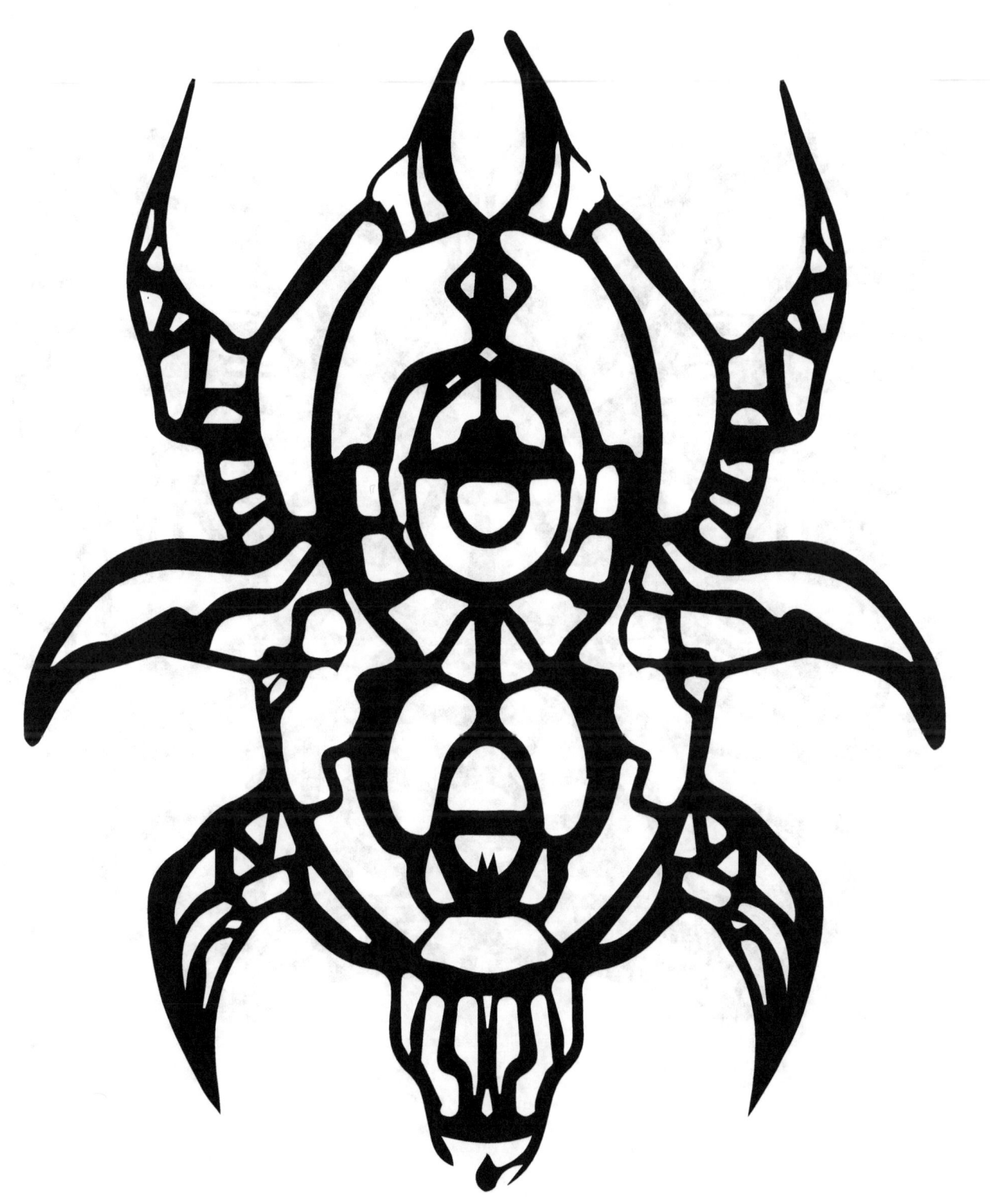

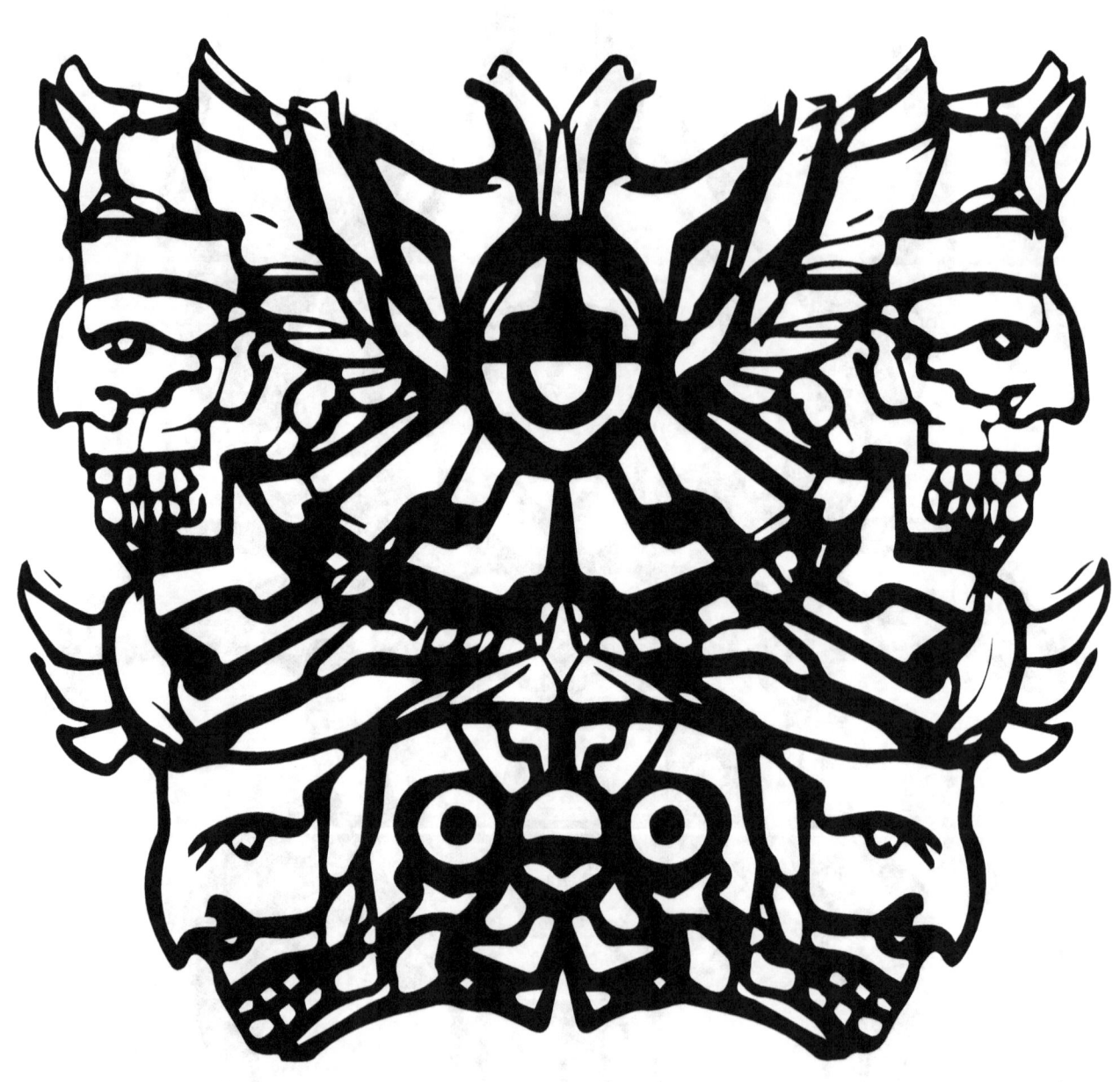

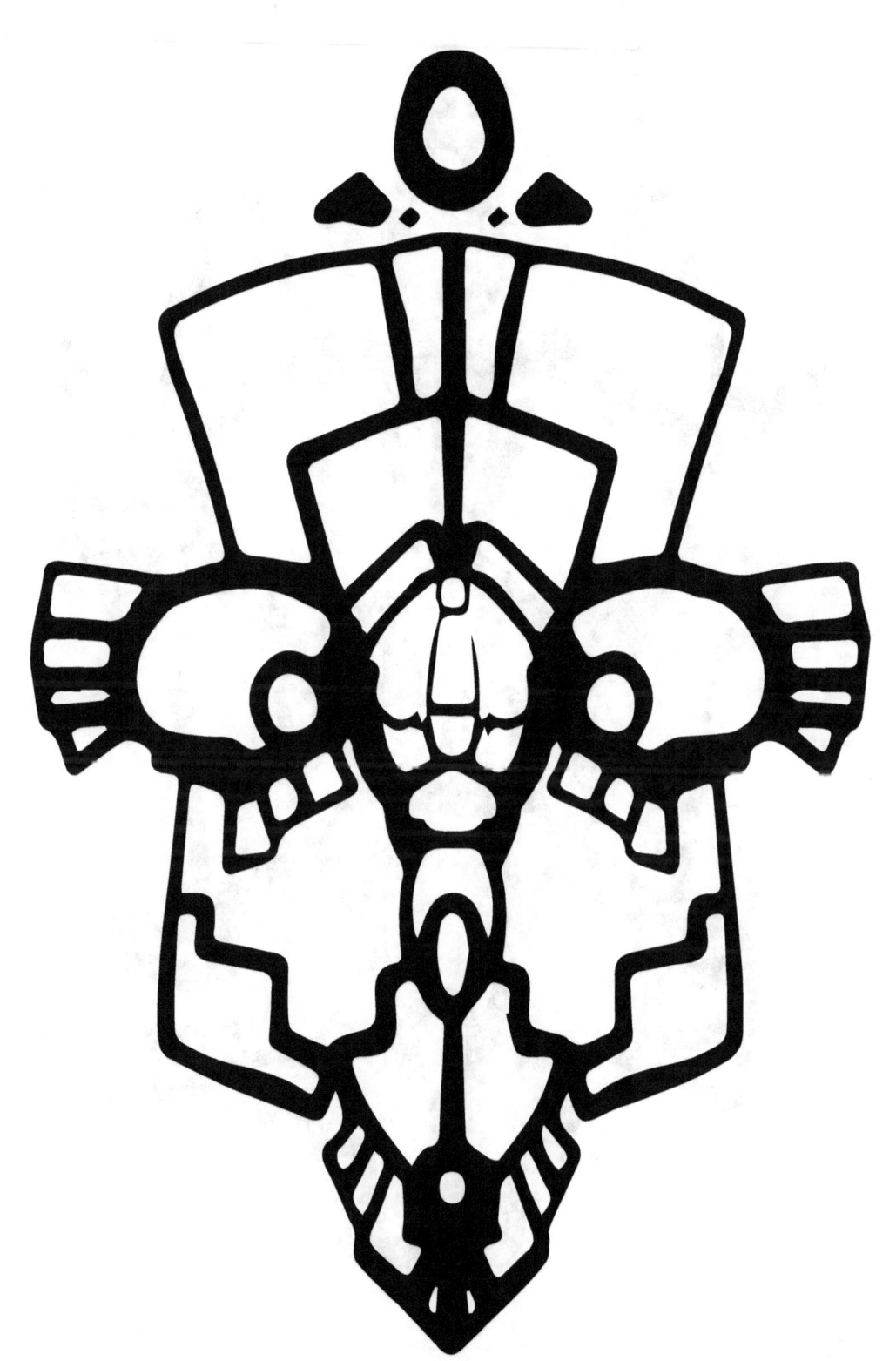

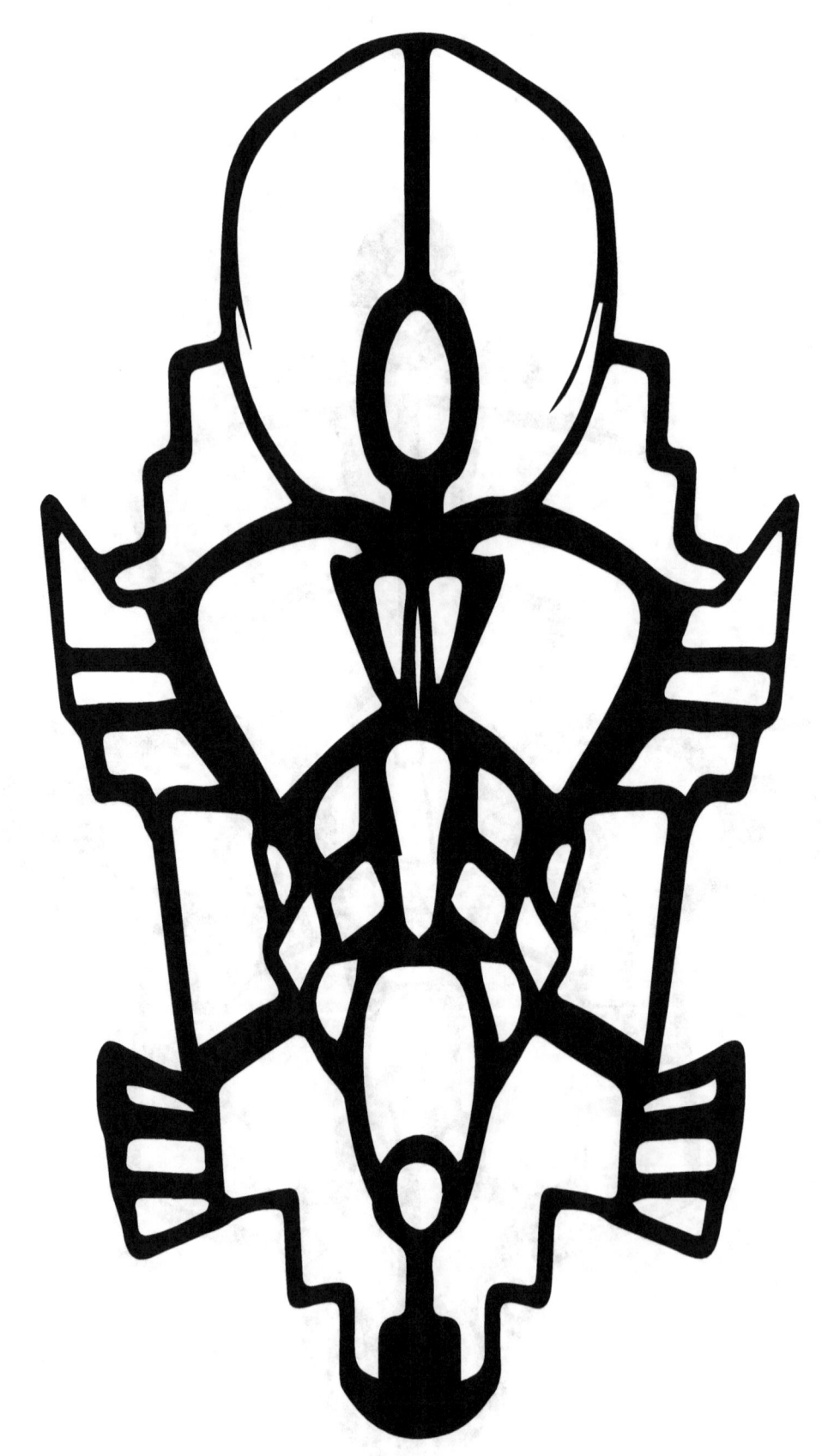

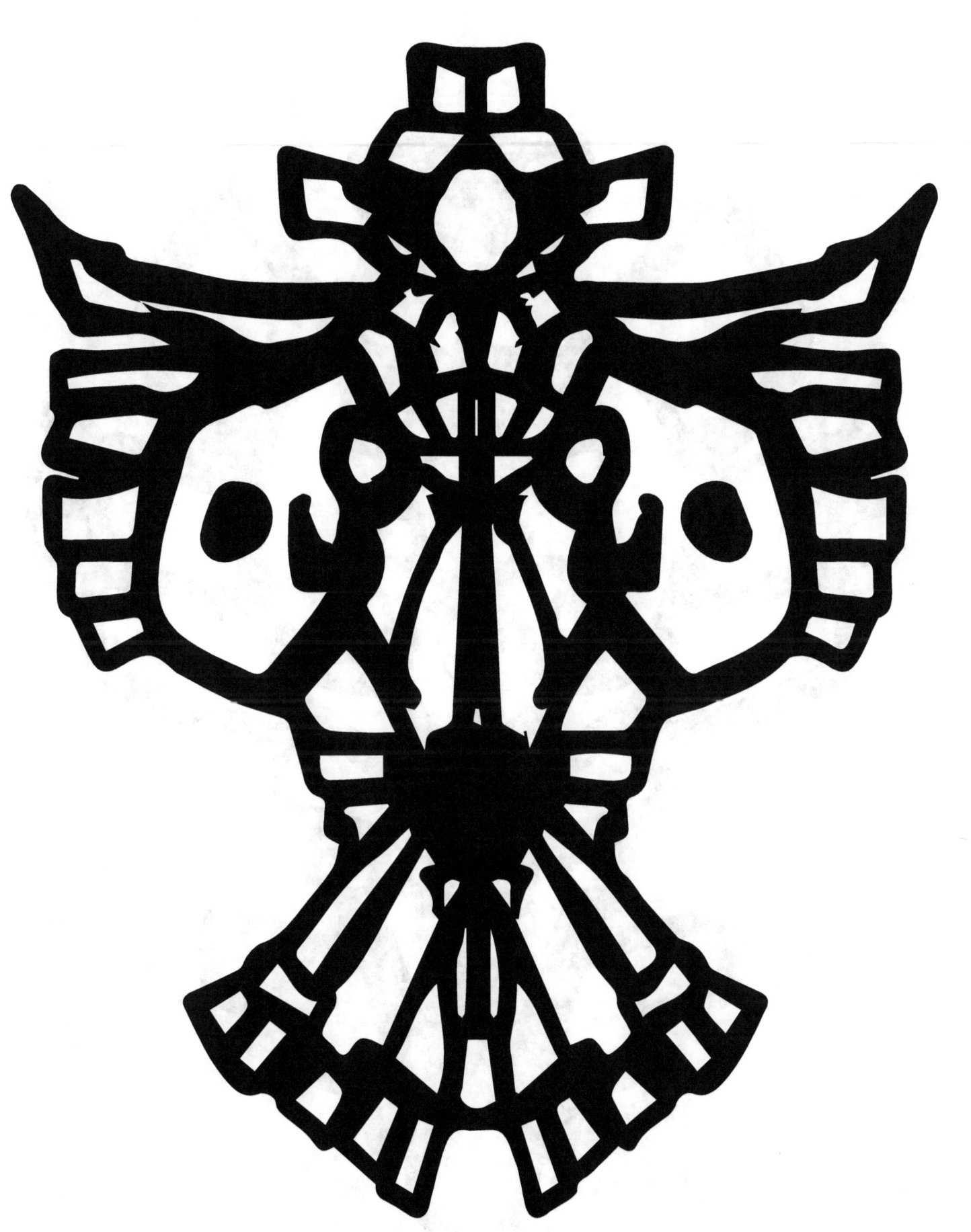

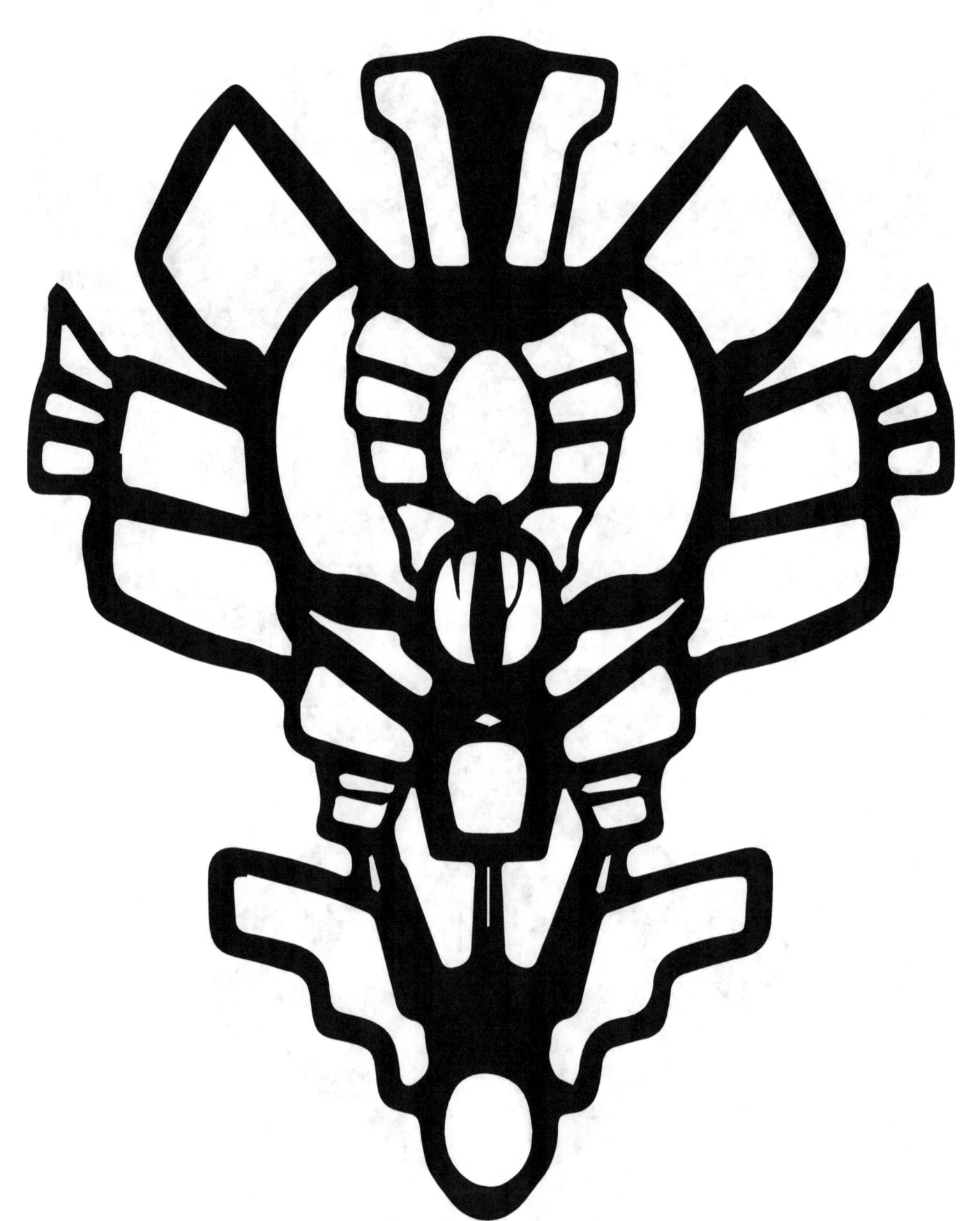

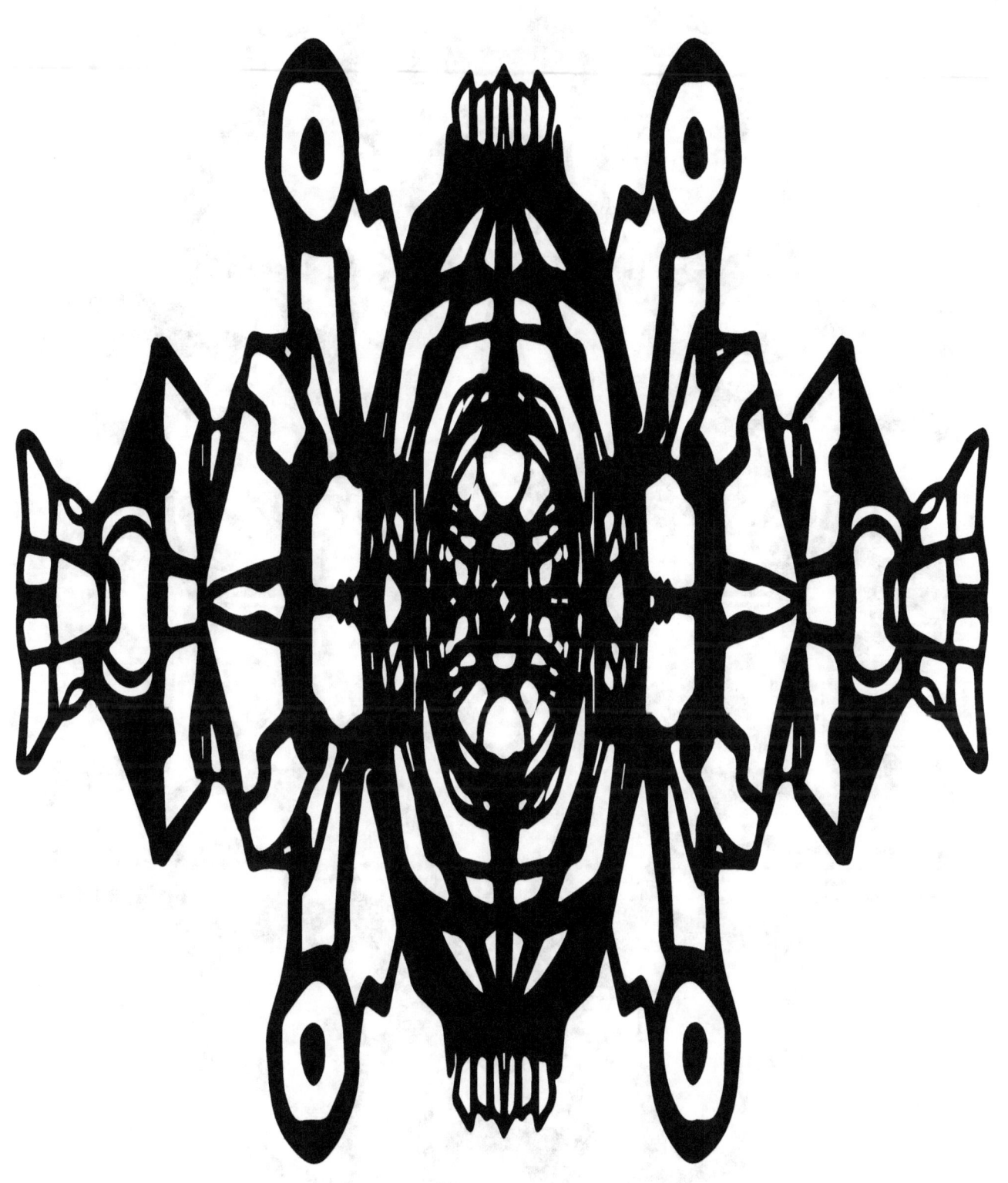

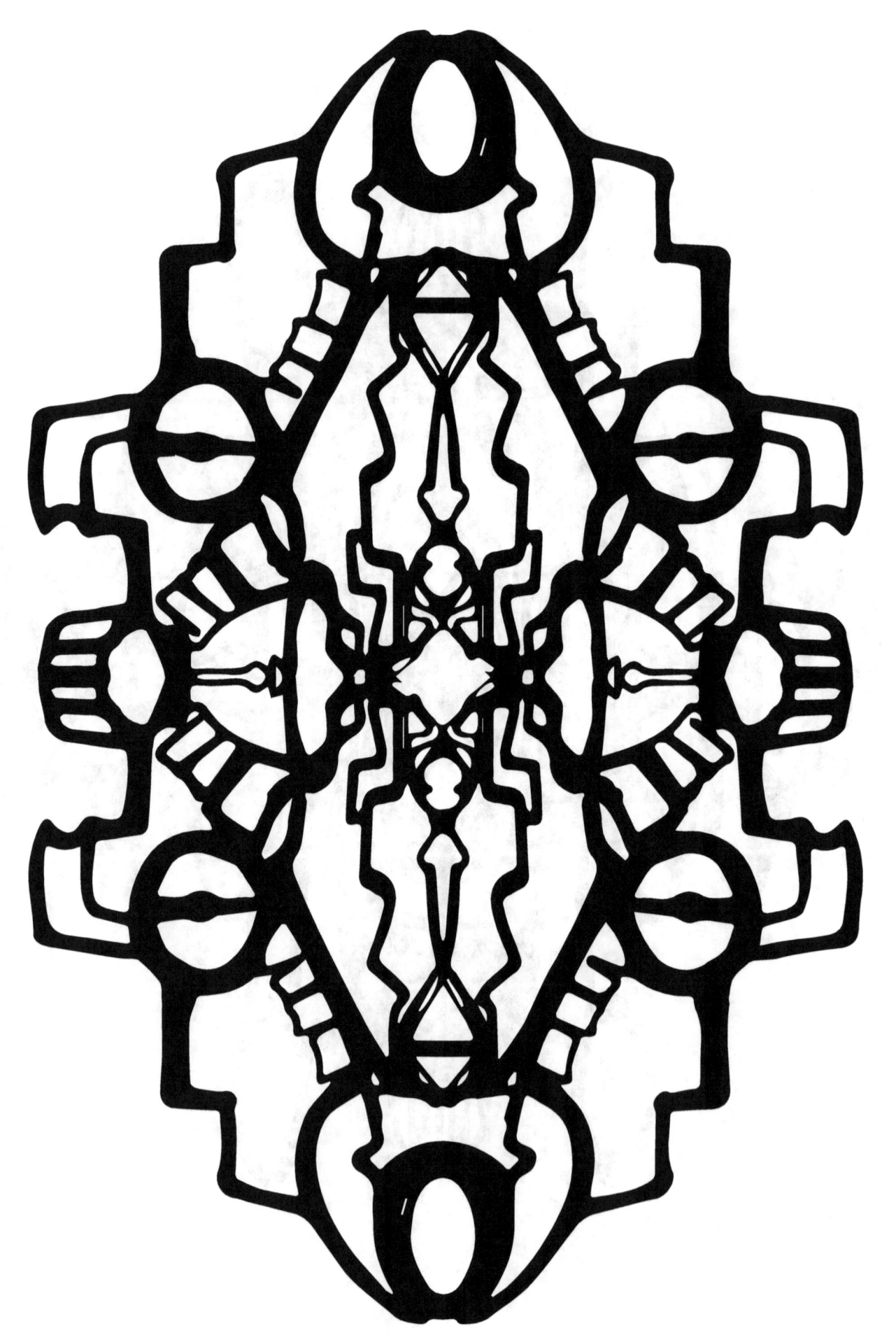

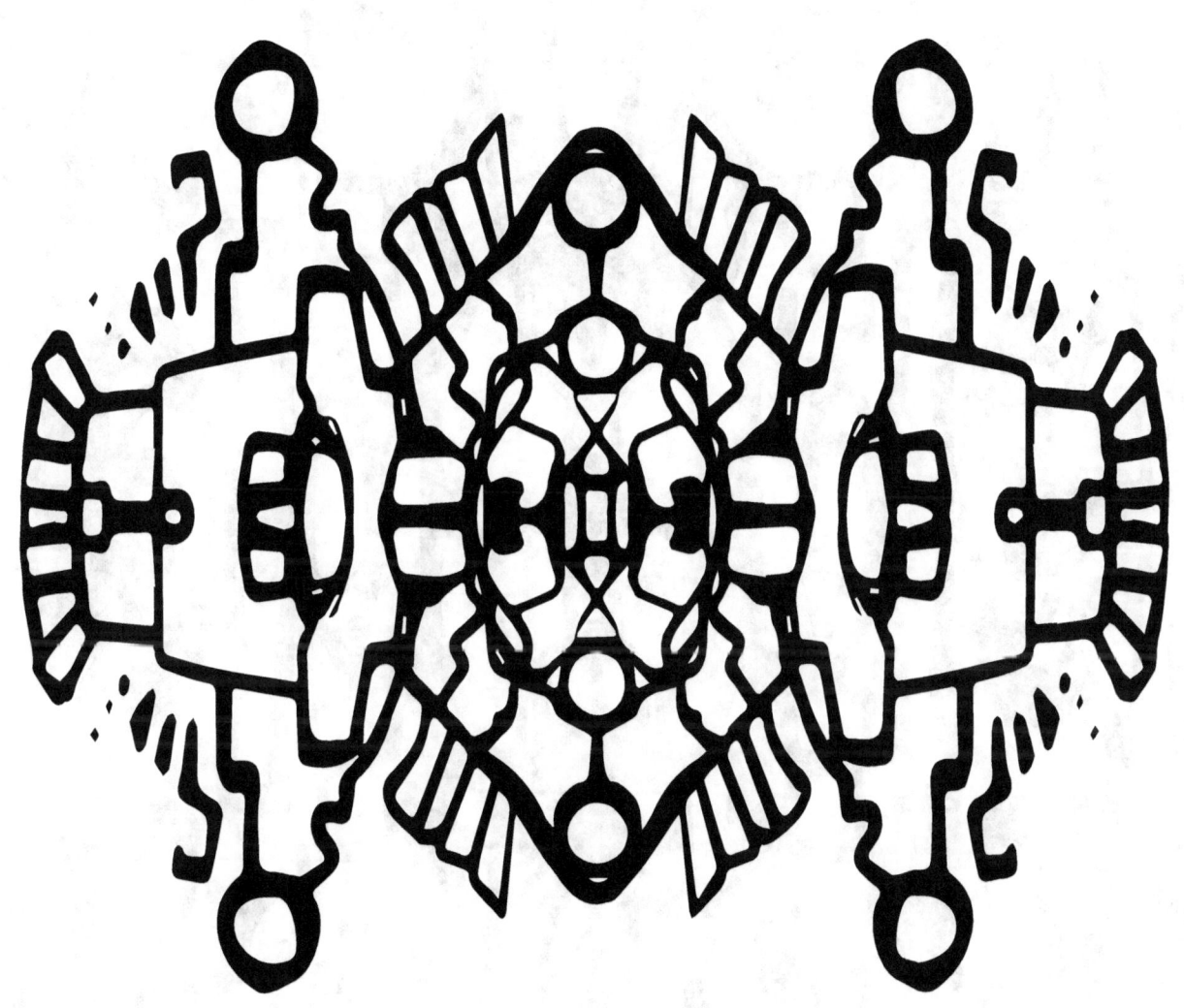

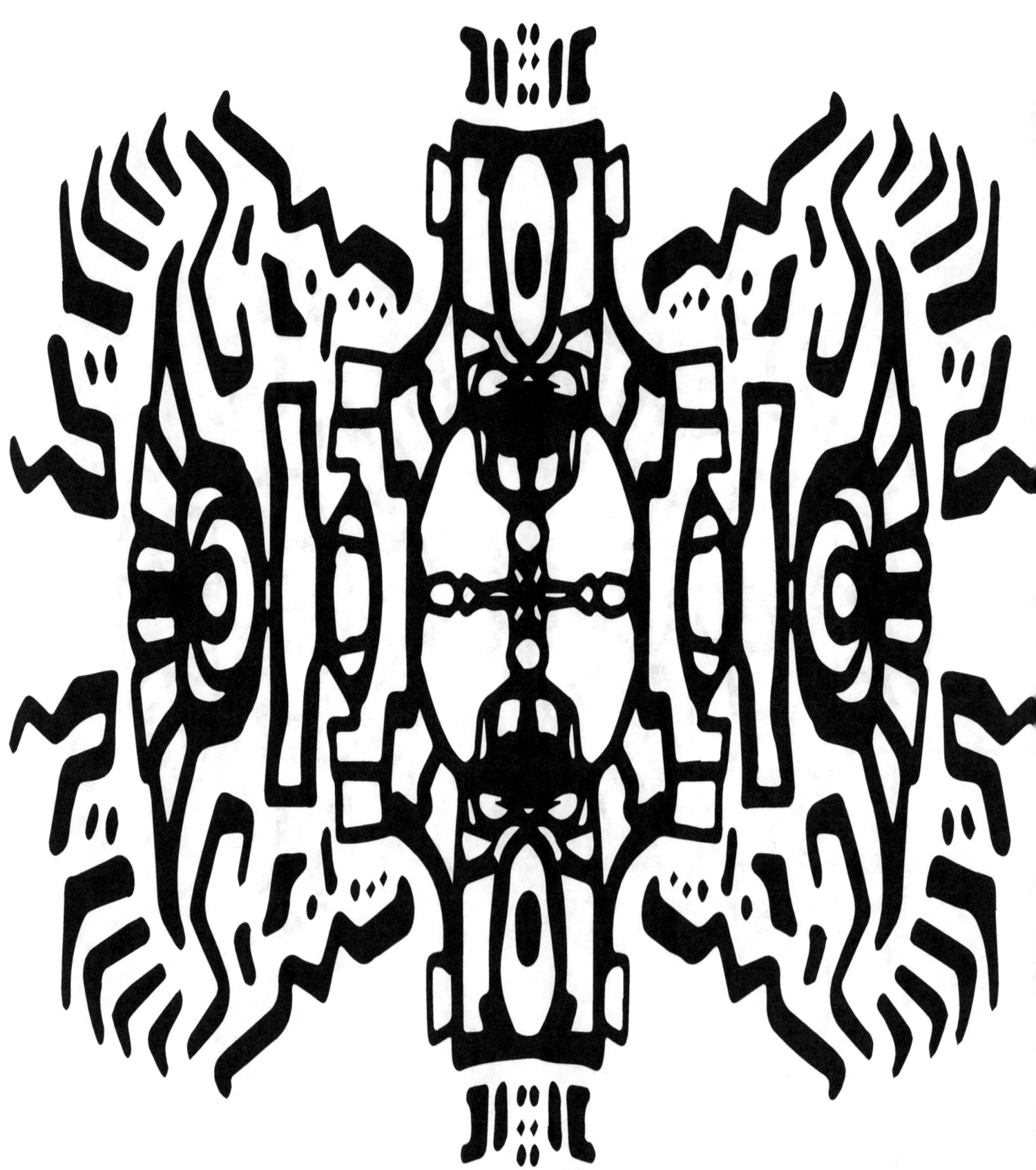

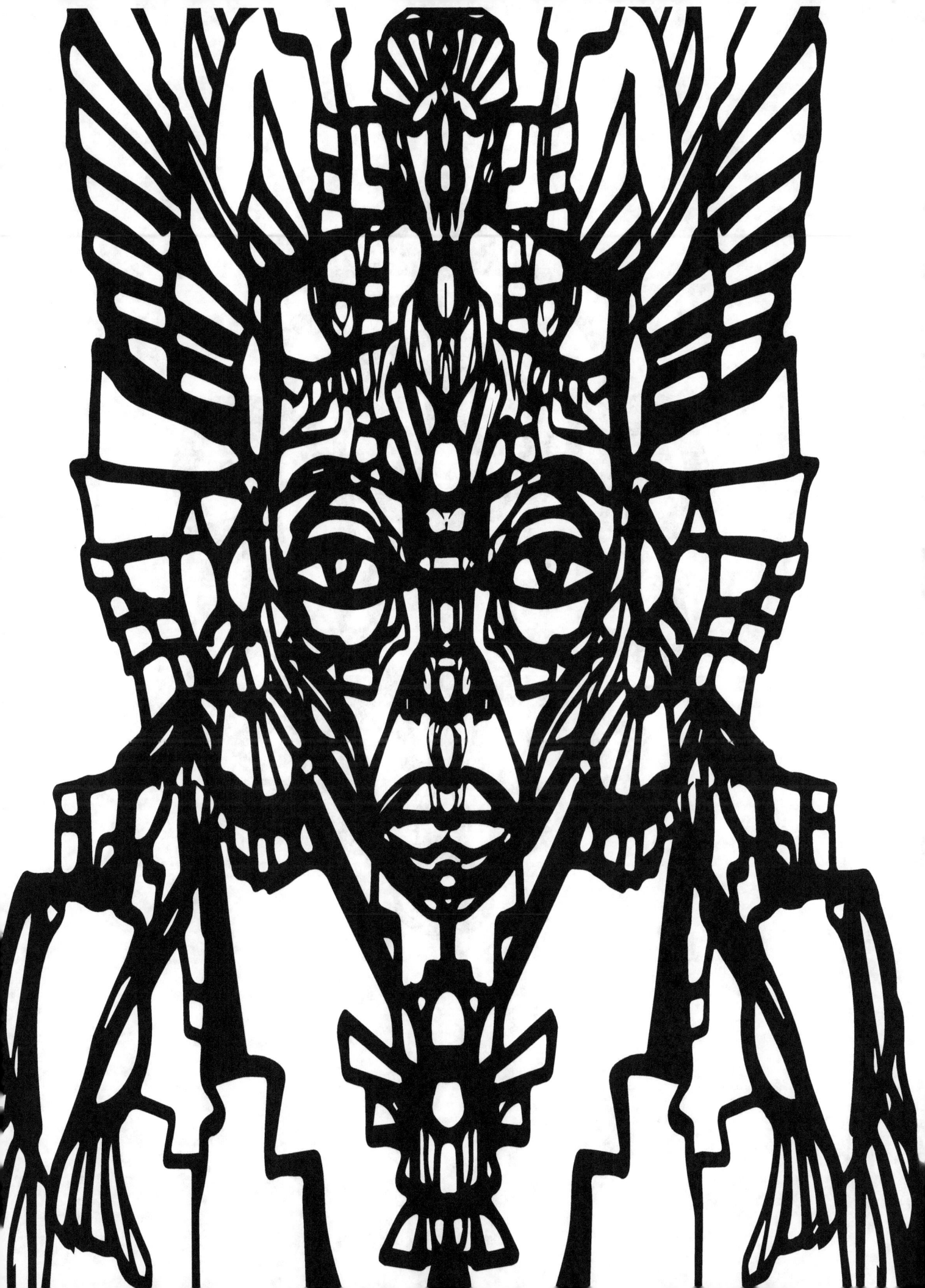

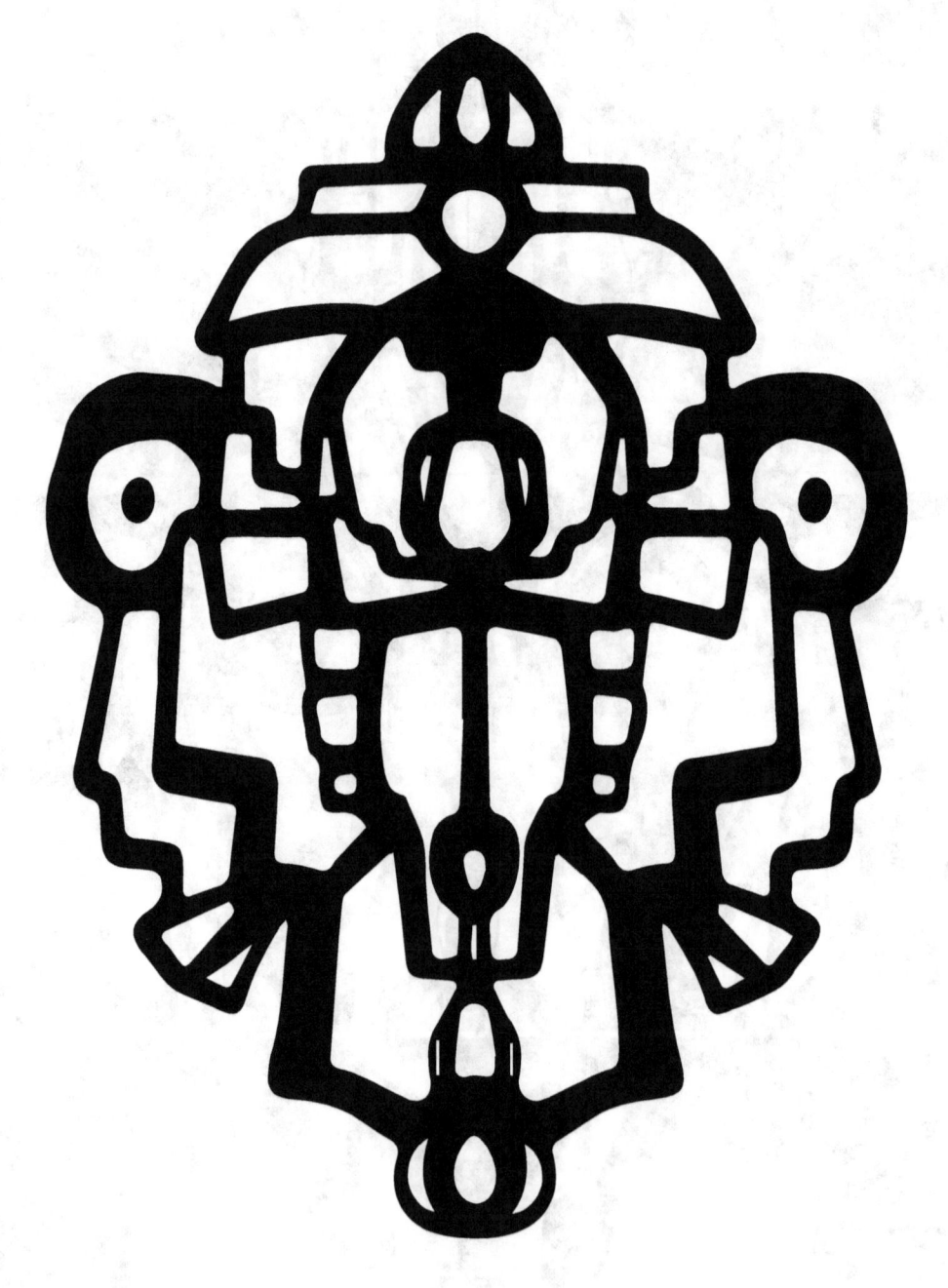

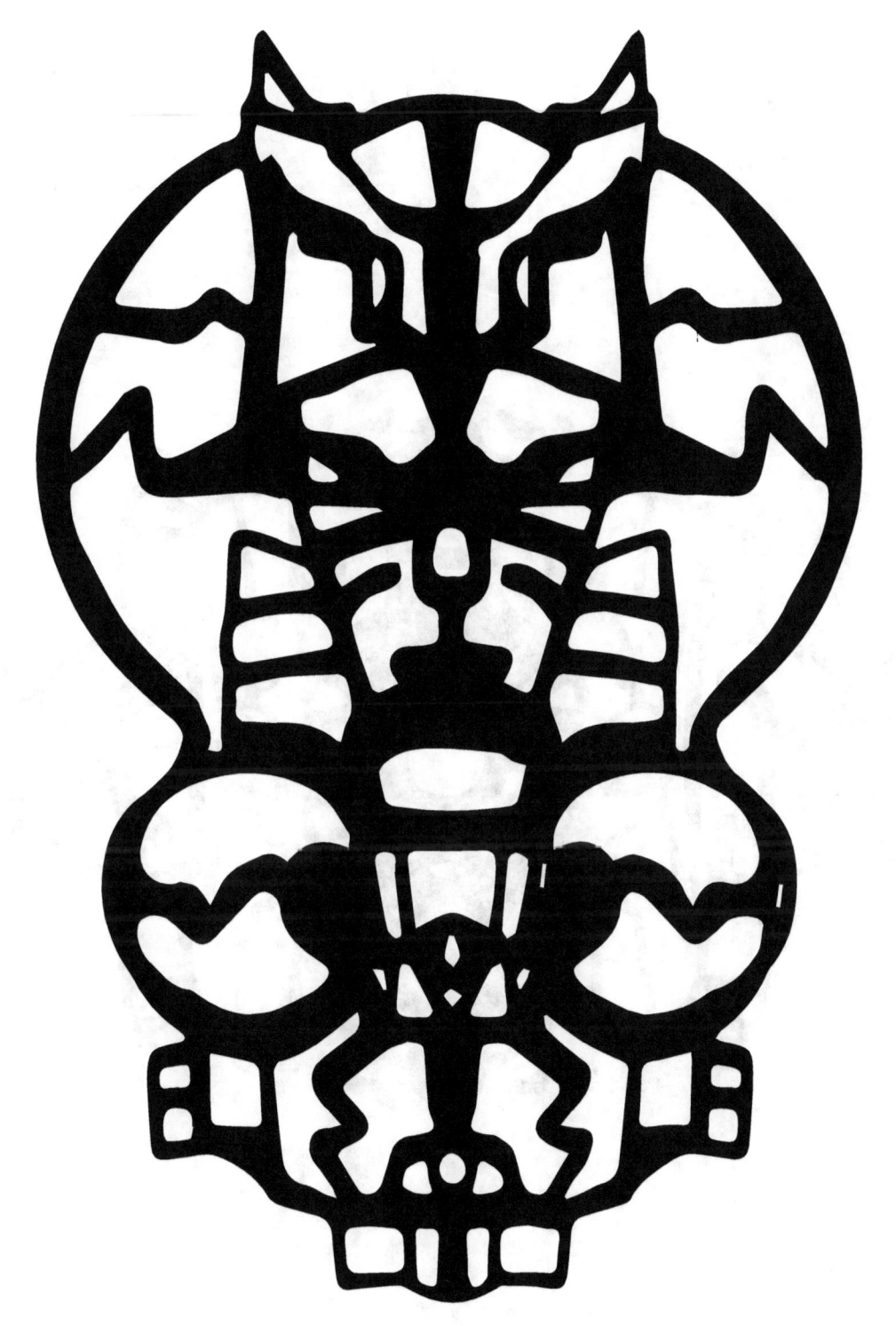

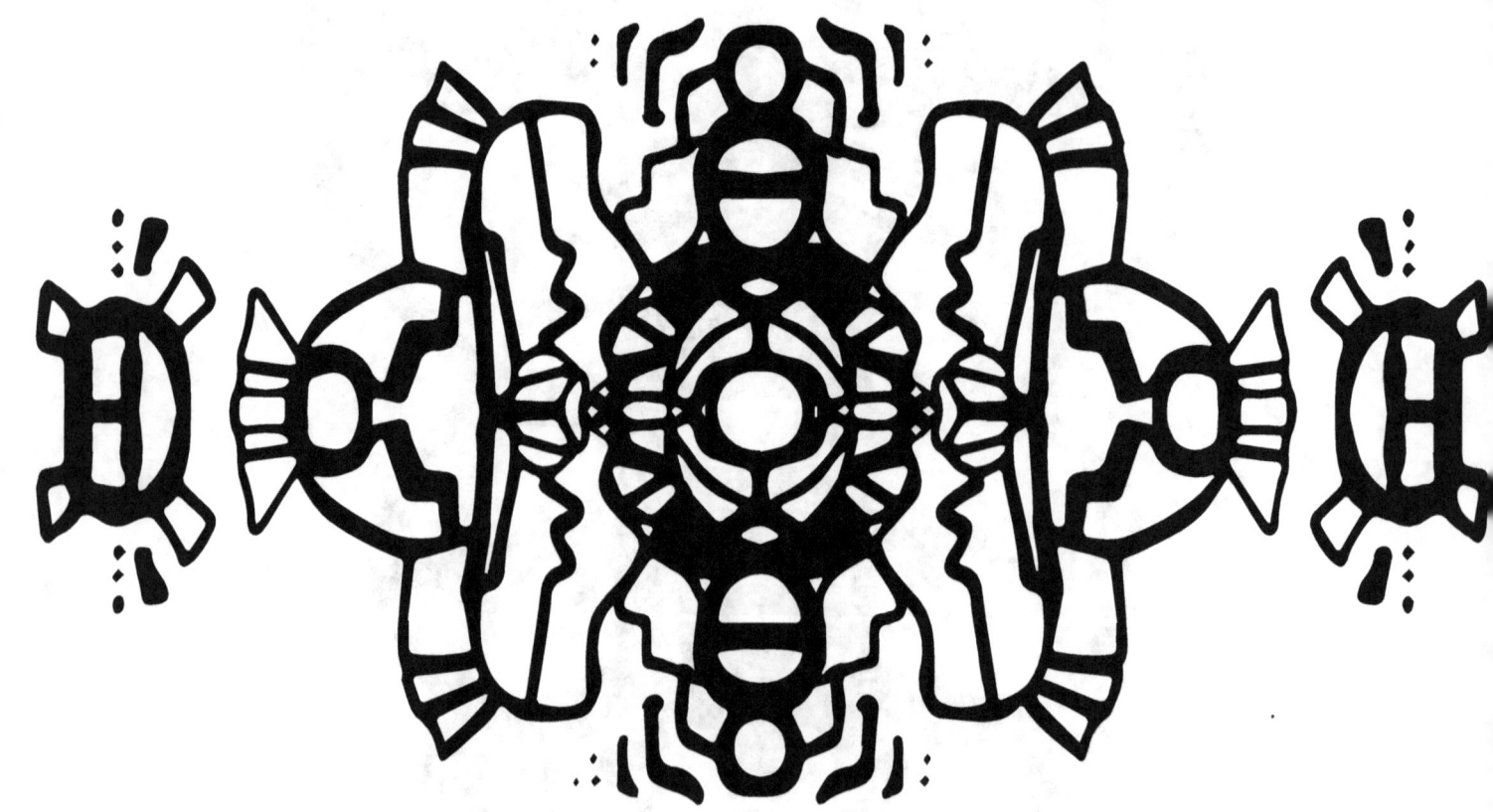

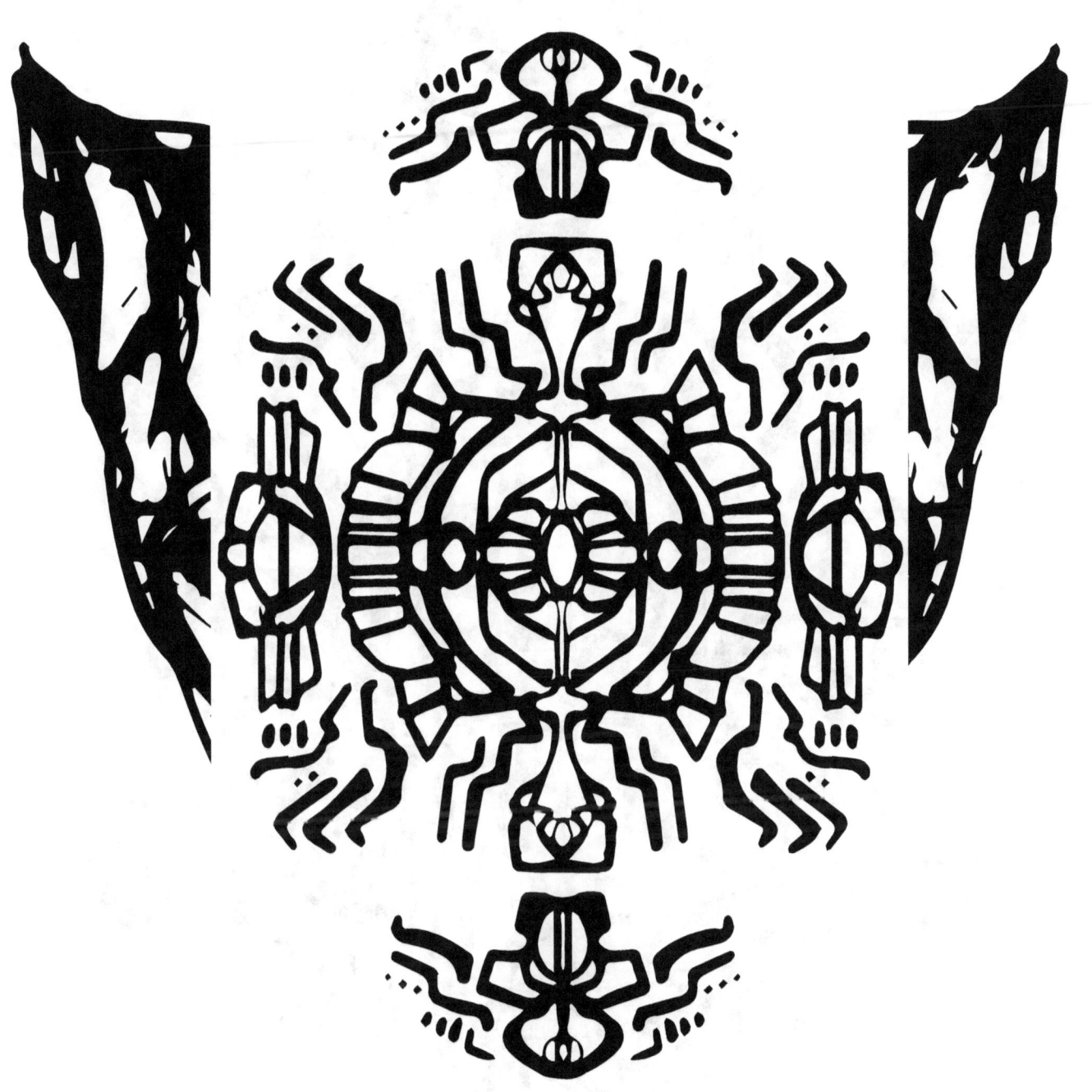

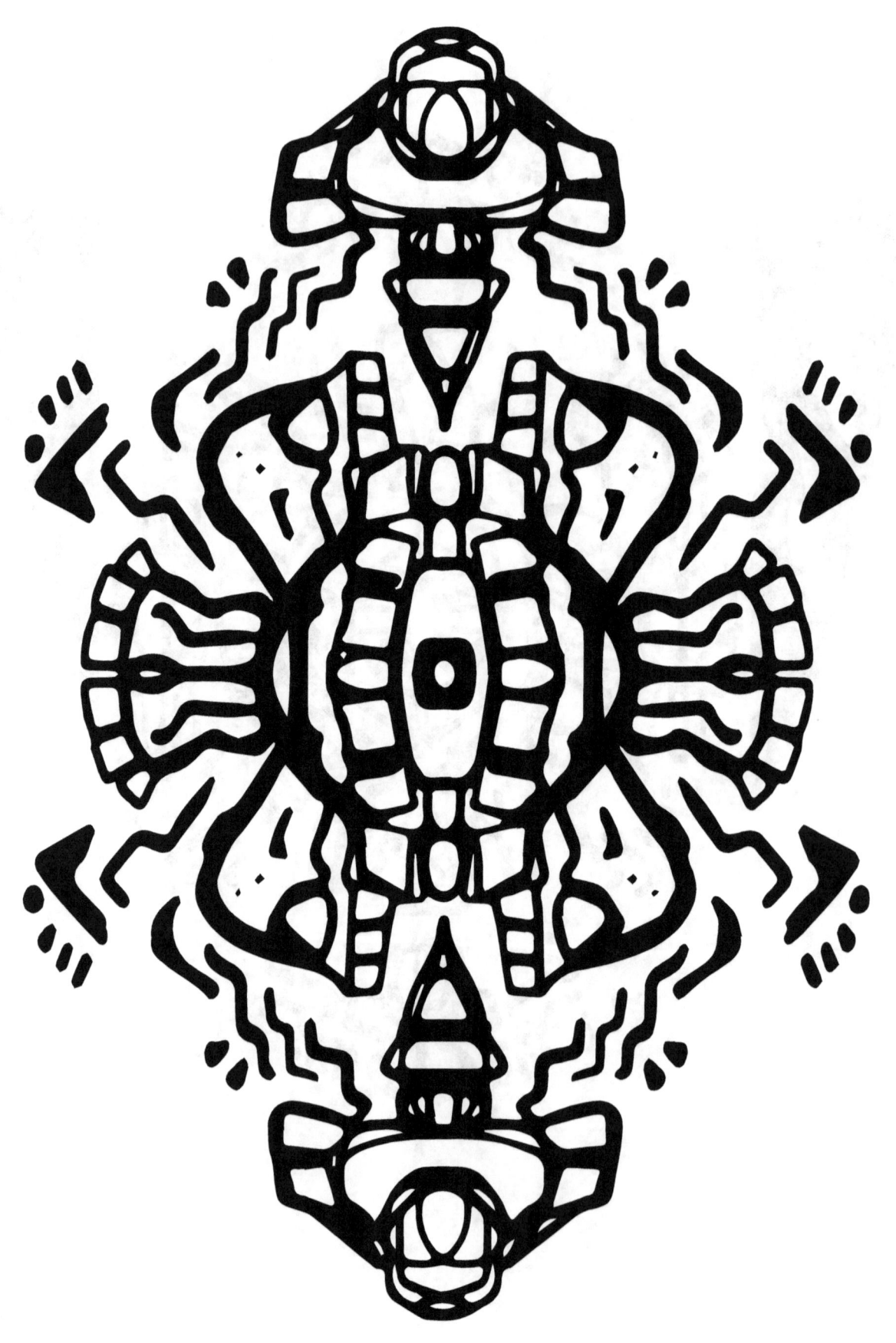

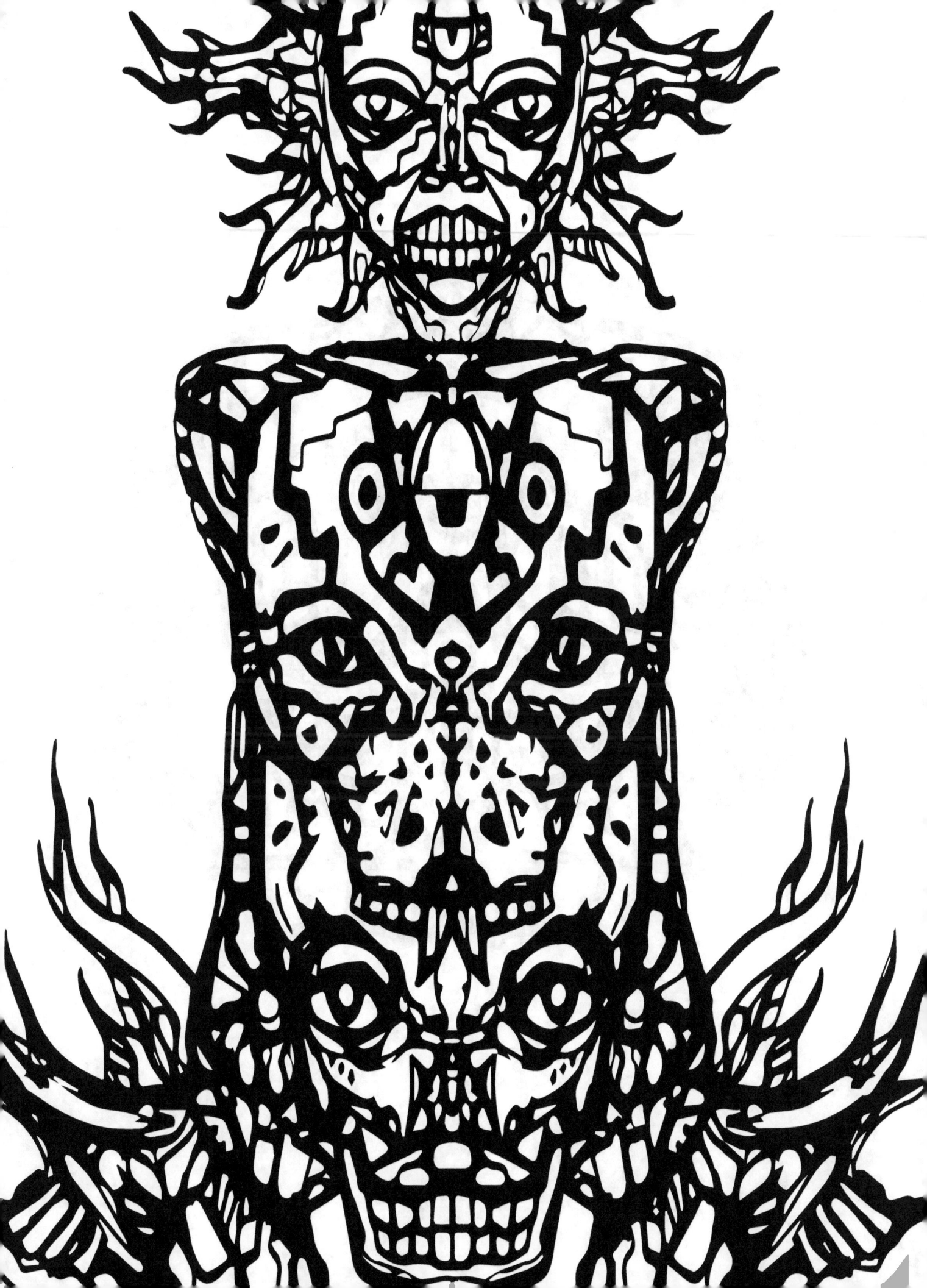

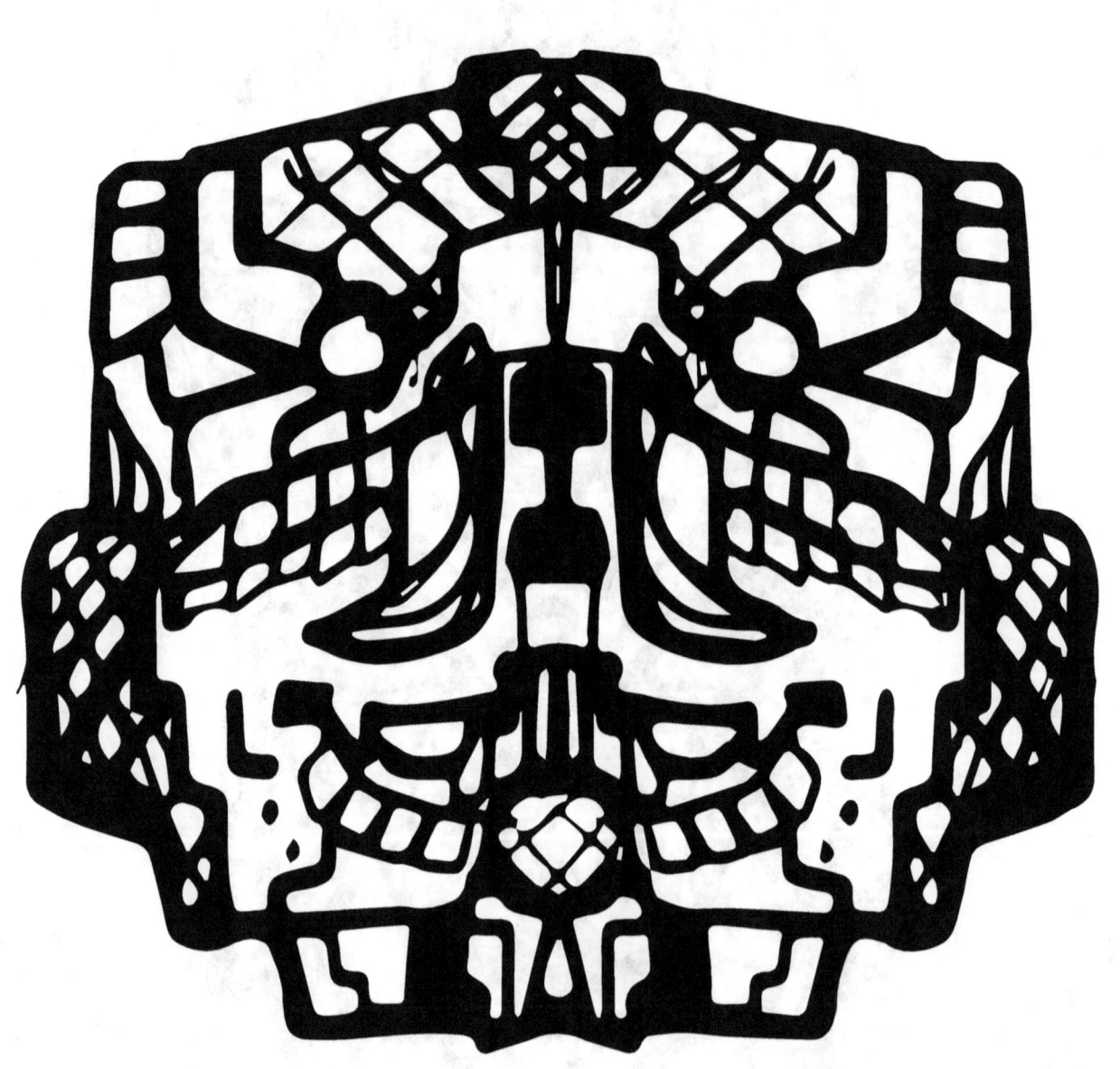

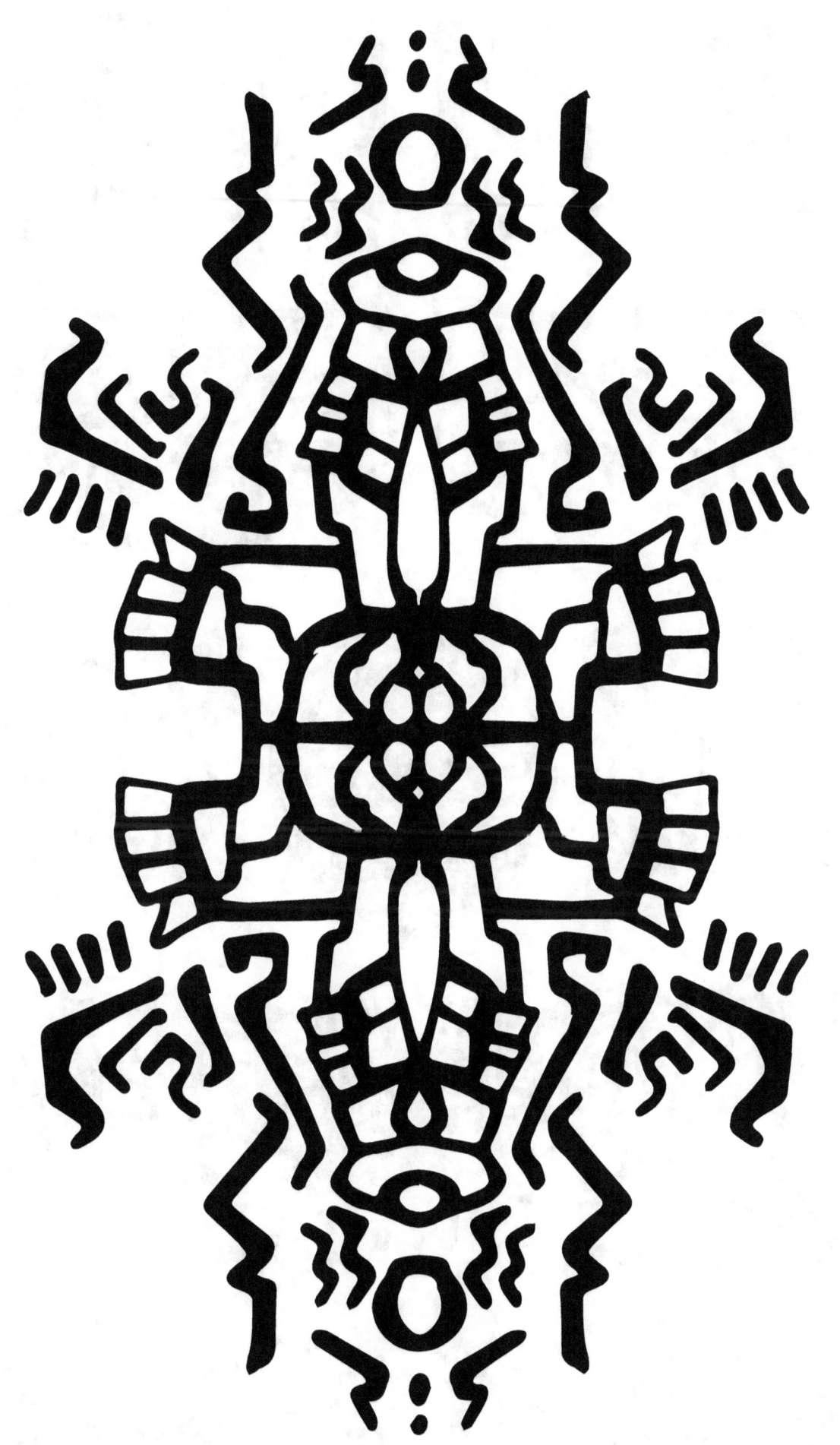

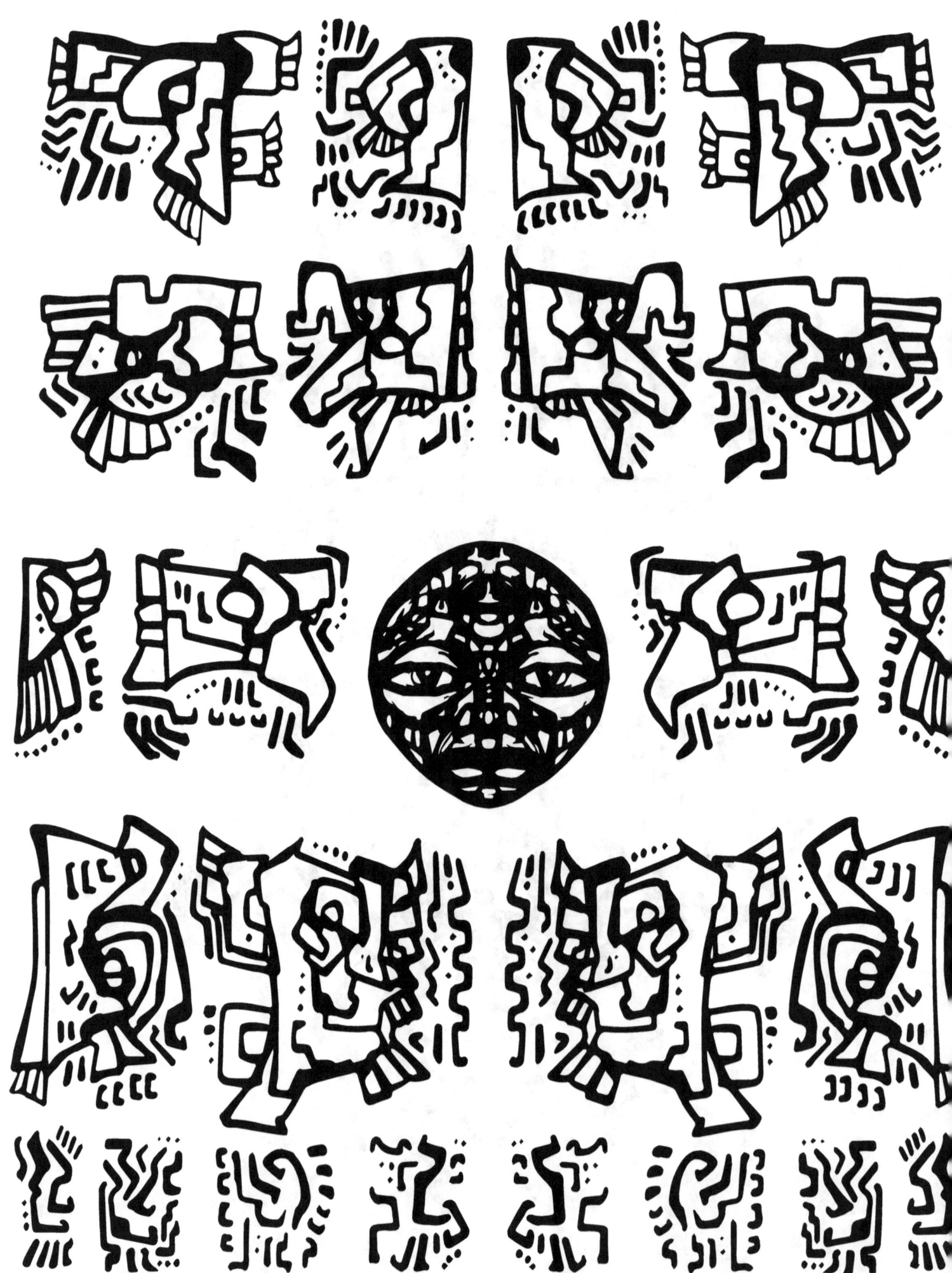

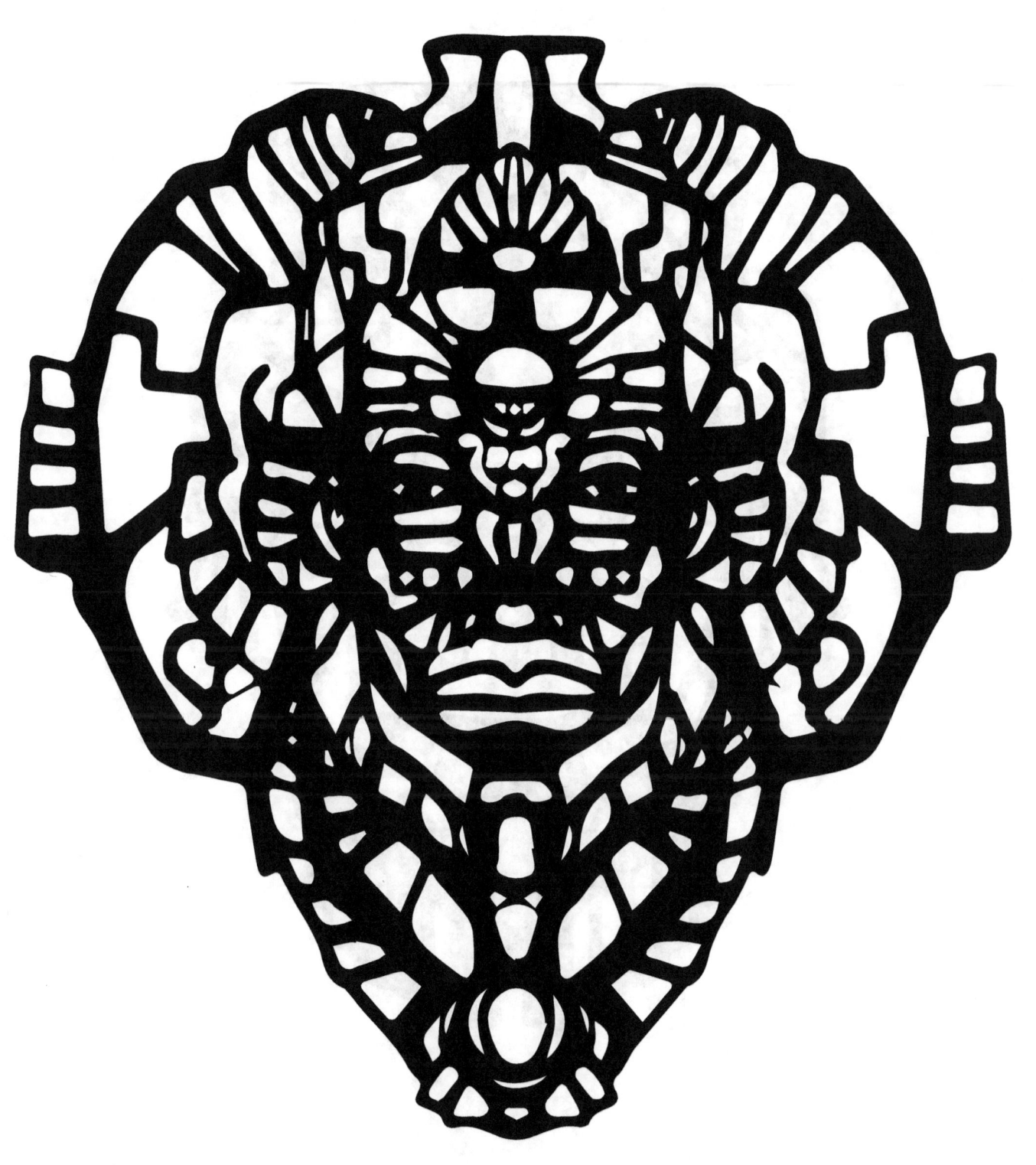

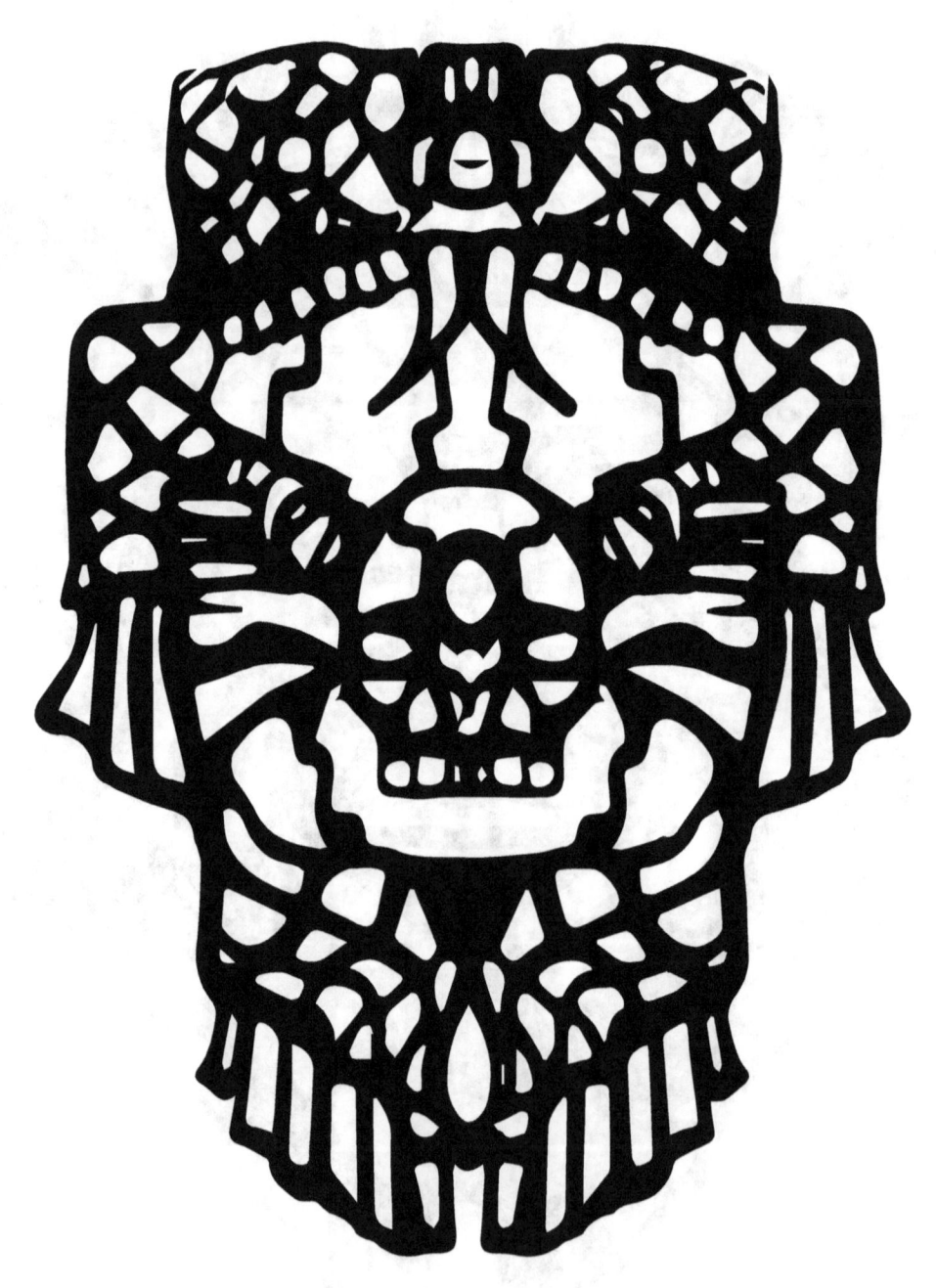

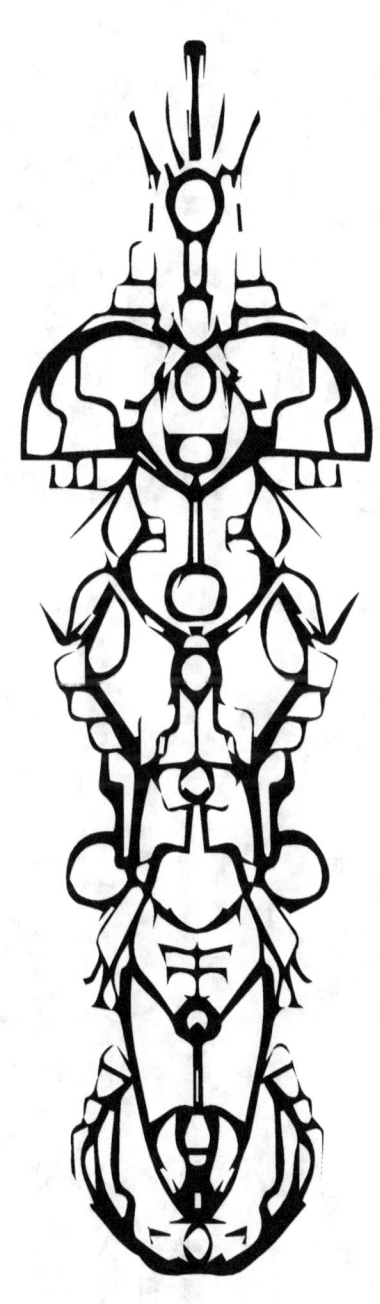

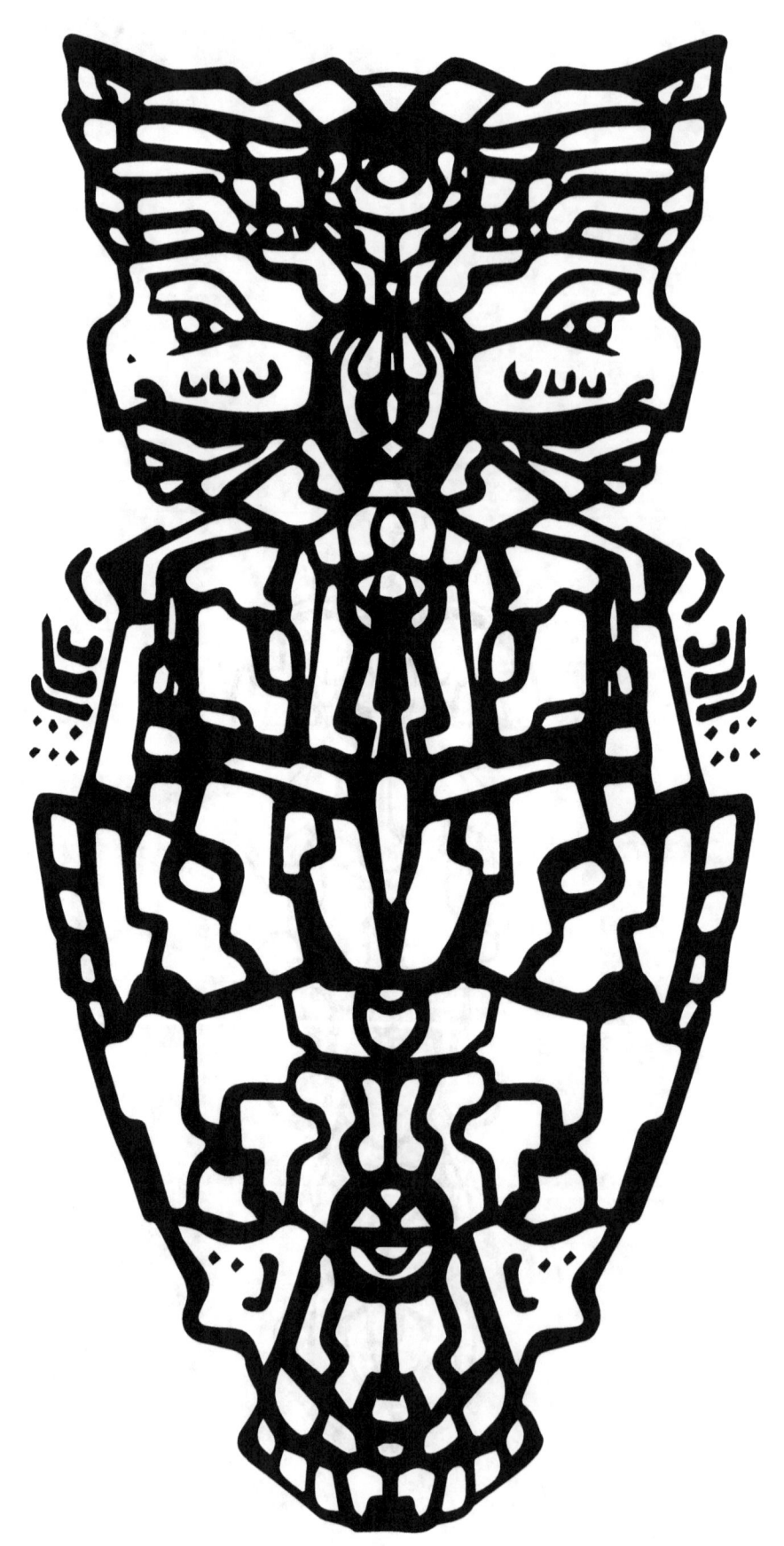

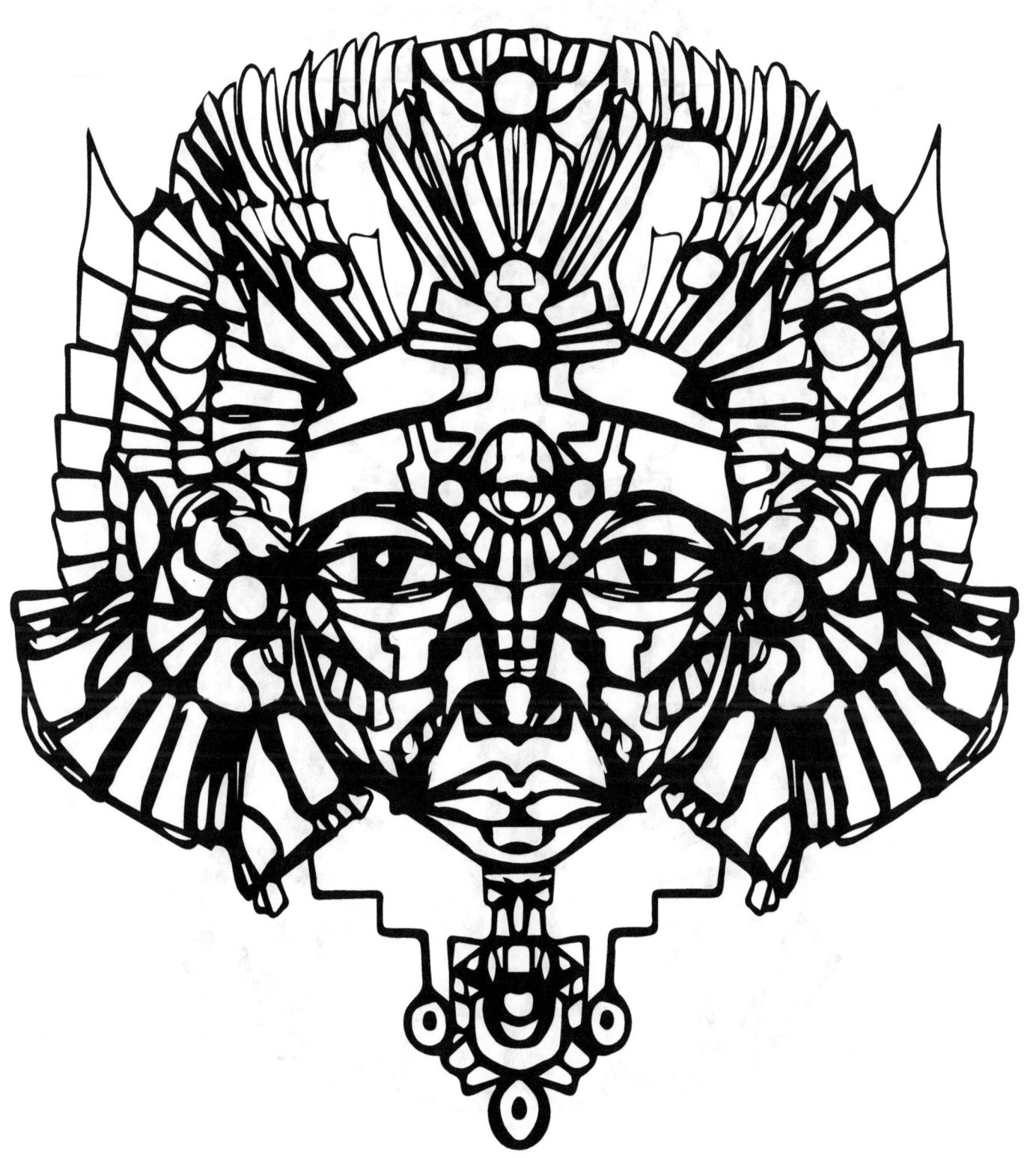

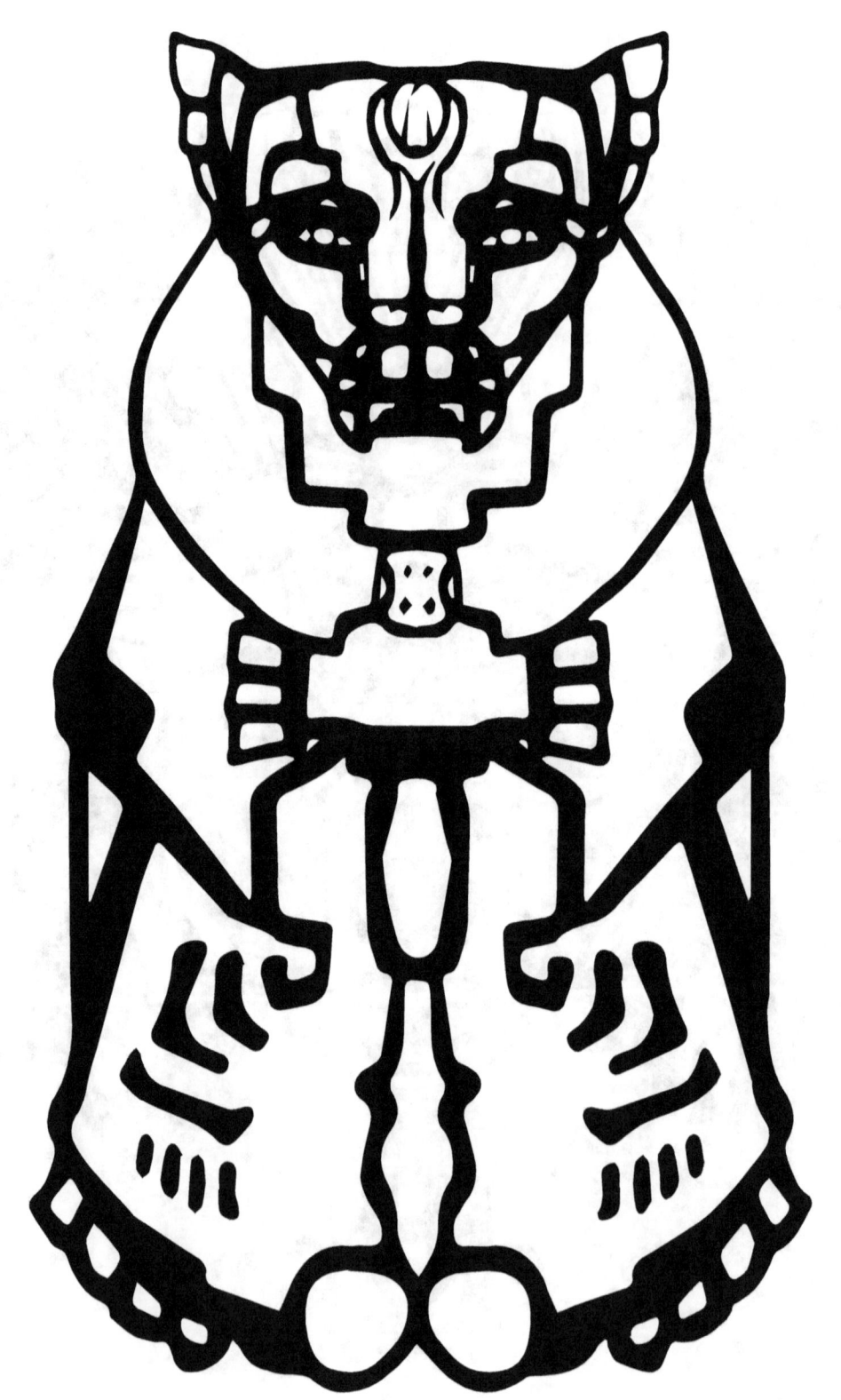

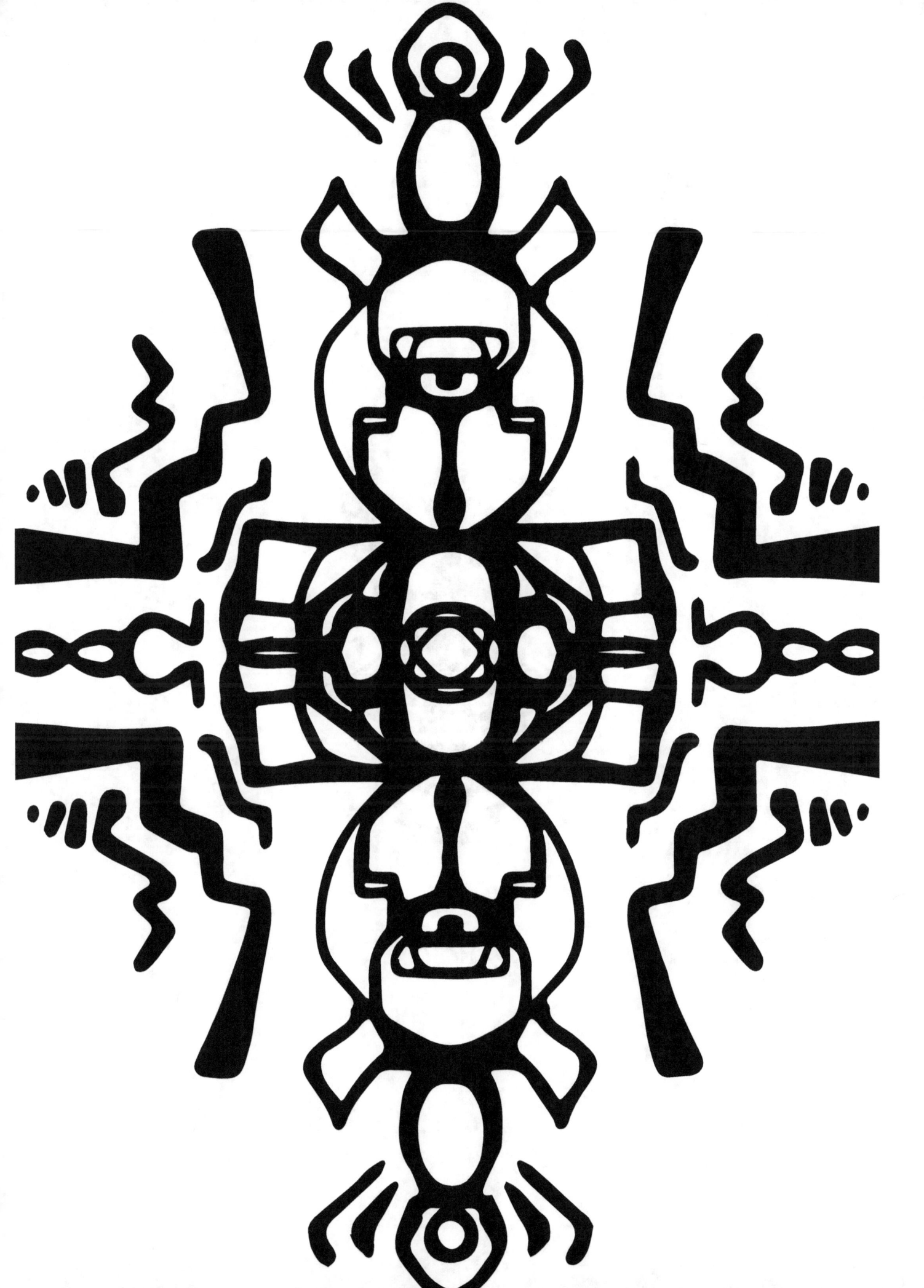

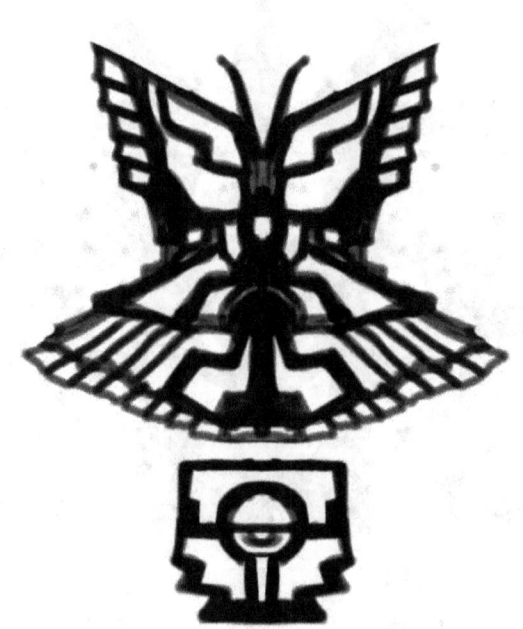

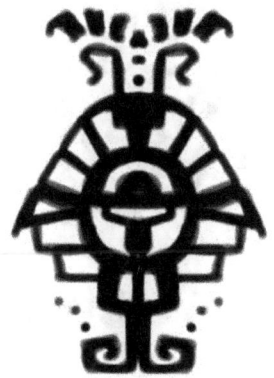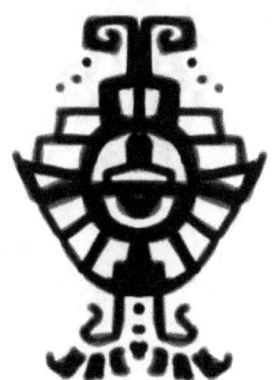

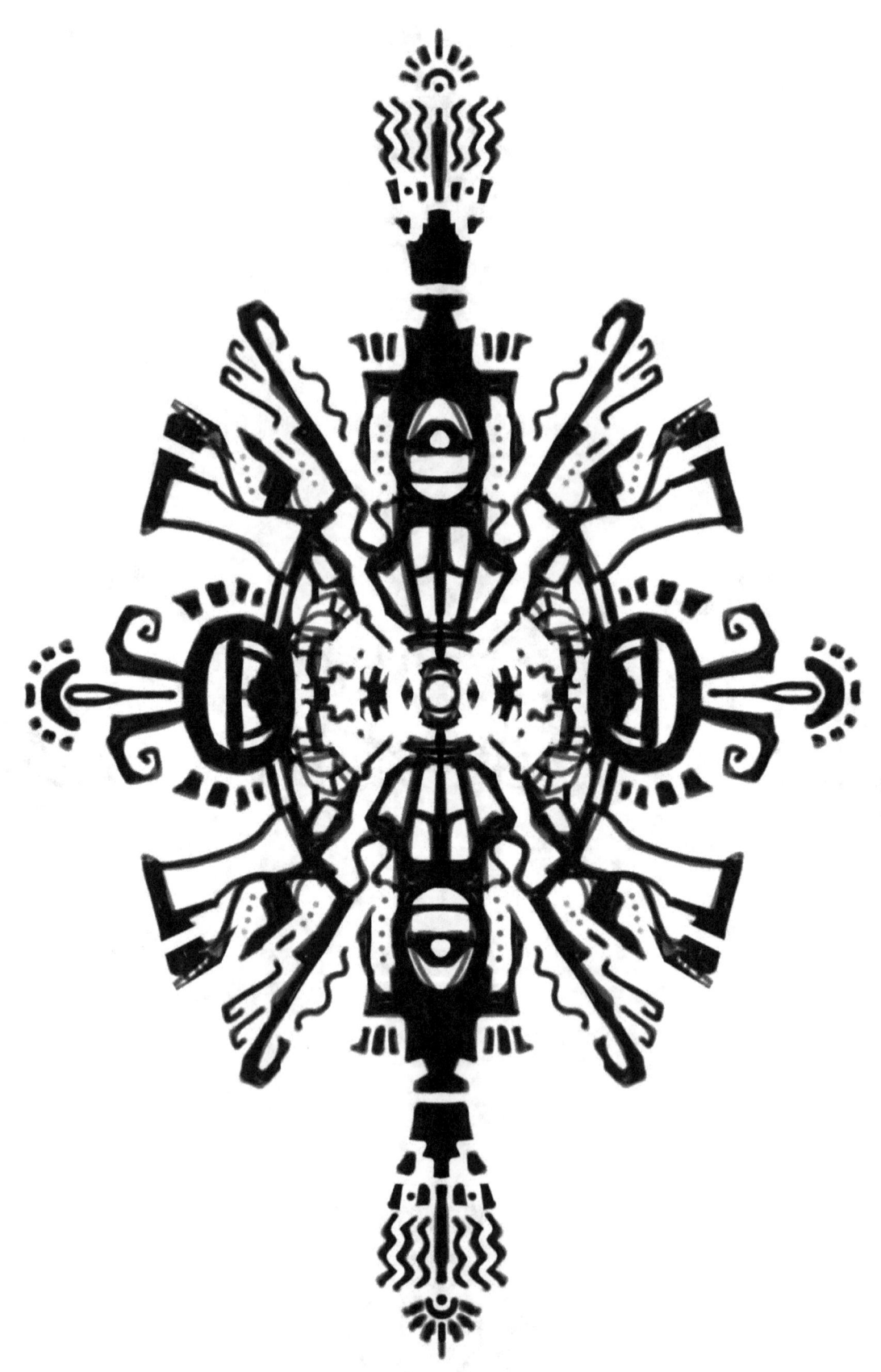

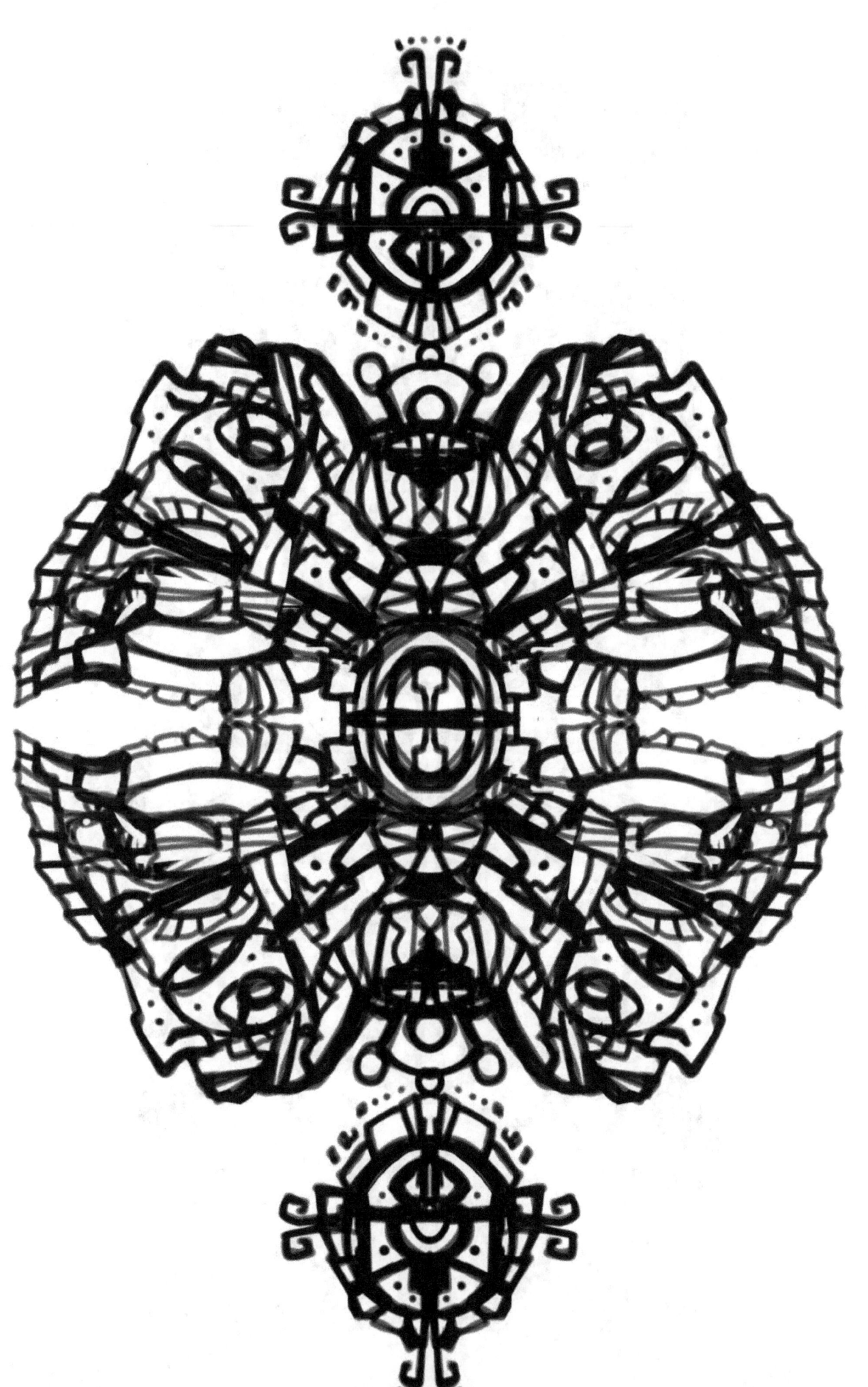

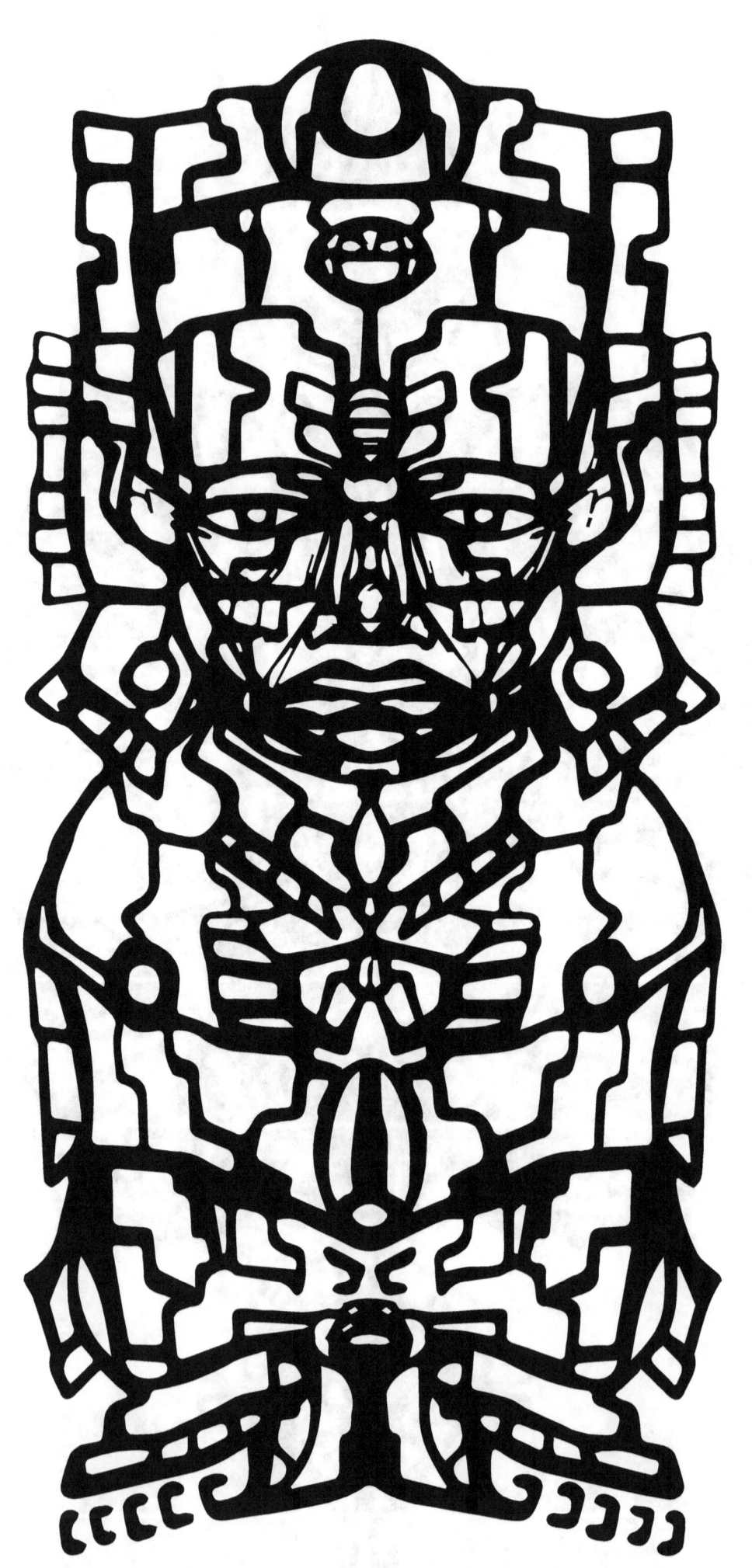

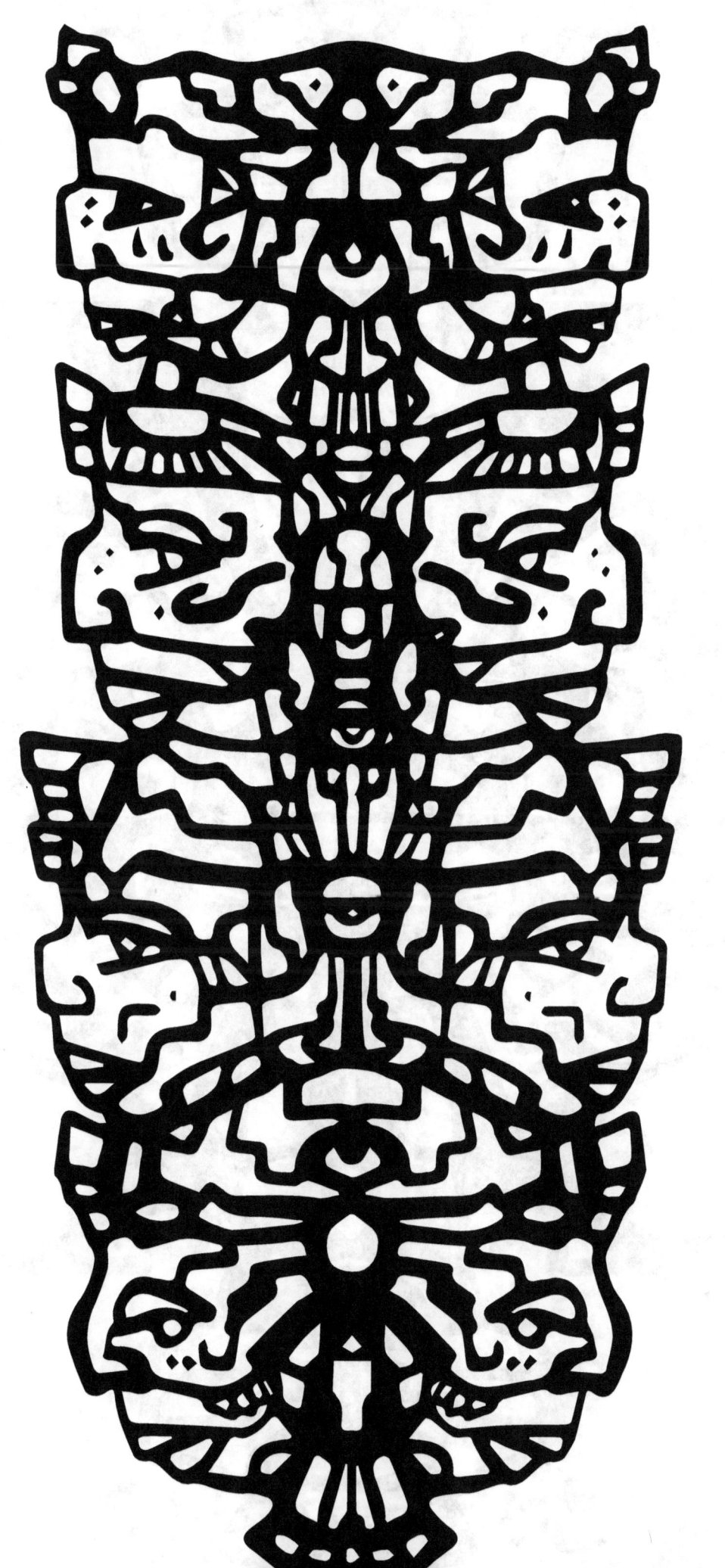

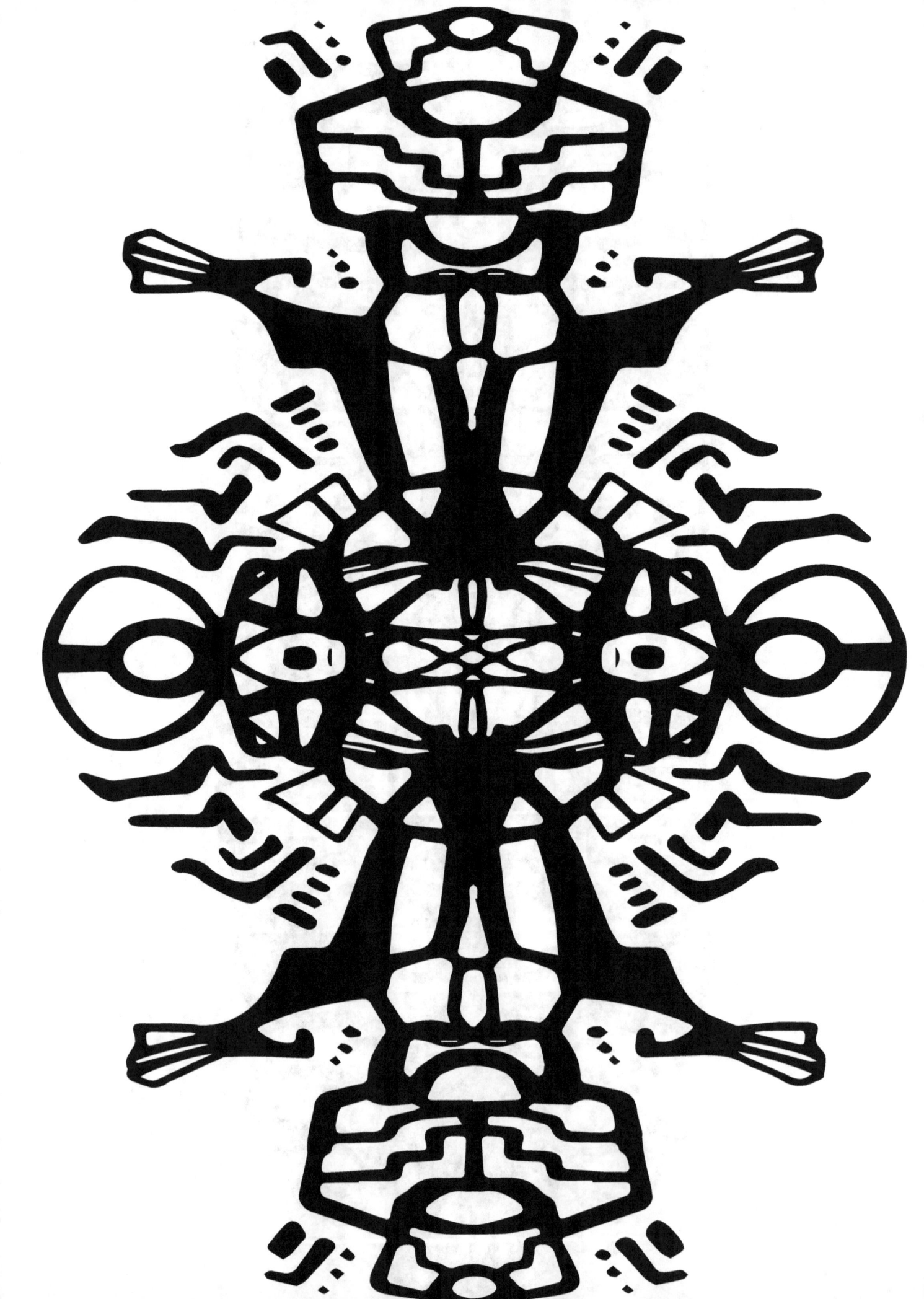

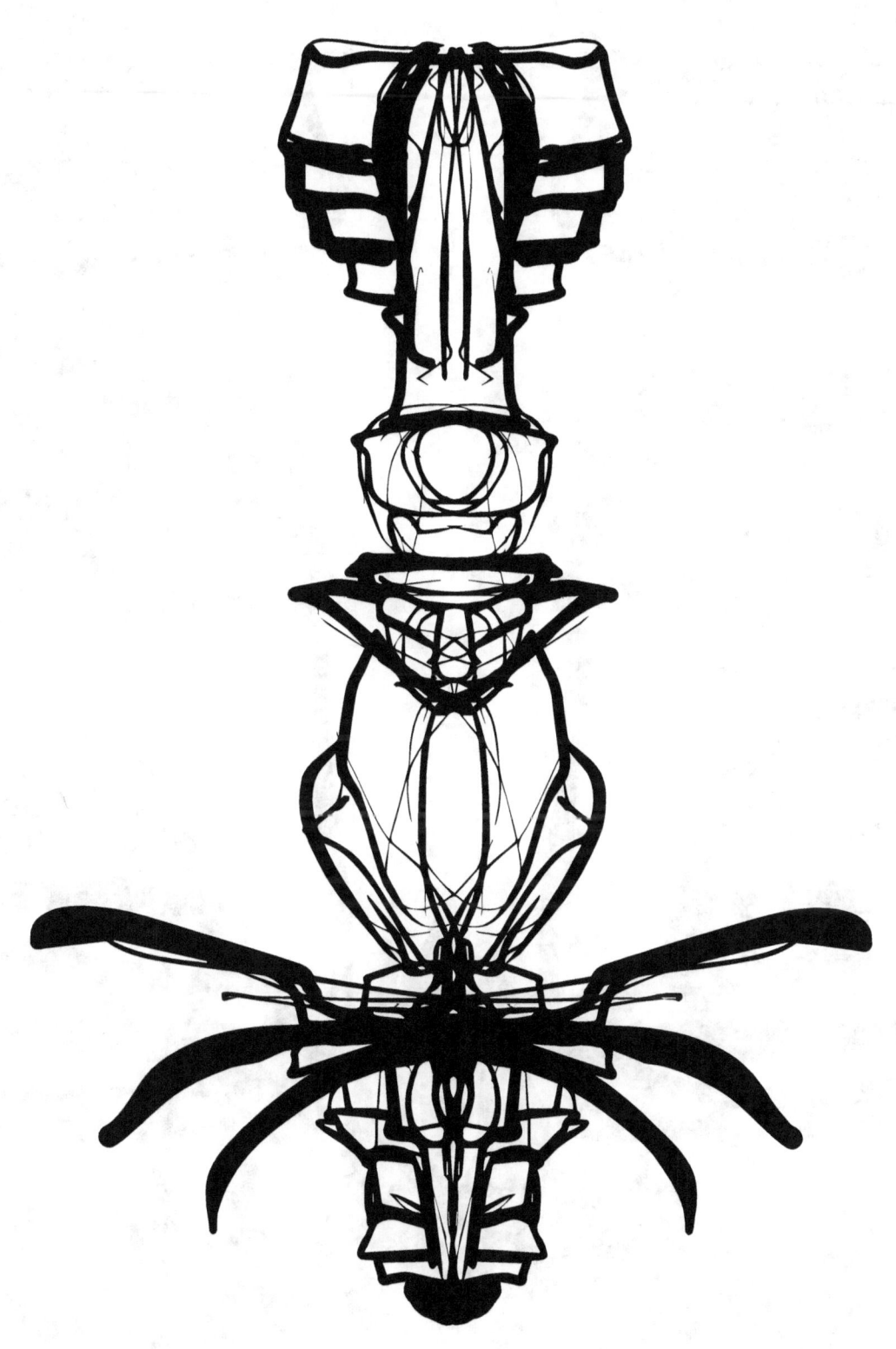

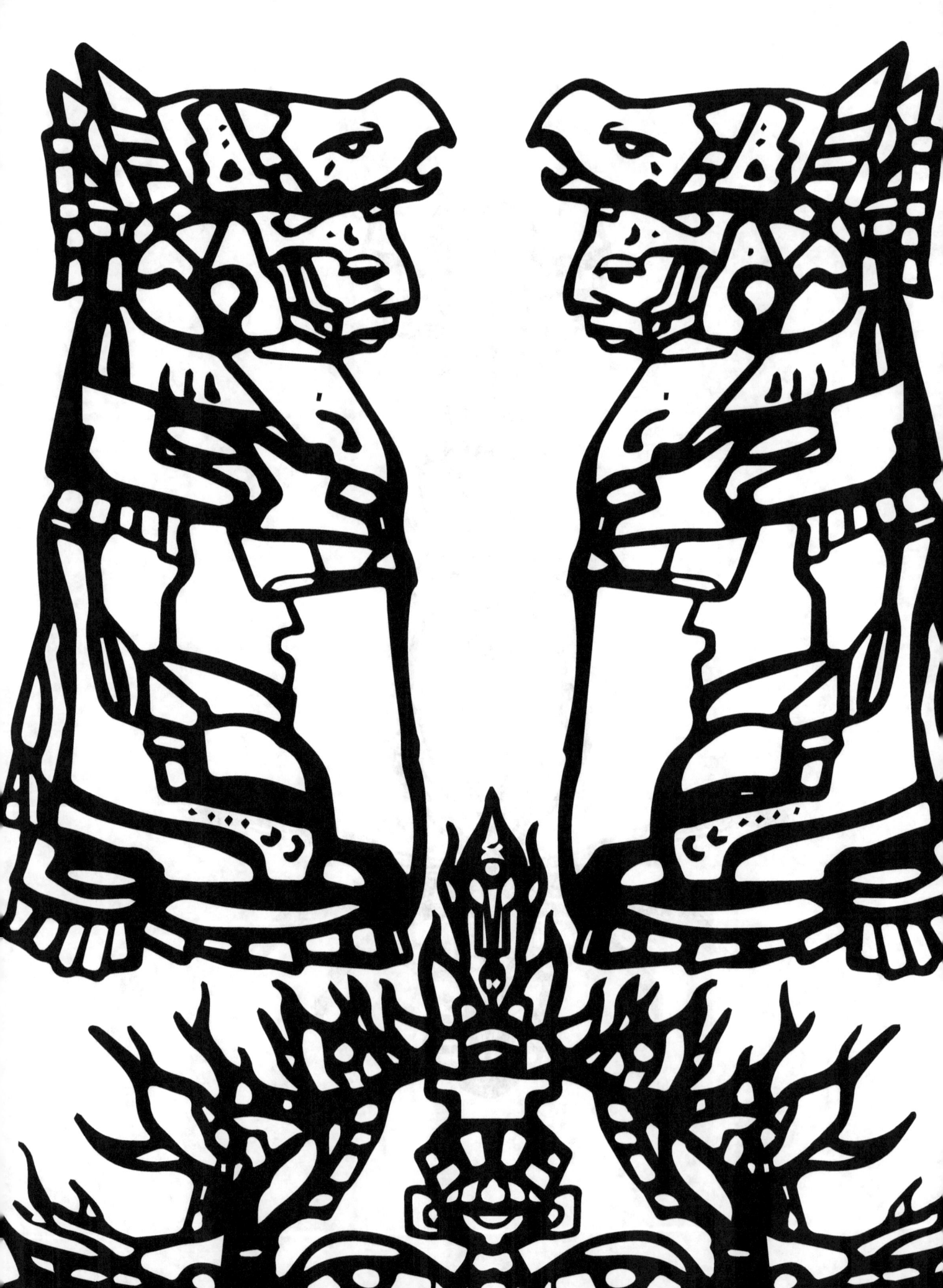

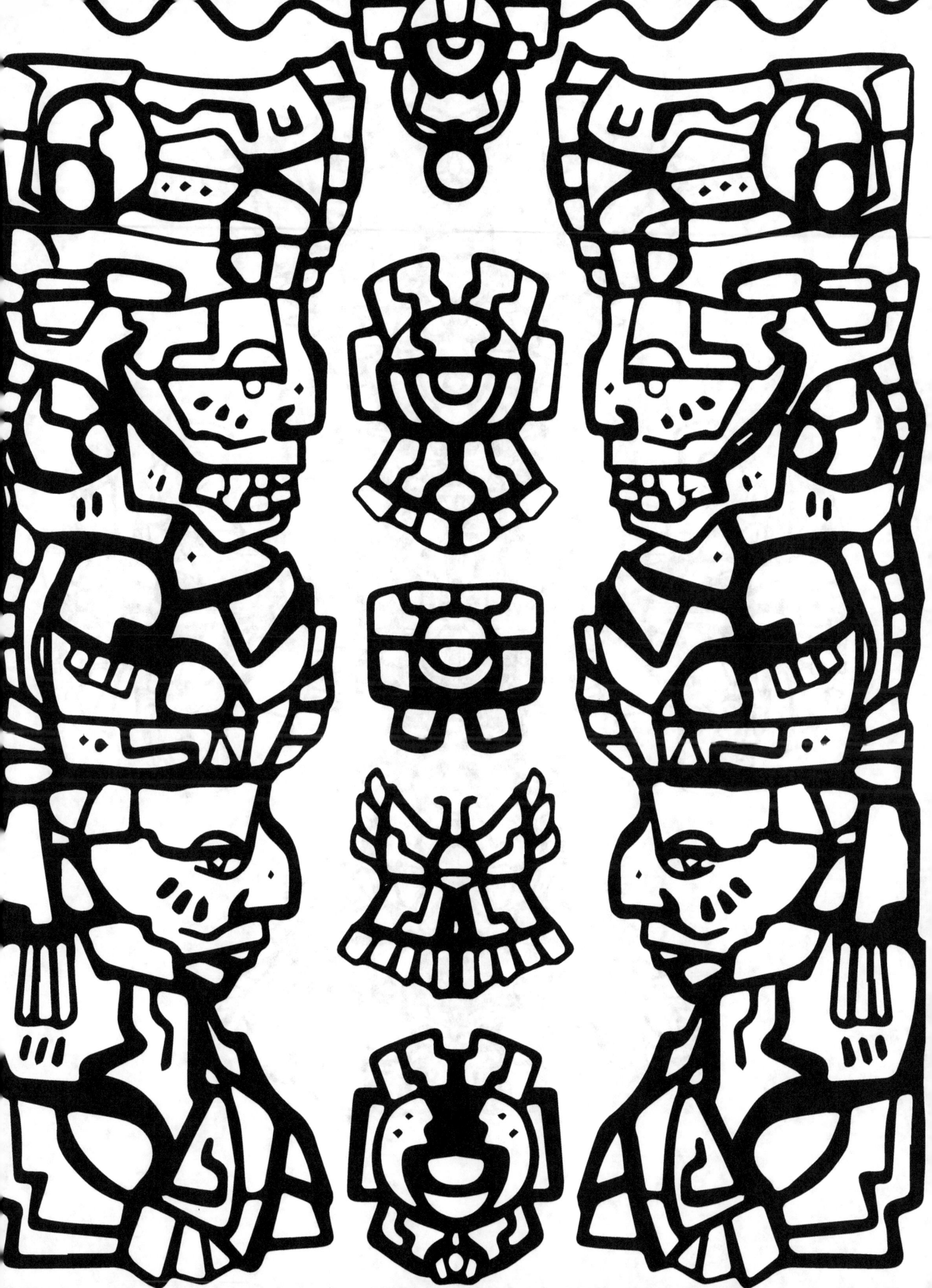

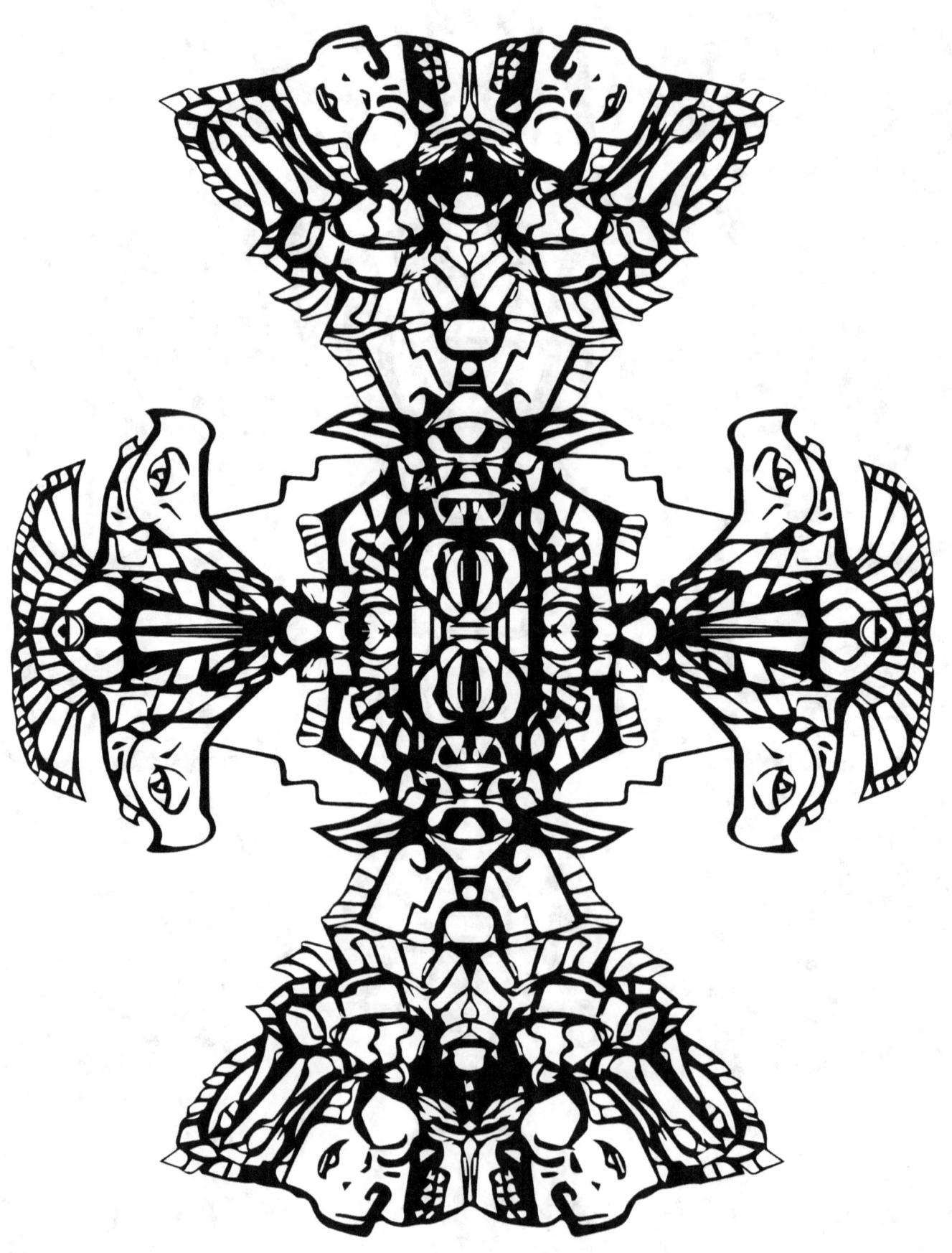

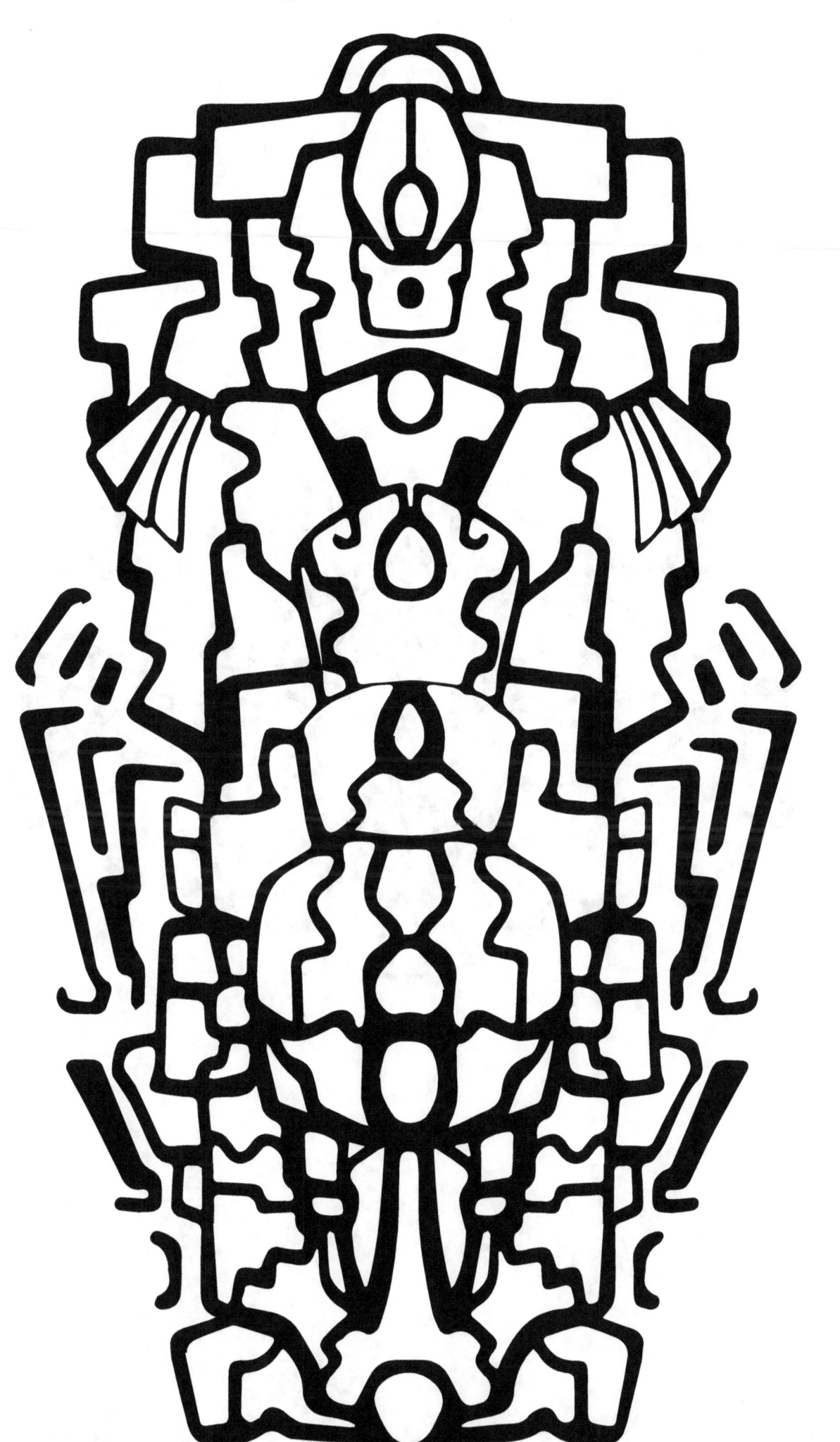

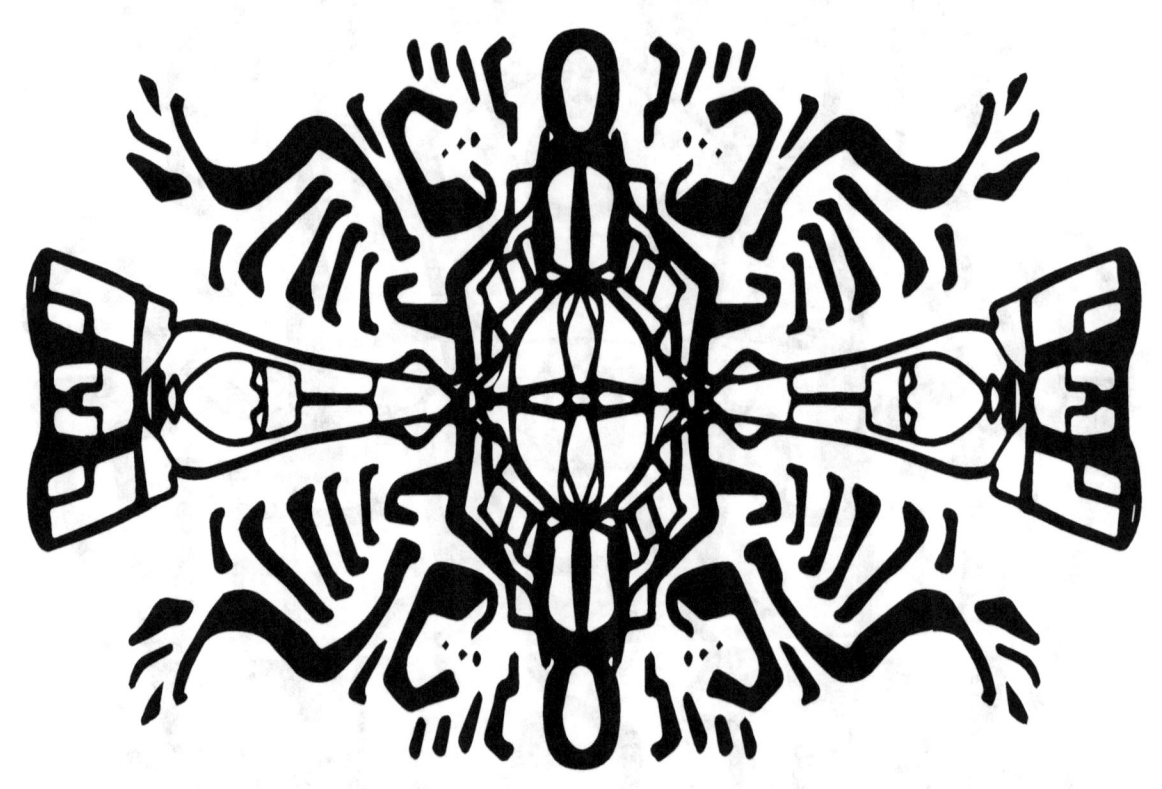

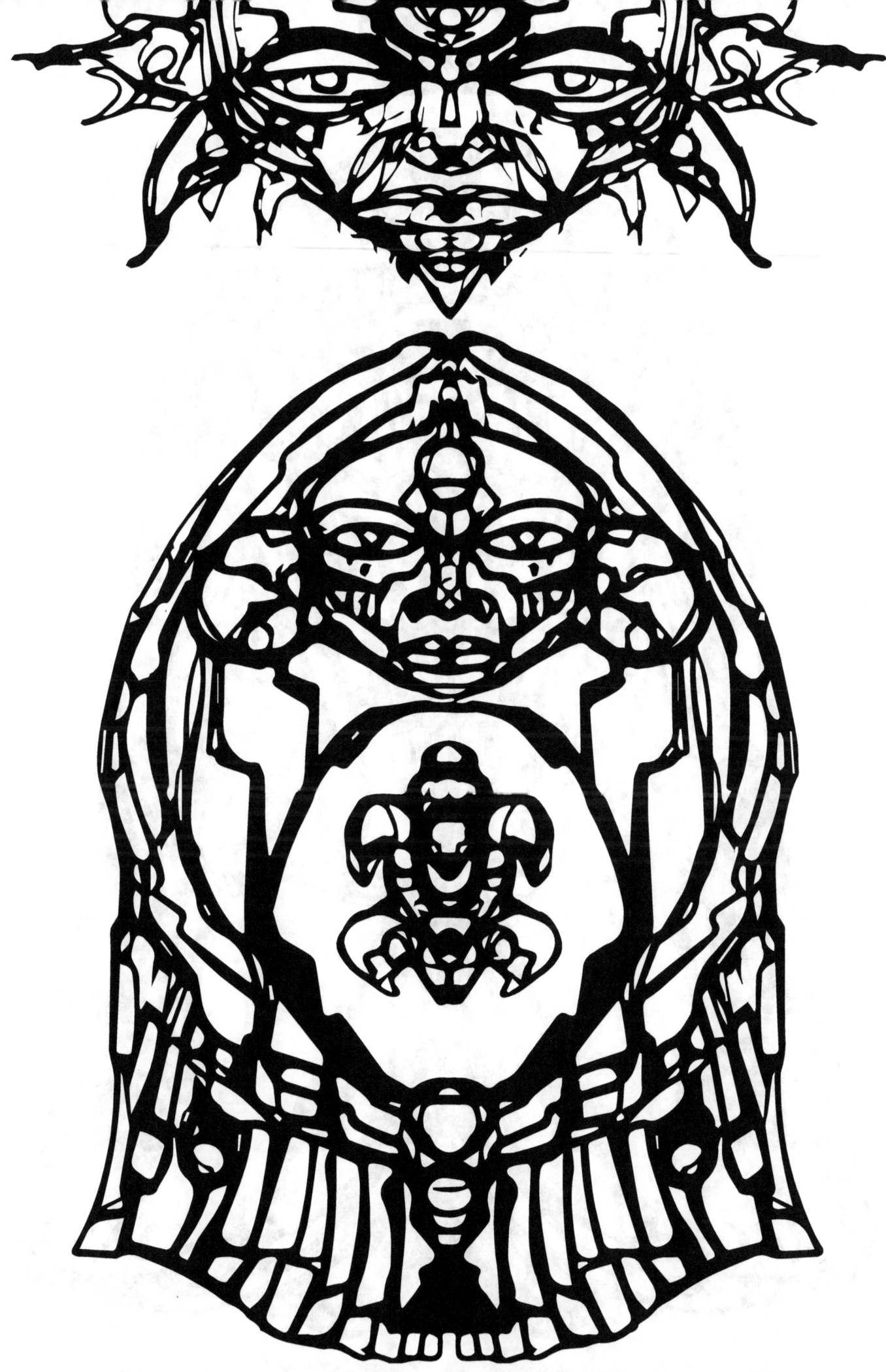

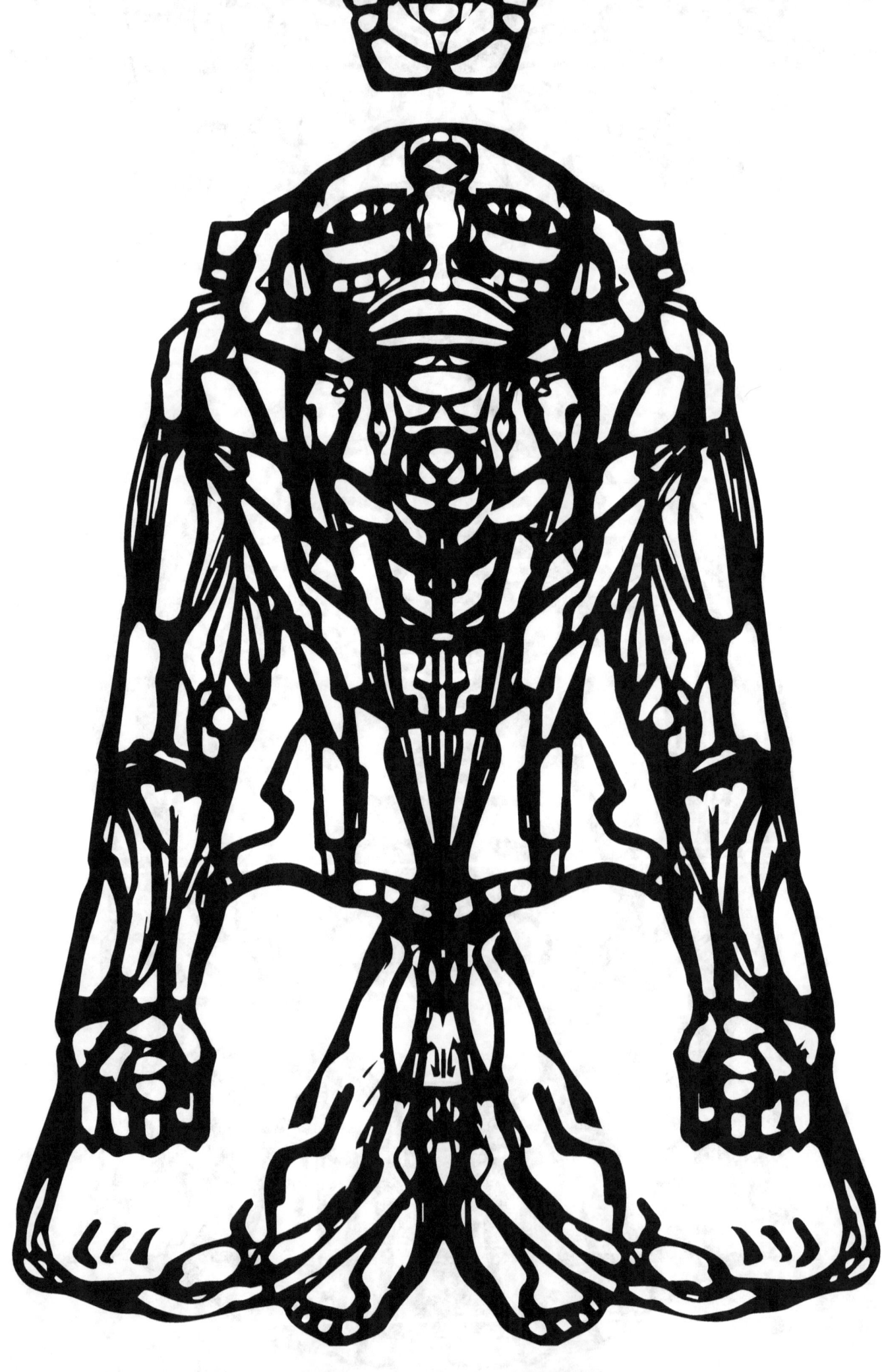

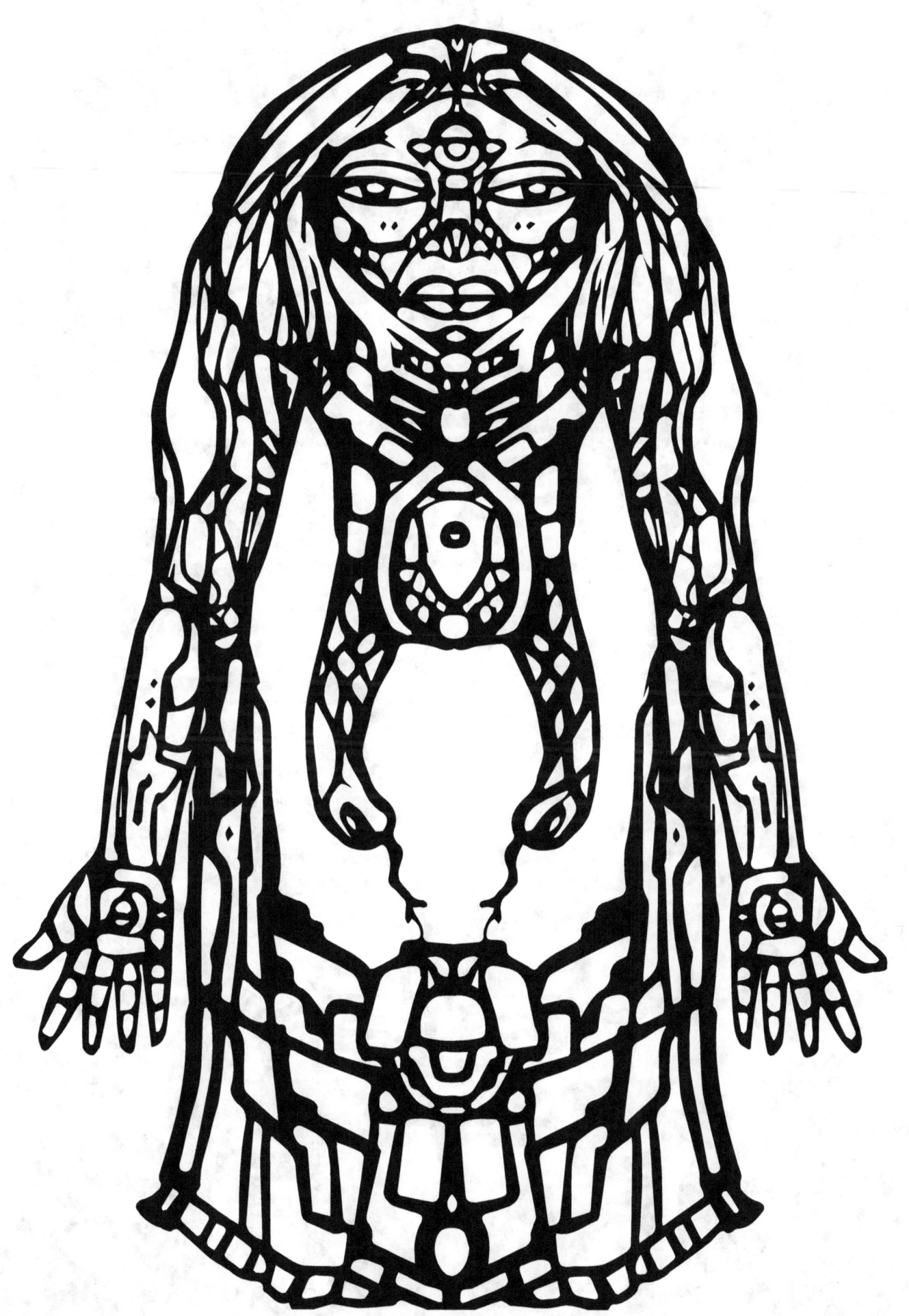

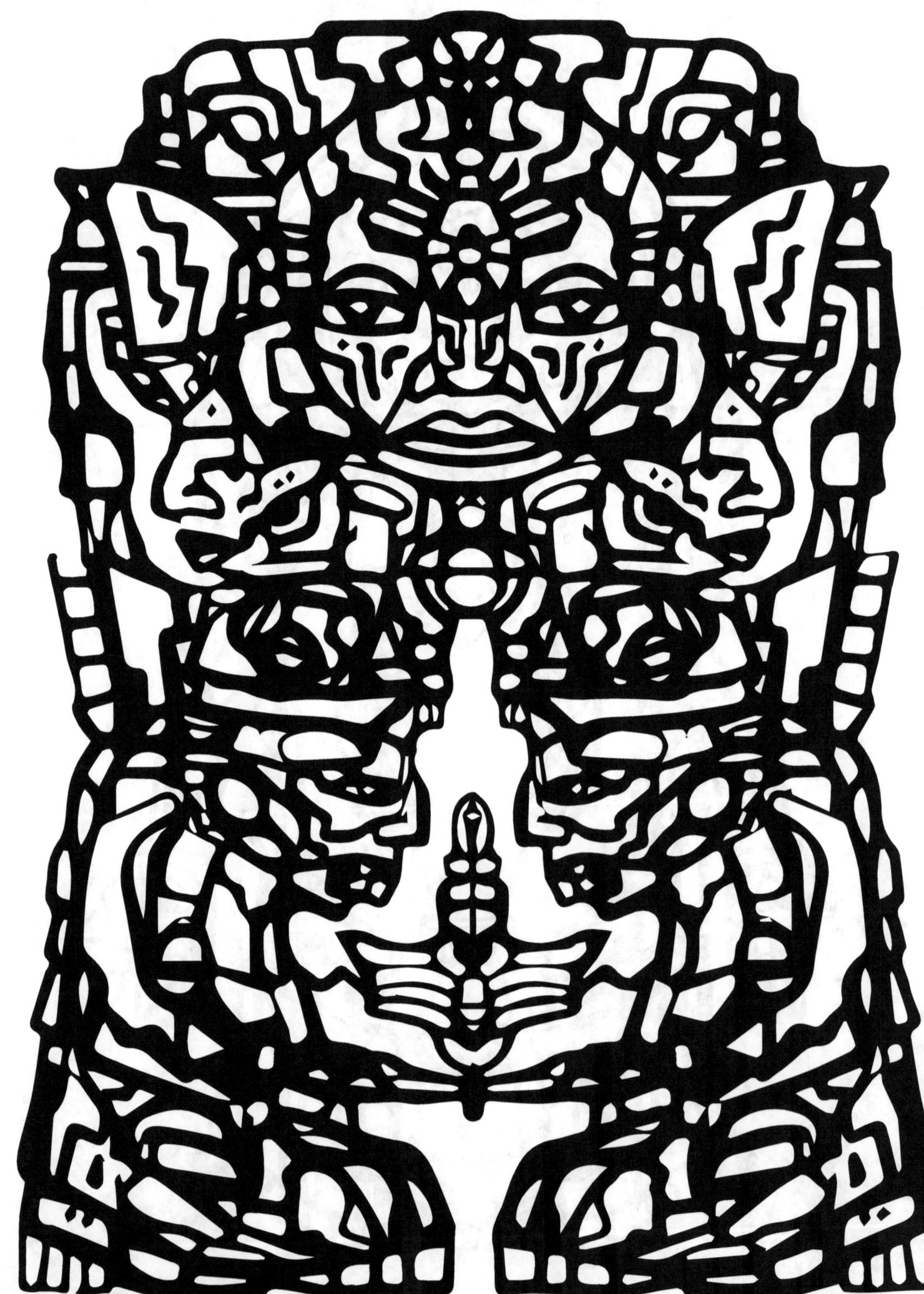

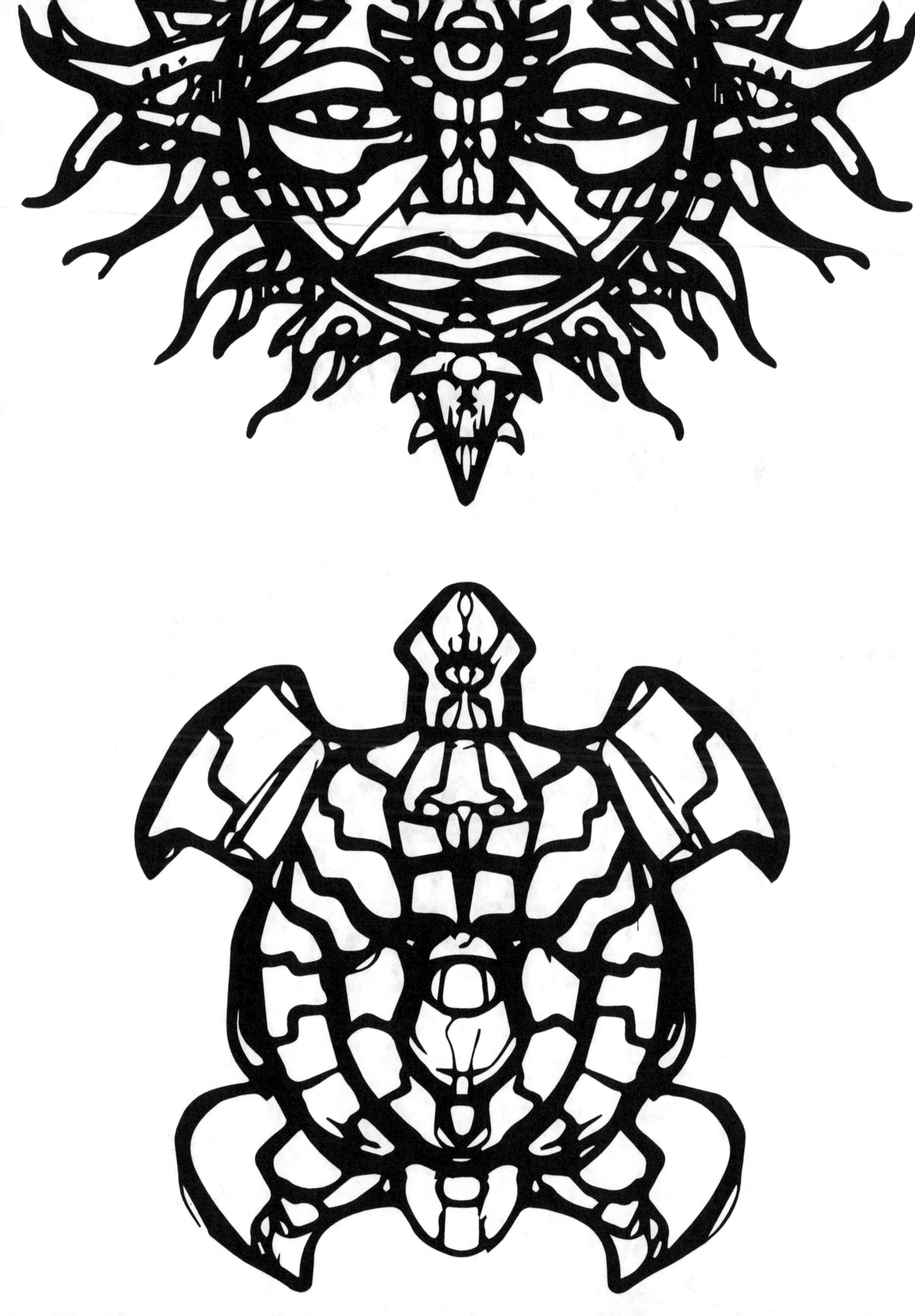

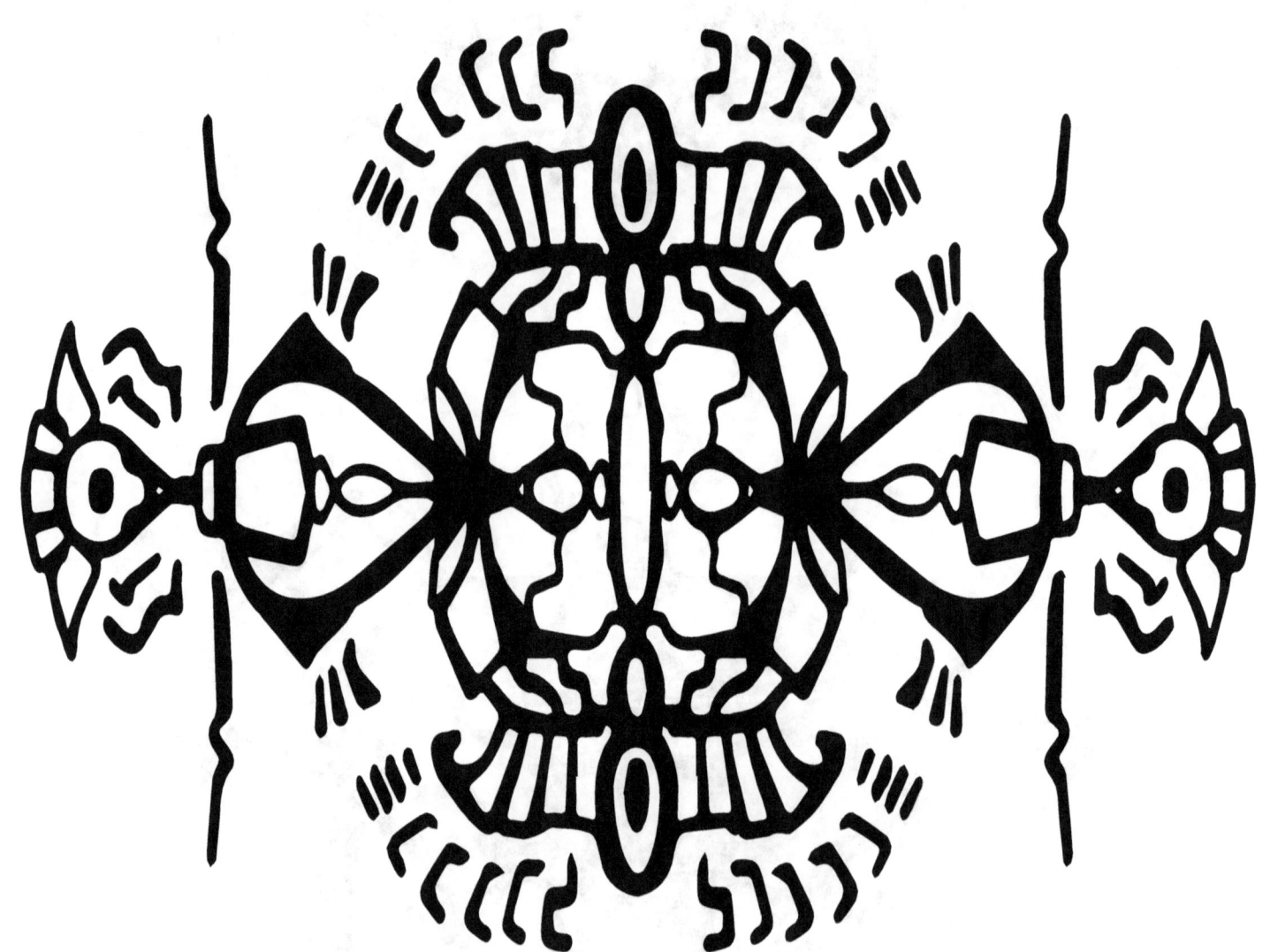

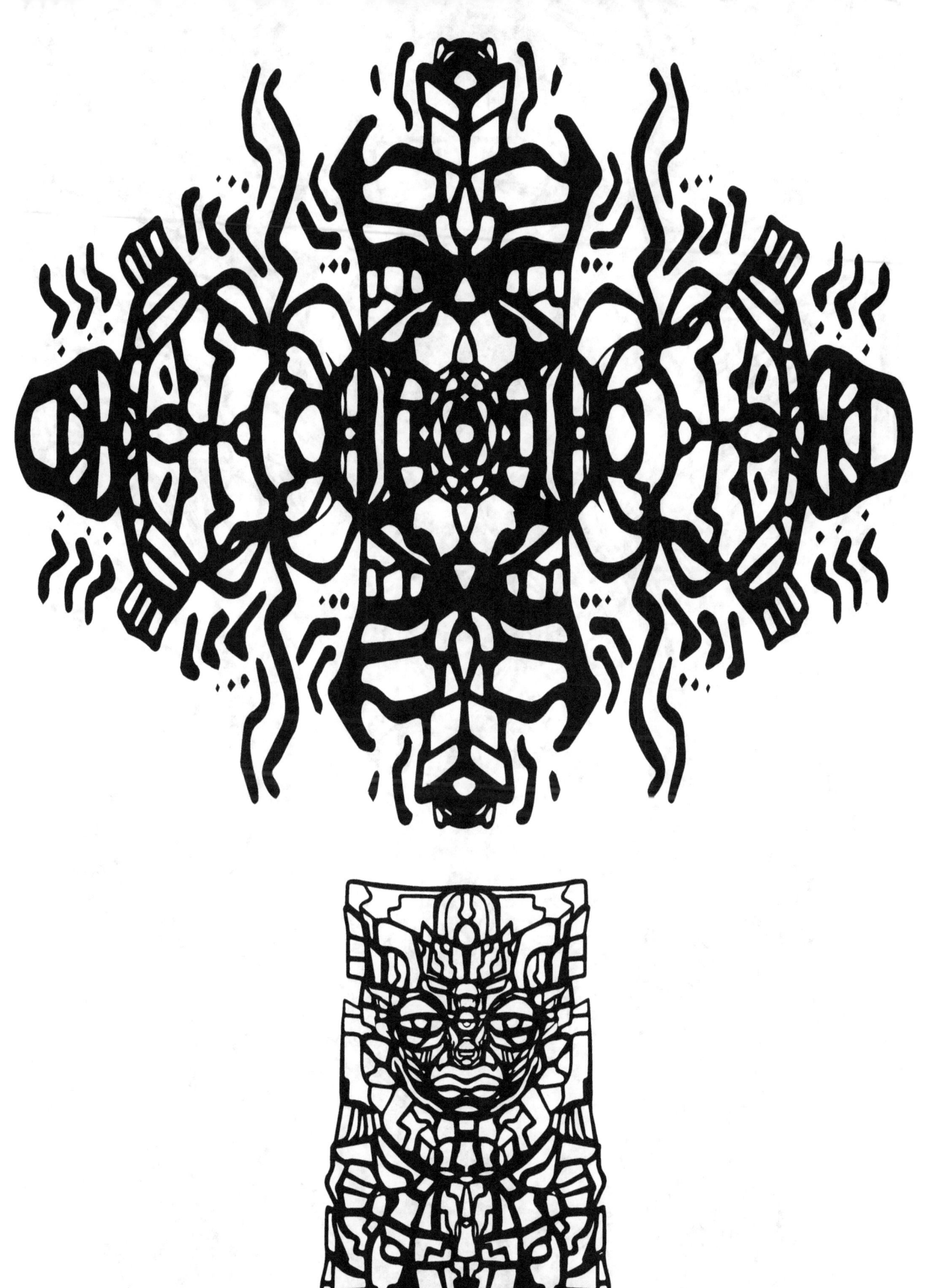

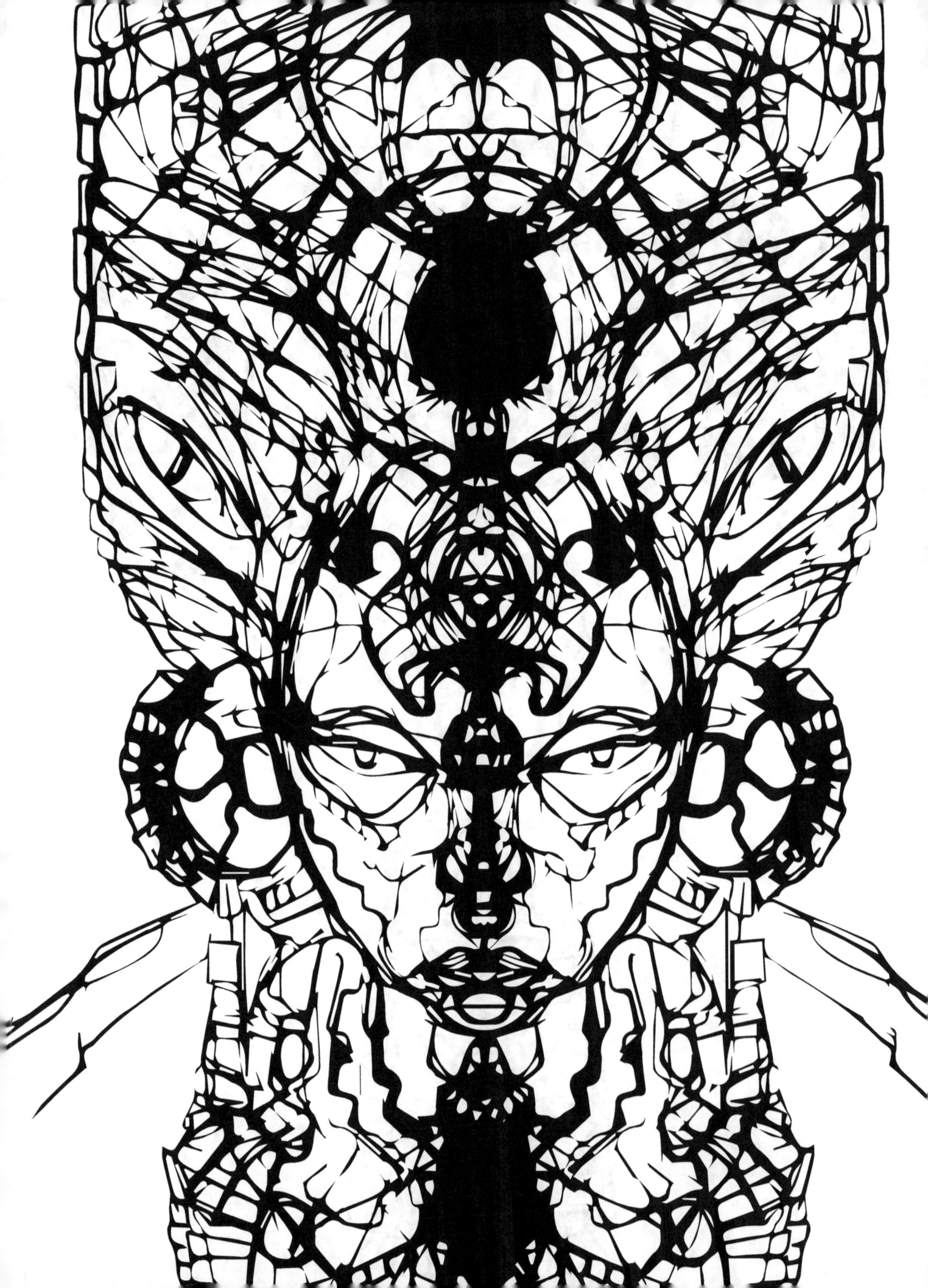

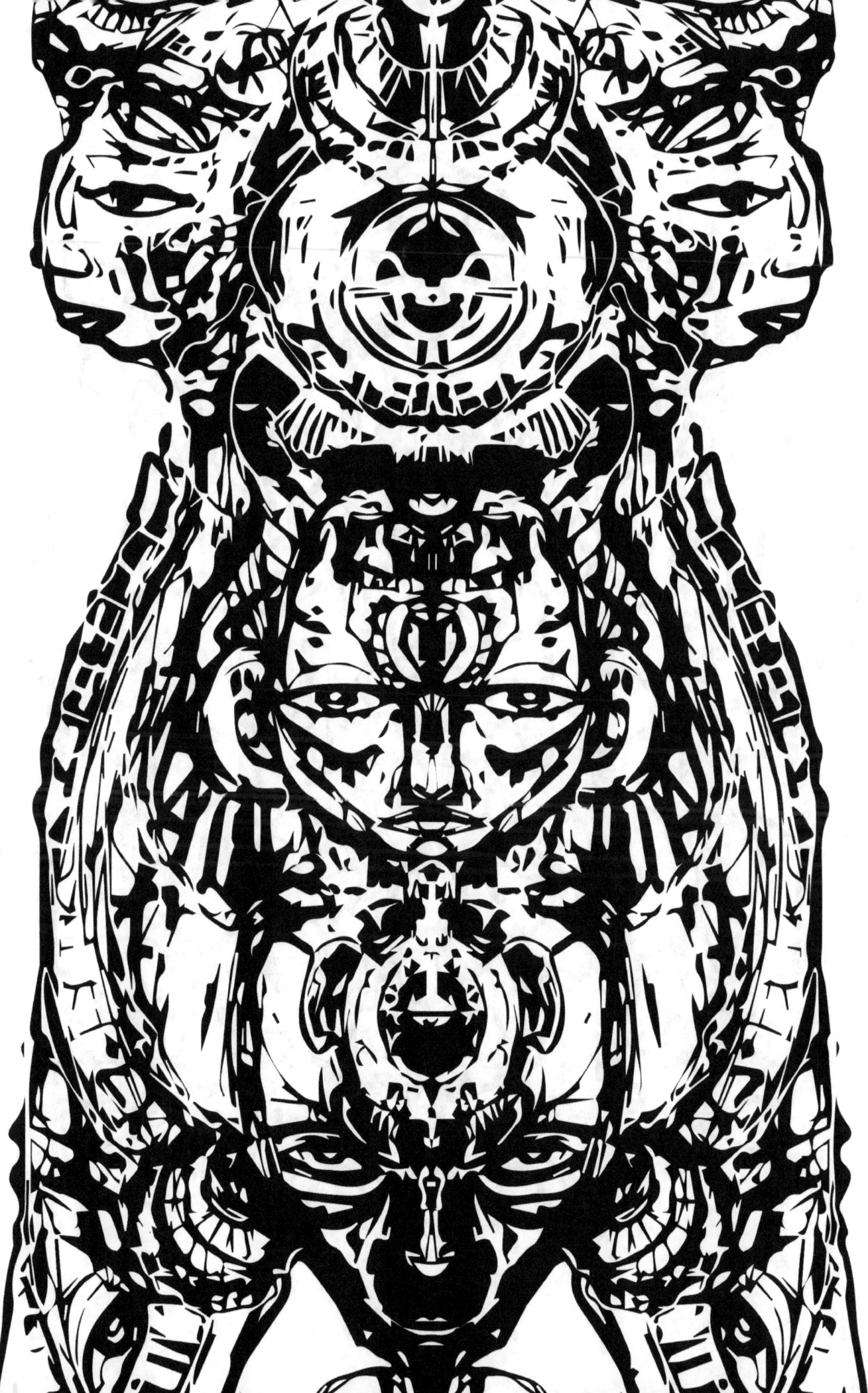

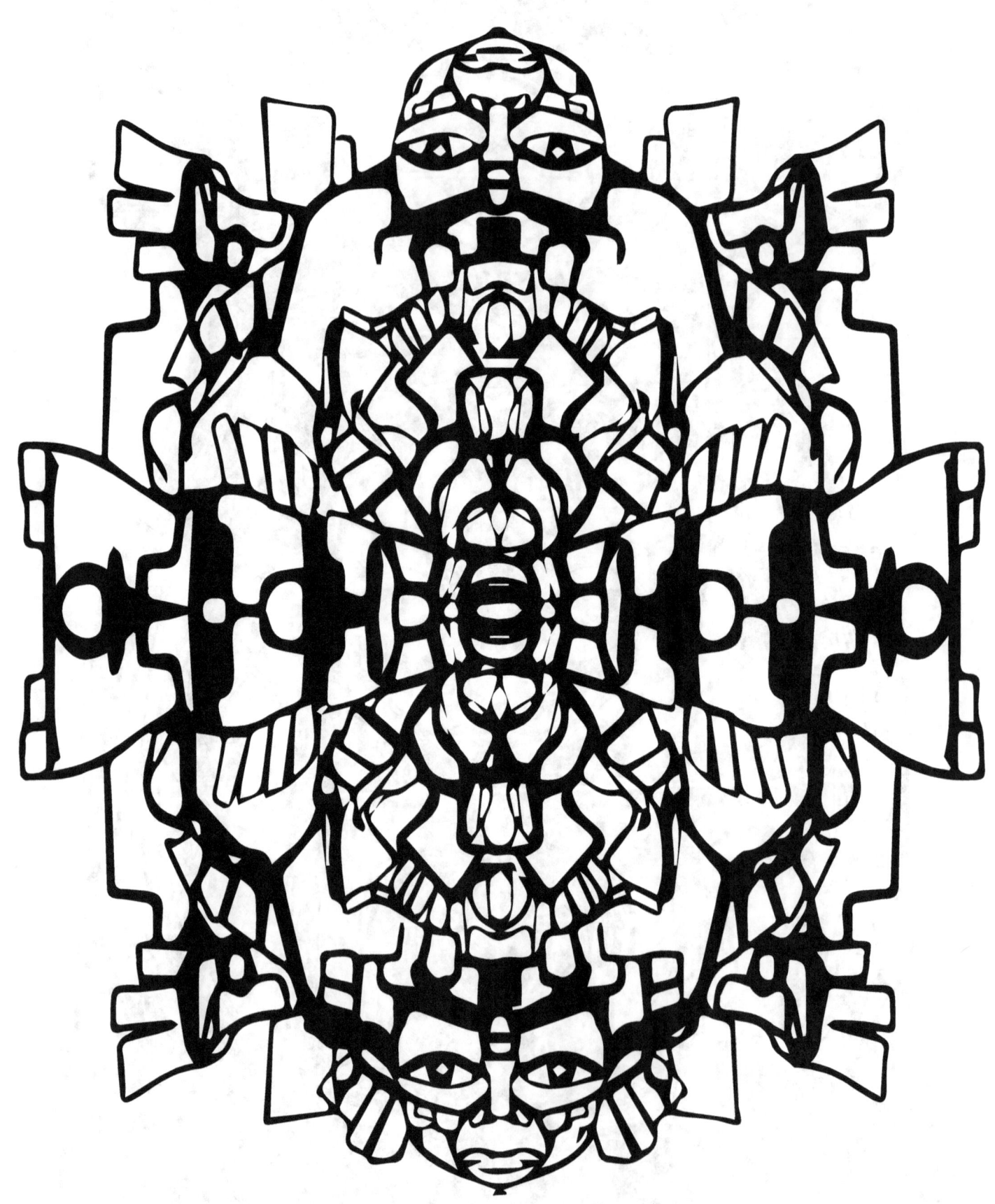

www.ingramcontent.com/pod-product-compliance
Lightning Source LLC
Chambersburg PA
CBHW050454210526
45167CB00026BA/3759